MODERN PAINTERS

LIONELLO VENTURI

MODERN
PAINTERS

*GOYA, CONSTABLE, DAVID,
INGRES, DELACROIX,
COROT, DAUMIER,
COURBET*

COOPER SQUARE PUBLISHERS, INC.
NEW YORK, N. Y. 1973

70355

Originally Published 1947 by Charles Scribner's Sons
Reprinted by Permission of Charles Scribner's Sons
Published 1973 by Cooper Square Publishers, Inc.
59 Fourth Avenue, New York, New York 10003
International Standard Book Number 0-8154-0458-1
Library of Congress Catalog Card Number 72-97507

Printed in the United States of America

Preface

THE modern painters discussed in this book are Goya, Constable, David, Ingres, Delacroix, Corot, Daumier, Courbet.

The selection and discussion of these painters are based on two considerations.

All of them created a few works of an absolute artistic excellence. Their common bond lies in their perfection as painters. It may also be well to stress the very high level of their artistic achievement. It is quite impossible to discover anything similar either in the sculpture or in the architecture of the nineteenth century. And with regard to the preceding centuries the frequent pessimism of art-historians and art-lovers as to the value of the leading painters of the nineteenth century is in no wise justified. Although the painting of that period was handicapped by lacking the support of a contemporary architecture deserving the name of art, and equally handicapped by certain confusions arising from digressive tendencies in sculpture, yet both in number and quality the pictorial geniuses of the nineteenth century may well challenge comparison with those of any preceding century, no matter which. So that the choice of these painters is based on the assurance of their artistic perfection and on the admiration which, in spite of critical doubts, the paintings themselves make well-nigh infinite.

The painters selected are not only perfect artists, but

modern artists as well. And we do not wish to use the adjective "modern" in a chronological sense only. It is absurd to separate the work of art from the spirit of its age, to carry it into a rarefied atmosphere in which it would suffocate, or hang it up, fixed in the sky for all eternity like a platonic idea. A work of art, in all truth, is eternal: that is to say, it lasts beyond its own time; yet its perfection is inconceivable without a coincidence between the liberty of the artist and the spirit of the time, between creative imagination and taste. The author of this book is convinced that the determinism of the milieu, à la Taine, is an error, precisely because it fails to recognise the creative liberty of the artist. But creative liberty does not act in a void, it acts under given historical conditions—conditions of life.

From the very outset, the nineteenth century conceived of art with a bias called romantic, from which it never completely succeeded in severing itself. In this ideal conception artists have sometimes found an incentive to their creations; at other times an obstacle, which in its turn has become an incentive to reaction. Still, they have never been able to neglect what was the ideal of their age without running the risk of aridity in their work, of achieving archaeology rather than art. And in spite of the prevailing anti-romantic tendencies of our century, in spite of certain affectations of abstraction, of certain returns to a remote past, our times have only one tradition, one mainstay, one point of departure: the art of the nineteenth century. This is equally true, incidentally, of philosophy, religion, ethics, political and social life. The reader is asked to identify the ivory tower with the tomb, and to consider art only as one of the activities of the mind,

the dearest to be sure and the most alluring, and as deeply immersed as any other in the fluid reality of the human spirit.

In this sense the painters here dealt with are considered not only as artists but also as modern men.

What the relation between the artist and modernity is, that is between art and the history of art, the author has represented in his *History of Art-criticism,* to which he refers those who would like to know the theories on which this book has been planned. It may be enough now to suggest that an attempt has been made to identify art-criticism and art-history; that is to say, no judgment has been expressed which is not at the same time historically justified, and no information imparted whose purpose is not the justification of the judgment. In other terms, history is here understood as the representation of an activity of the spirit—art—in its historical conditions; and criticism is understood as the dialectic between those historical conditions and the creative imagination of single personalities.

Concerning the painters of the nineteenth century we have more ample information than for the centuries which preceded it. We can follow up the reaction awakened by their work, as it were year by year; we can learn what were the ideas and the passions that accompanied each painter's labour. To ponder the work of art, the light and shade of those ideas, those passions, those reactions, immerses the work of art in its spiritual history, making it live again beyond the moment in which it was completed, varnished, shown and sold; taking from it the character of an object for a museum or a drawing-room, maintaining its nature as a product of the life of the spirit. We do not propose to follow the history of the fortunes

vii

of a mummified masterpiece. Rather do we propose to follow the masterpiece in its life beyond the grave, in its life eternal, as it unrolls itself in our æsthetic consciousness.

Such are the historico-critical method and ideal which may probably distinguish this book from the many—from various points of view often remarkable—histories of painting in the nineteenth century.

The painters dealt with are largely French. Although the book begins with the Spaniard Goya and the Englishman Constable, who owed nothing to French art but, on the contrary, gave much to it; subsequently, French painters dominate. A museum director asked me recently: "I should like to know why, in speaking of nineteenth-century art, one confines oneself exclusively to the French?" I answered him: "That you must ask of God." And indeed I cannot answer such a question; I prefer to tell the story of some of the greatest painters of the nineteenth century.

<div align="right">

Lionello Venturi

</div>

Contents

Plates

AT END OF VOLUME

PLATES

PLATES

PLATES

MODERN PAINTERS

Chapter One

GOYA

Towards the close of the eighteenth century the art of painting had certain extremely well-known representatives: Tiepolo and Guardi in Italy, Fragonard and Louis Moreau in France, Mengs in Germany, Reynolds and Gainsborough in England. And it is possible to trace in the various tendencies of the nineteenth century the continuation of one or the other element in the art of all these men. However, this continuation is sporadic and fragmentary. Confronted with them the Spaniard Goya appears, not only as a gigantic personality, but also as the man who broke the tradition of the eighteenth century, in its ideals and its technique, and created a new tradition. To look at Delacroix and Daumier, Manet and Toulouse-Lautrec, is to feel the historic rôle and even the inevitability of Goya.

If we turn our eyes from painting to the history of the mind in general, we see how homogeneous is the change that has occurred in Europe, even if it takes on various aspects that may seem to be contradictory. They can be noted in the French Revolution and in the consequent rise of the spirit of liberty and nationalism, in romanticism and in the new movements of religion and sentiment, in the idealistic philosophy and in the new historical orientation of science.

The new tradition created by Goya is informed by pre-

cisely this new way of feeling liberty, religion and love of country.

Concerning the religious or unreligious spirit of Goya much has been written, but without due regard to the true conditions of the problem. French critics have affirmed that Goya was a Voltairian sceptic, freed by the influence of the "illumination" from all Catholic faith. But in his letters he shows himself ingenuously attached to the faith and the practice of Catholicism. We have erroneously attributed scepticism to Goya, misled no doubt by the vehement attacks on priests and friars in the "Caprichos". And yet it was highly natural that a man of genius and of strong moral feeling, sprung from the people, should have his eyes open to the vulgarity, hypocrisy, materialism, and corruption of the clergy, amongst which he lived. It is not, in fact, surprising to find Goya imbued with that popular instinct which is naturally rebellious against all doctrinaires—religious as well as civil. But it was exactly Goya's passionate nature which prevented all contact with French rationalism. If he exalts human liberty, it is not because he practises it or theorises about it, but because he spontaneously loves it. Even from the religious point of view, to be sure, we can discern the unfavorable aspects of that duality between modes of feeling and modes of living, to which he had perforce to subject himself if he wished to work for the Spanish Court.

We shall see how in the pictures painted by Goya for churches he was unable to express his faith, or able only to express it incompletely. On the other hand, where Goya truly felt Christ and his martyrdom, where he expressed the heroism and the martyrdom of belief in a unique and matchless

2

way, is in the "Executions of the Third of May" of the Prado Museum in Madrid. His patriotism, above all, his humanity, enabled Goya to feel the transcendent value of faith, as though the lazzarone who opens his arms were the Christ once more on Golgotha. The exceptional value of this epoch-making fact is this: Goya expresses his religious feeling, not when he has to represent a religious scene, but when he lights upon the motif of his own religion, the religion of independence, liberty, humanity. It is well known that the Reformation, by making religion more subjective, had also made it more profound. But it had stopped half-way. It has been the task of the nineteenth century to reach an absolute form of liberty, by allowing everyone the right to his own religion. At the very beginning of the century, following the course of the European spiritual current, and without belonging to any intellectual system of free thought, by sheer force of genius Goya reveals in the "Executions of the Third of May" the task of the entire century. The new conception of religious feeling is accompanied by an equally new vision.

A few parallels with literature may throw light on Goya's spiritual message. How incapable of coming close to the life of their time his contemporaries showed themselves is proved by Goethe's *Hermann und Dorothea*. Hermann is the son of an inn-keeper, of the lower bourgeoisie, although in easy circumstances: he drives a carriage; his horses are thoroughbreds, the oats are "first-rate," the hay is dry and mown in the best meadows. The bit gleams, "the buckles are silver-plated". Well, Goya demolished with one blow all this heroic, Homeric or "philological," if you prefer, tradition, and represented the tragedy of the tatterdemalion, so different from the tragedy

3

of the hero, precisely because, without being any the less tragic, it is that of a ragamuffin.

Goya renounces all distinctions whatsoever between the beautiful and the ugly. The expression of deliberate will-power in Corneille or of destructive passion in Racine is always accompanied by a moral judgment implicit, or explicit, on this will-power or on that passion. Not so in Shakespeare. The expression of passion draws its potency from the very abeyance of all moral judgment. In this suspension of all moral judgment Shakespeare's art does not search for the beautiful expression as opposed to the ugly one, paralleling the good subject as opposed to the wicked one. This would imply the art of the "characteristic", as Goethe has said. But Shakespeare's art is a representation of life which comprehends the beautiful and the ugly, the good and the wicked, without partiality. And so it is with Goya. No one thinks that the soldiers who are killing are doing their duty, or that the beggars are the heroes of Spanish freedom. You only feel that a blind machine is crushing a human value which rises to epic heights purely and solely because of that contrast, that of a human value opposed to the inhumanity of a machine. But the comparison with literature goes further. "Rebellion against society" was, as we know, a theme amply dealt with by international literature in those days. We need only mention *Werther, Don Juan, Manfred, René, Jacopo Ortis, Eugen Onégin*. Nothing of the kind in Goya: he does not represent intellectual rebellion, but rather the revolt of popular passions—and he sanctifies them. He is not sick with individualism. He does not analyse himself. He suffers and cries out. And he is, moreover, very close to what is most vital in the spiritual life of the nineteenth

4

century. That his influence went beyond the limits of painting is proved by the fact that the realistic movement in France, forty years after the "Executions of the Third of May", received its first stimulus from painting rather than from literature.

The canons of beauty inherited from the painting of the eighteenth century are reversed by Goya, as regards the form, which is split up and impressionistic, the colour, which is contrasted rather than blended, and the ideal, which becomes the heroic valour of the masses, of all that is ugly and vulgar. There is a clear break with all that went before. The dwarfs and cripples of Velasquez, the invalids of Rembrandt's last manner, are barely hints of what is to come. Without the new consciousness created by the French Revolution it would have been impossible to conceive one of Goya's scenes.

To understand this phenomenon we must remember that throughout the course of centuries "beauty" has always presented itself as a choice. And if the choice was not perhaps exerted on the object represented, it was always exerted on the mode of representation. That is to say, when the thing in itself was considered as not beautiful, attempts were made to seek out a formal relation between the ugly object and the form of beautiful objects. The drawing of a Brouwer, the lighting and the relief of a Velasquez are proof of it. This is no more so with Goya. The spirit of one of Goya's scenes does attain its perfect and therefore sensory expression. But (and this is the point) the spirit is expressed in it in a manner completely independent of a sensible form considered as being beautiful. In order to adhere to the spirit, the visual form subordinates its own autonomy. Passion has been kept under

control, but without attaining to any abstract idea of form; it is kept under control by the very vivacity with which passion has been rendered. Not only is it impossible to distinguish content and form, but in the very contemplation of the artist there is no connection with a traditional form, there is only the form dictated by the content. But this is the consequence of realism. If by realism we mean a fancy for representing the lower strata of society, this is realism. But if by realism we understand the renunciation of an ideal expression, then this is not realism. In fact we must consider the "Executions of the Third of May" as the expression of an *epic* ideal. Whatever is poorest and most miserable and vulgar in the life of nations has been elevated by Goya to the level of the *epos,* without being modified in its social or moral character. The human interest engendered by the French Revolution for the flotsam and jetsam, the victim, the conquered, became for Goya the material for a picture. It marks the end of feudalism in painting.

This conception of the epic derives its novelty from the fact that it is not based on what was traditionally known as the "sublime", but on its contrary. Before the "Executions of the Third of May" Goya had engraved the "Caprichos". The "Caprichos" belong to the genre of caricature, but it may be necessary to explain that a caricature is not of necessity endowed with a comic spirit. The antecedents of caricature are to be sought for in the imaginative fancies of the ancient *grottesche,* in the lyrical conceits of the Romanesque monsters and in the scientific deformations of Leonardo da Vinci; and when in the seventeenth century the term caricature made its appearance, it was associated with "giuoco" (play) as well as with "scher-

6

no" (mockery) (Baldinucci, 1681), with the "colpi caricati" (satirical) effects in Bernini's drawings—"as a result of his straightforwardness" (Baldinucci, 1682)—with the contrast of white against the foil of the black producing "some indefinably graceful *caricatura* and a delightful vivacity" (A. M. Salvini, 1695). At the end of the eighteenth century people were conscious that the concept of caricature was drawing ever nearer to that of the comic, but they also recognised that the original motive was the "characteristic" (Sulzer, 1777); and that the merit of the caricaturists consisted in their "sagacité fine à saisir les caractères et les expressions" (Watelet, 1792). Whoever recalls the importance assumed at that time by the clash between the concept of the "characteristic" and that of the "beau idéal" can understand the æsthetic influences of caricature: it was, one might say, a means of arriving at certain moral and political ends, but it was also an end in itself, with a special capacity for cultivating the field of the characteristic, the only fruitful one after the field of loveliness had been sterilised by the prejudices of this very "beau idéal". To this must be added the entirely Spanish tradition of picaresque literature initiated by "Lazarillo de Tormes," 1554. A life of hardships and expedients, the poorest and saddest aspects of society, the most wretched humanity, people, driven by hunger, to ruses and slyness and selfishness and vulgarities of every kind: that is the picaresque world. And the tone of this literature is satirical, it is partial to the ridiculous and the grotesque, and it sometimes verges on cynicism. This picaresque world does not belong exclusively to Spain, but Spain discovered it artistically, without doubt because in Spain the contrast between the misery of the people and the "grandezza" of

7

the upper classes reveals itself more crudely than else-
where.

Baudelaire has observed that Goya "unit à la gaieté, à la
jovialité, à la satire espagnole du bon temps de Cervantes, un
esprit beaucoup plus moderne, ou du moins qui a été beaucoup
plus cherché dans les temps modernes, l'amour de l'insaisis-
sable, le sentiment des contrastes violents, des épouvantements
de la nature et des physionomies humaines étrangement ani-
malisées par les circonstances". Now it is important to note
that the romantics in general, and Schelling in particular, saw
in the romance of *Don Quixote* the eternal conflict between
the ideal and the real, and, in the hero's defeat, the magnificent
triumph of his heroism, a model for romantic irony, a con-
fession of Cervantes' innermost disappointments. They found,
that is, in *Don Quixote* precisely what the painters of the nine-
teenth century found in Goya. Mysticism, the poetry of
dreams, found a counterpoise in reality, and were in turn
modified by the contact with it; they in their turn infused it
with a new energy. The transcendental realism of the roman-
tic poets had its origin in Cervantes, just as that of the romantic
painters had its origin in Goya. The Spanish contribution to
realism was pointed out to us by Friedrich Schlegel in 1802 in
connection with the "Young Mendicants" of Murillo in the
Louvre. "Whereas others would have emphasised the pic-
turesque and the comic, the grave Spaniard has succeeded in
elevating his subject in such a way that the individual appears
to us in the form of a general reflection on the misery and
degradation of human life and of existence itself." The novelty
of nineteenth-century realism as compared with that of the
seventeenth and eighteenth centuries consisted precisely in this

8

new vision of life, representing a transition from the recognition of individual wretchedness to the religion of shipwrecked humanity. In painting, this transition is called Goya.

It has been said that the Spaniards never went beyond popular literature, and to this limitation has been attributed their small influence over European literatures. And yet the *popular* has always found energetic expression in Spain and has been capable, through its moral dignity, of attaining to that humane ideal which permeated all the best art of the nineteenth century. During the nineteenth century the state of mind provoked by the idea of the people seems to have been the state of mind most fecund for artistic production. That was the case in painting, at least, and it was Goya who made it so.

Art-criticism in Spain followed this change in taste. At the time of Goya's youth it had undergone, even more than had the painters, the neo-classical influence of Mengs. Even appreciation of Velasquez was reduced to recognition of his naturalistic virtuosity, for instance in Azara. And Jovellanos too had begun to write in a neo-classic spirit, although at a later period he awoke to the beauty of medieval architecture, and in 1789 he wrote that "if idealistic painting arouses greater admiration, the naturalistic produces greater delight", that Velasquez has attained to "that gift of expression which belongs to the sublime and philosophical branch of art". That is, the neo-classical principles championed by Mengs had been tacitly abandoned, more from a spontaneous enthusiasm for authentic art, than from a critical conscience. It was the same Jovellanos who in 1790 submitted to the Real Academia de la Historia in Madrid a memoir concerning the necessity of the

people's taking part in the civilising influence of art, in which he stressed the melancholy and neglected state of the Spanish people in a manner reminding one of Goya. Which is a precious symptom of how closely Goya's work responded to the needs of his time and of his country.

Goya first saw the light of day in 1746 at Fuentetodos near Zaragossa in Aragon, but in 1772 he had not yet seen the light of art. He had then, after studying under a certain José Luzán y Martines, a painter of the Neapolitan school, after attempting in vain to obtain a scholarship in the Academy of St. Ferdinand in Madrid and barely succeeding in getting a second prize at the Academy of Parma, completed a few religious paintings for the Madonna del Pilar in Zaragossa, and for the Charterhouse of the Aula Dei near Zaragossa. His paintings of 1771–72 reveal a certain easy familiarity with the baroque tradition, a taste for large zones of light and shade akin to those of Mattia Preti. In a "Crucifixion" at the Prado Museum dating from 1780, the influence of Mengs is evident as well as a certain over-emphasis of sentimental values. But no one could as yet have even divined the Goya in store.

Then certain events brought a change into Goya's life. Through the patronage of the painter Bayeu, a fellow-Aragonese whose sister became Goya's wife, he received from Mengs the commission to create the first designs of tapestries for the royal factory of Santa Barbara (1775). In 1779 he was received by King Carlos III; in 1780–81 he became an academician, and in that year he rebelled against the mentorship of Bayeu; in 1784 he won his first official success with a mediocre painting representing Saint Bernardino of Siena preaching in

the presence of Alfonso of Aragon. In 1785 he already re-ealed his optimism with regard to his official position, which was gradually getting better and better.

Two new experiences made themselves felt in his art: one is the discovery of Velasquez, of whom in 1777–78 Goya engraved various paintings; the other is the work on designs for the tapestries. In fact these designs or cartoons did not need the academic finish accorded to pictures, and this permitted the young Goya to express his ideas more spontaneously and directly. Moreover, in spite of Mengs' direction, the subjects selected for the tapestries were of a popular character, drawn from contemporary life: and so Goya must have found in them a fine opportunity for giving free vent to his imagination.

The "Crockery Vendor" of 1778 (Fig. 1; Prado Museum) shows in most felicitous fashion the fundamental qualities of Goya's art. The liveliness of pictorial effect, with the perfect fusion of image and background, the apparent disorder and richness of the composition, the rapidity of touch which succeeds in rendering airy and as it were impromptu every figure, the grace and elegance which gives to every woman of the people the dignity of a lady, and to every bit of crockery a Chardin-like humanity—all this is spontaneously created by Goya even if it does not depart from the subtlest European tradition, that of Velasquez, the Venetians, the French. But Goya's accent, the sole unmistakable accent, already dawns; there is an assurance, a decision, a presence, that are quite unexpected; the significance of each figure appears with a surprising readiness, and thereby takes on an entirely new intensity. Goya loves his figures, light-heartedly, and not without a

flash of laughter. He creates a fairy-tale, but he fashions it like a poem.

With the death of Carlos III and accession of Carlos IV in 1789, Goya becomes a member of the court at Madrid, being appointed court-painter, and thus can personally observe the rapid moral disruption of the court and the government, caused by Queen Maria Luisa and the King himself.

Goya was a man of the people. From the artisan level to which his father belonged, he had wanted to elevate himself to the level of an artist, and, as the rule then was, the way there led only through the Academy. As a result of his spontaneous non-conformity and his lyrical vivacity as a colourist, he had met with difficulties: this is confirmed by the opinion of the Academy of Parma (1772) and by the quarrel with his brother-in-law Bayeu (1781). In 1784 he writes: "I have certainly been lucky as regards the appreciation of the intelligent and of the public in general, because everyone is favourable to me without question." In 1786 he writes that his earnings are limited "and that none the less I am as satisfied as the happiest of men."

If, before this, he had betrayed his contempt for court life, he now adapts himself to it, without even changing his sentiments. In 1788 he is snowed under by success and commissions. He cannot satisfy all those who ask him to work for them. He would like to have fewer commissions so as to be able to execute more efficiently the ones he has accepted, to live at greater ease and work for himself according to his own taste, which is what he most anxiously desires. In 1790 he realises that he is quite well known to everybody, from the

Royal Family down, but that he is not sufficiently clever to ask for adequate remuneration so as to be freed of his monetary difficulties. The director of the Tapestry Factory protests in 1791, because Goya does not deliver the cartoons according to his promise. And in order to excuse himself the painter waits on the King, who entirely agrees with him and tells him what evil tongues are saying against him. The better to stress his condescension, Carlos plays the violin for him, filling Goya with pride!

In this way, Goya, without having the soul of a courtier, played the rôle of one. But, all unbeknown to himself, the soul of a rebel was hidden within him. Suddenly a catastrophe opened his eyes to what was going on around him, gave him, as it were, the courage of despair, with which he expressed himself in all sincerity, and this lifted him all at once to the level of moral liberty.

In 1792 Goya suffered from a grave illness, which left him deaf. Bayeu thought that he would never recover. Zapater, while expressing his sympathy, attributed the illness to the painter's carelessness. Jovellanos speaks of apoplexy. The illness has its ups and downs. In 1794 Goya writes: "As regards my health, I am still the same; at certain moments I am mad with a humour which renders me insupportable to myself, at others I feel calmer." When we remember that he lived until 1828, and that he continued to work with exceptional energy, we can measure the force of his recovery. But something was lost: his optimism. As a result of his deafness he is isolated from the world, he belongs more completely to himself. The consequence is the increased depth of his art. In 1794 he writes: "The better to occupy my imagination, mortified by

the thought of my illness, and to repair at least in part the great expenses it has caused me, I set to work to paint a series of *tableaux de cabinet;* in these I have succeeded in making room for observation, which as a rule is absent from works made to order, where caprice and fantasy cannot be developed." Among these *tableaux de cabinet* is the "Judgment of the Inquisition" (Fig. 2; Academy of Fine Arts, Madrid). Compare this scene with that of the "Crockery Vendor". It is a new art, an entirely new one; even though you are able to perceive that the artist's personality is the same, you cannot shake off your amazement at this transformation. The light touches which, in the "Crockery Vendor", represent a trustful smile of joy, in the "Judgment of the Inquisition" become a mocking sob, at the bottom of which lies despair. And the vast, gloomy zones take on the significance of fearful phantoms. In the background, the half-light is mysteriously vague. Amidst these motifs and these forms opening onto the infinite, there swarms a throng of monkish judges, whom the devil alone can possibly have invented, a jumble of intrigue and cruelty, falsehood and cynicism. Among them there is only one human note: the accused, bent and resigned under the moral burden of the ridiculous hood. All these sentiments form the background for the painter's personal independence, not only through the fusion of light and shadow, through the quicker, lightning-like apparition of lights in the penumbra, but also in the absolute dissociation of the significant and the spiritual form, no matter whether human or diabolical, from every plastic one. Thus in the principal defendant there not only becomes visible a moral beauty independent of anything physical, but we are also plainly shown beauty in bestiality: in a

14

tragically smiling monk, in another who is giving an infamous command, and even in an empty and immobile glance.

In the meantime, Goya engraved the "Caprichos". There is no doubt that they represent the revolt of an exasperated spirit. His heart was that of a man of the people, completely natural, and could not but revolt against social hardships, the degradation of the poor, the ignorance, vice and greed of the court and the ruling class, the superstition, Jesuitism and cruelty of the clergy, the misconduct of women, the inconstancy of his mistress the Duchess of Alba, the paltriness of married life, the meanness of domestic life. It is a world of horrors, on the whole seen pitilessly, under the glare of the harshest light, in order to give in each event the unmistakable impression of idiocy or malignance. It has been noted that in the portraits, under the semblance of humanity, the bestial character peeps forth. In the "Caprichos" the bestiality of a certain kind of human life makes itself clearly manifest. Goya seems to pounce on the vice and folly of his age, and to portray them with so much fervour that he has neither the time nor the requisite detachment to sit in judgment on them. His imagination is transported to the world of witches, rendering more credible, in its absurdity, the power of cruelty. He grows aware of this and comments on these flights of fancy in his print no. 43: "The dream of reason produces monsters." That is what Goya wrote of himself, perhaps to avoid being worried by the Inquisition and by the court, but he knew that his fantasies were not monsters. Thus he wrote in 1794 that he was not attempting "to imitate the work of any master, or even to copy Nature." He was conscious, then, of his independence as regards the double foundation of all painting:

the tradition of the schools, and Nature. We recognise the value of style in his work, but it is a created style. We recognise the value of the performance when it has been completed, but it is a reality created after Nature's way and not imitated from what Nature has created. Imagination and intuition, ideal and real are resolved into art.

Baudelaire stressed the "fantastic" character of the "Caprichos". "Il plonge souvent dans le comique féroce et s'élève jusqu'au comique absolu; mais l'aspect général sous lequel il voit les chosès est surtout fantastique, ou plutôt le regard qu'il jette sur les choses est un traducteur naturellement fantastique. . . . Le grand mérite de Goya consiste à créer le monstrueux vraisemblable. Ses monstres sont nés viables, harmoniques. Nul n'a osé plus que lui dans le sens de l'absurde possible. Toutes ces contorsions, ces faces bestiales, ces grimaces diaboliques sont pénétrées d'humanité."

Goya accentuates the extremes: he is both realistic and fantastic to an extreme. Yet we wonder at the absolute fidelity to truth of his fantasies. In order to explain this identity between realism and pure imagination, Brieger imagined that Goya did not hesitate "to cause this realism to return upon himself. He was superstitious, coarse, ignorant, capricious, but as he was conscious of all these defects, they made him suffer; he was cynical enough" to employ his own defects and sufferings to give increased power to the work of art. Something of the kind has, in fact, occurred; and this explains the lyrical character both of Goya's realism and of his fantasies. Only, we should speak of cynicism rather than of passion: man of the people that he was, Goya created, not as an escape from the obligation of judgment, but from a moral impulse.

16

When Goya engraved the pictures by Velasquez he adopted a technique imitated from Tiepolo. That is, we have an interpretation of Velasquez made by Goya within a framework of Tiepolo's. This is also significant for the paintings: there is a Tiepolesque accent in the "Carlos III Hunting", which is an imitation from Velasquez. In the "Caprichos" (1793–96), Rembrandt is added to Tiepolo. The contrasts of light and shade not only grow stronger and more pictorial in the sense of an obvious synthesis, but they too take upon themselves the burden of expression. They do not subordinate themselves to the human figure, but subordinate the human figure to themselves. We must moreover remember that the idea of the "Caprichos" and the comment that Goya makes on them in his famous letter of 1794 are in evident relation with the "Scherzi di Fantasia" designed by Gian Battista Tiepolo and engraved by his son Gian Domenico, and with the "Vari Capricci" by the former. Even Tiepolo had given in these drawings a place to scenes from popular life. But it is not only the influence of Rembrandt that separates Goya from Tiepolo, it is above all the new content. Tiepolo imagined folk-scenes for the sake of variety and amusement; Goya imbues them with a revolutionary spirit. Goya's drawings grow harsher in the engravings, the irony is accentuated. Tiepolo had made Goya conscious of the pictorial effect. Mengs had suggested to him the need for a closed line, for a contour valid in itself, which could isolate the figure from the surroundings. Rembrandt had revealed to him the lyric value of contrast between light and shade, and the power of half-lights to express the impalpable, the mysterious. Velasquez last of all had directed him towards the realisation of plastic, solid and static volumes, and

towards the possibility of their harmony within the energetic whole.

The form of the "Caprichos" is extremely varied. Sometimes Goya analyses with lines the particulars of physiognomies, of expressions ferocious with anger or with a sarcastic sneer, of the bestial expressions of the senses: and then the effectiveness of the caricature is at the expense of art. Sometimes he constructs volumes solid in depth and strikes through with the vigour of his representation. At other times, giving an ampler sweep to his art, he provides contrasts of light and shade. In this way, in the half-lights, he succeeds in enclosing the mysterious, betraying a glimpse of his religious spirit. Print no. 17 (Fig. 4) represents a young woman straightening her stockings while a crouching hag looks on. It belongs to the satire of manners. The contrast between the abject misery which still maintains the illusion of beauty and that which manifests only its own animality is extraordinarily effective. Print no. 34 (Fig. 6) exhibits four pitiable wretches asleep in a prison, and goes beyond the power of satire. Goya comments: "Do not awaken them; sleep is often the only happiness of the unhappy." The caricatural intention is at an end, the spirit of humanity reappears, the compassion of eternal sorrow and, with it, art new in universal value. The Spain of Carlos IV, with its priests, its noblemen and all its other afflictions, retreats before the life of humanity, as caricature retreats before art.

Moreover, when he engraves, Goya is given to exaggerating his effects; often his designs for the prints are decidedly the best, more delicate in their touch, of greater pictorial value (Fig. 5).

18

We have said that 1784 represents the beginning of Goya's optimism, of his relations with the court and the aristocracy, of his social activity. The most complete expression of this activity was in the portraits. To achieve a greater nobility, he draws his inspiration from English painters, and above all, in his female portraits, from Gainsborough, for instance in that of the Marquesa de Pontejos, yet without forgetting Velasquez and his solid volumes in the male portraits, such as that of Carlos IV in hunting costume, of 1790.

His colouring loses the great sweeps of shadow and takes on new and delicate harmonies. He realises how useful to him, to confer an added nobility to his figures, are Mengs' purity of line and his greys. But he understands forthwith that his line must never lapse into conventionality, that it has to grow ever subtler, purify itself and grow more primitive. His psychological attitude towards this purification is complex. As a man of the world he throws himself into it, as an artist he treats it with irony. And the graceful result is ambiguous and yet fascinating, for instance in the "Portrait of the Duchess of Alba" of 1795 (Fig. 7). Goya loved this beautiful aristocrat: and yet his sense of her is remote, as of something a little outside of life, like a very precious puppet, and alien to the world of human beings. Compare her with the "Portrait of Doña Antonia Zarate" (Fig. 8), which was painted a little over ten years later, and you will feel how the Duchess of Alba is indeed a doll, and la Zarate a lovely woman, close to the artist's imagination, a living being in perfect fusion of body and spirit, an illimitable masterpiece. By this time the line is barely suggested, and the relations of light and shadow which have absorbed the line reveal the charm as well. This is the intimate

portrait, the portrait of the heart, which takes the place of the portrait on parade. It is a soul rather than a person.

The introduction of significant line into Goya's portraits proceeds step by step with the introduction of grey. Mengs' grey was neutral, Goya's is a synthesis of all the shades of colours. The pinks, the greens, the violets assume an incredible delicacy, as of flowers that have just opened in the spring air, precisely because they rise over a grey which, like a fertile humus, potentially contains them.

The series of portraits of personages is vast, and frequently the artistic invention, a relation of colours, a formal characterisation, the intense vitality stamped on the canvas, give them a fame which they entirely merit. We may say, however, that the "intimate" portraits are much more artistic than the "official" ones, in which a matchless skill often takes the place of free creativity. In some of them there is not even that sense of remoteness we noted in the "Duchess of Alba", there is mere indifference. And the richer the decoration, the more manifest the indifference.

"The Family of Carlos IV" (Fig. 3; Prado Museum) presents to a maximum degree Goya's skill in embellishing his masters. And you need only look at the composition to perceive how far away Goya's soul is from it all. But there is also something else. In spite of the rigid etiquette, Goya has seen in the faces of the royal family the bestiality behind the protruding mask, so that it is hard to say which prevails most in the artist, his sense of respect, of indifference or of contempt. The show picture verges on caricature to an upsetting degree. Carlos IV and Queen Maria Luisa were satisfied with the many portraits that Goya painted for them. So they cannot

have felt the artist's disdain. In order to understand this strange phenomenon, it is not enough to remember their defective intelligence. There is something more. Their lack of insight depends on the amorality which dominated their life, and on their very vices themselves. They were in no way conscious of them, and they were greatly pleased to see themselves portrayed *as* they were, because they did not know *what* they actually were. And so they did not observe that the man of the people, Goya, at the very moment in which he seemed to be embracing them, had a lively desire to crush them. But their callous amorality transferred itself, to some degree, to their painter, who was, in a way, impeded in his creative work by an insuperable contradiction between the unusual task and his way of feeling.

Meanwhile even in Spain the fashion had quite turned to neo-classicism. And Goya gave way to it, committing several grave blunders of taste, such as the portrait of the Marquesa de Santa Cruz, which dates from 1805, and in which the body, shown as a muse, is a complete spiritual vacuum. Goya's neo-classicism provides a new way of linking the intense sensuous vitality of a few women, such as the Condesa de Haro and Doña Isabel Cobos de Orcel, with ideal beauty. And a few high officers, such as the "Conde de Fernan-Nuñez" (1803: Fig. 9) (collection of the Duque de Fernan-Nuñez, Madrid), are endowed with a new dignity and *grandezza*, in the costume so much severer than that of the eighteenth century, in attitudes worthy of marshals of the empire. In fact, Imperial neo-classicism is very different from that initiated by Mengs. The same principles are applied to entirely novel themes. And the form perforce is different. In his neo-classical

portraits, that is, Goya finds himself in the same situation as Géricault, struggling with a form no longer adapted to the new romantic content, which is just taking shape.

In 1803, Carlos IV had accepted from Goya the gift of the "Caprichos" (copper-plates and printed copies) and in recompense had given a pension to his son. It was a business transaction, in which Goya won, rather than the pension to his son, shelter from the accusations of the Inquisition. And the King made *bonne mine à mauvais jeu:* by accepting the "Caprichos," he officially affirmed that the insinuations concerning the attacks against him they were said to contain were false. Thus Goya was able to go on living at court and, through the court, to go on painting his portraits. And he extroverted his interests, creating works of art undeniably artistic but lacking all that was innermost in his genius.

In 1808, however, a new catastrophe occurred. This time it was not restricted personally to Goya, but was a catastrophe for all of Spain: the French invasion, the abdication of Carlos IV, the reign of Joseph Bonaparte. Goya's intellectual friends, Moratin, Llorente, Melendez Valdes were favourable to the French. And precisely as Goya had accepted as patrons Carlos IV and the court, so now he accepted from Joseph Bonaparte the "Spanish order" and the task of selecting fifty paintings to be sent to the Napoleon Museum. But his soul, which despised Carlos IV, revolted at the idea of the French invasion. To the feeling of offended justice, the sense of ignorance and vice triumphant, which he had expressed in the "Caprichos", was added, in 1808, revulsion at the horrors of war and military repression, anger over the martyrdom of his country. Goya the

man is no longer isolated in his debate with the world; he has become a patriot and therefore love and wrath are pervaded by a new feeling of human solidarity. In 1808 he goes to visit the ruins of Zaragossa "because of the great interest which I have in my country's greatness". When the French have gone, on February 24, 1814, Goya writes to the regency "his most burning desire to perpetuate by means of his brush the most remarkable and heroic actions or scenes of our glorious insurrection against the tyrant of Europe".

The works that express this state of mind are: "The Second of May at the Puerta del Sol" and the "Executions of the Third of May". It has been said that Goya was an eye-witness to the fight of May 2, 1808, at the Puerta del Sol. But perhaps that is a legend arising from the impression that the picture which describes that event evinces the confusion peculiar to struggles in actual life, rather than the clarity of a struggle as depicted in art. All the painter's skill as a draughtsman and a chiaroscurist cannot remove the impression that violence has not been dominated in a catharsis.

Violence is even greater in the "Executions of the Third of May" (Fig. 10), because it is surprisingly manifest. But this quality of being manifest is in line with the new order, which gives to the *fait de chronique* the universal value of art. It is Goya's masterpiece, and a masterpiece unexampled in all the history of art. The ordinary limits of his personality are here surpassed, not because of any renunciation of the specific character of this personality—for, quite to the contrary, this painting may serve as a synthesis of all Goya's work—but because the personality is potentialised by a force transcending it, identifying it with the eternal tragedy of human violence.

This transcending force is, and cannot help being, a mode of religious feeling.

The form is the new body adequate to the consciousness of such horrors. The composition is oblique, in order to accentuate, within the space occupied, the fact of the event. The form is revealed by the light or hidden by the shade, in such a way as to present itself squared, sketched, dynamic, as positive as it is violent. It is Hell, and only on a distant height, a church and a house represent the indifference of nature, to offset the human tragedy.

In the face of the profound religious feeling of this picture, the works painted by Goya for various churches puzzle us.

In 1798, in the fullness of his artistic maturity, Goya painted a vault in the church of San Antonio de la Florida in Madrid (Fig. 14), obtaining a huge success. But it is clear that this work is one of the most profane things Goya ever painted, so profane that the work of art may be suspected of insincerity and suffers thereby. This has been noticed by many critics, who have called the scene dedicated to Saint Anthony of Padua an "artistic *can-can*" (Muther), or an act of "cynicism" (Rothenstein). And the Conde de la Vinaza speaks of "camelia-like skin, eyes of flame and the beauty of a courtesan". In order to understand such appreciations, we need only remember that many churches of the eighteenth century were reduced to being *boudoirs de femmes galantes,* and yet there was no outcry against them because of the scandal, as there has been against the paintings of St. Anthony by Goya: which goes to prove that Goya, suffering to the utmost the provocation dealt to religious feelings, revealed his own conviction that the scandal was an actuality.

24

There is one work, however, of Goya's last period, "The Communion of St. Joseph of Calasanz" (1819), in which various critics have professed to see not only a masterpiece of religious art, but also the proof of Goya's religious spirit as he was drawing nearer to the tomb. In it, Goya reveals some of his greatest gifts as a painter, yet accomplishes a task of ecclesiastical rhetoric which he was certainly capable of achieving without incommoding the Absolute.

On the other hand, the "Prayer on the Mount of Olives" (1819: Fig. 13, Escuelas de Piedad de S. Antonio, Madrid) is a genuine work of art. Goya has represented Christ and the angel as two spots of light within a great mass of shadow. And the Christ is reduced to a poor wretch, a beggar, who opens his arms and asks for mercy. The human expression of the scene is perfect. But I doubt whether there is aught of divine expression in it.

Before and after the "Executions of the Third of May", between 1810 and 1820, Goya composed the series of engravings: "The Disasters of War". They are far superior to the "Caprichos" from the pictorial point of view—more spontaneous, more gradual, more coherent, more unified, without insisting too much on details—as well as from the human one, by means of a profounder sense of the tragedy represented. The illustrative interest is absent, pure art dominates more often.

The "Tristes Presentimientos", which open the series (no. 1), shows a figure praying with wide-open arms half-covered with rags, in a dark grotto. Dazed by his own cruelty, a soldier looks at a hanged man (no. 36: Fig. 15). A woman does acts of mercy in contact with misery and death (no. 49). A liv-

ing man surrounded by the dead realises his solitude and isolation (no. 60: Fig. 16). And all this ferocity, all this slaughter, serves what end? Goya answers by representing a dead man, already turned to a skeleton, bearing a message from beyond the grave: "Nothing". The entire series is a long lamentation, now desolate, now desperate, now throbbing with anger, which comments on, particularises and accentuates the "Executions of the Third of May".

The prints of prisoners belong to the same sphere of moral motifs. They are few but of very great beauty. I give a reproduction of "The Prisoner" (no. 262: Fig. 11), in which the space affords free play for pity for the poor stricken woman. Other prints declare in the title the explicit intention of protesting against the torments inflicted on prisoners. And the effects of light and shadow give a poetic value to the civil law's harsh judgment. A drawing in the Museum of Bayonne, "The Convict" (Fig. 12), has equal force and value: it is another "J'Accuse", of great gloom and power.

On the return of Ferdinand VII in 1814, Goya was not, like so many of his friends, punished, but merely set aside. He continues to produce copiously: portraits and popular scenes. He retires to a house in the country and decorates it. He withdraws always, more and more, from the world. The period between 1820 and 1822, during which Ferdinand VII is obliged to grant a constitution, is followed in 1823, as a result of the new French invasion, by a white terror, and Goya, under the accusation of holding liberal ideas, seeks refuge in the house of a friend. He cannot bear it all any longer. In 1824 he obtains from the King permission to go

to France, and with the exception of a brief return to Madrid in 1826, he stays there, at Bordeaux, until his death in 1828.

The patriotic passion, the moral revolt against the horrors of war and revolution, have left an indelible imprint on Goya's mind. He isolates himself and turns away from themes of horror. But his imagination cannot produce anything outside of visions of tragedy. This tragic state of mind, even without a tragedy for theme, is the central motif of all his final production. His colors keep on growing gloomier, the forms increase in volume as they grow less precise in contour and plastic statics. Goya himself explains his vision in this way, in contradistinction to the formalism of one of David's disciples, whom he met in Bordeaux: "Always lines and never bodies! But where do they find lines in nature? As for me, I see only bodies that are lighted and bodies that are not, planes that come forwards and planes that recede. My eye never perceives lineaments or details. . . . So my brush ought not to see any better than I do. . . ."

In spite of his eighty-two years, his vital energy remains formidable until his last days. In 1825 he is busy with lithographs, and writes: "Sight, heart, pen, ink-stand, I lack everything, and will-power is the only thing that I own in abundance." With this he created masterpieces. Compare the portraits of don Juan-Antonio Llorente (Fig. 18), a friend of Goya's, an historian and Jesuit-hater, painted in 1809, and of don José-Pio de Molina (Fig. 17), painted in 1828. The portrait of Llorente strikes us as vivid, synthetic, severe, a mass of dark tones against the half-light of the background: magnificent as painting, undoubtedly. Yet it seems almost elementary in comparison with the pictorial complexity and richness of

the "Molina", which was painted shortly before his death. But that is not all: the "Llorente" has an undoubted pictorial interest, but also a psychological, extra-pictorial quality. It is a poem and at the same time a subtle psychological analysis. In the "Molina" it is precisely the pictorial vibration that gives the imagination its character. This is pure creation, without any need for analysis, for an external reality. Between 1814 and 1818 he painted two pictures, "genre" in subject, the one representing "Youth", the other "Old Age", now in the Museum of Lille. "Youth" (Fig. 19) is a masterpiece of pictorial sensibility, which reveals itself indifferently in the umbrella, the dog, in the young woman's breast, in the figures sketched in the middle distance, and in the houses in the background. The principal figure is meant to be serene, but the serenity is not natural. In the middle distance there is a drama of confusion, of violent reactions, of an uncompleted reality. Goya's "pathos" manifests itself just as intensely in serenity as in violence.

In his house near Madrid he painted visions of violence without any thematic relationship, and without subjects, yet in a unified mode, both as regards the style and the monochromatic treatment: black, white, burnt sienna and *terra di Seviglia*.

Two visions are here produced. "The Vision of St. Isidore" (Fig. 20) shows forms even freer and far more three-dimensional than those of the "Executions of the Third of May". It is a macabre scene of poor wretches, with a maximum of misery, for which Papst's film, "The Beggar's Opera", has prepared us. The deformation of the faces is extreme, but no one could take them for masks. For amidst these deforma-

28

tions, which inspire us with dismay and pity, life flows with monumental vigor. In the "Fantastic Vision" (Fig. 21), the specters fly through the air like winged evil-doers. It has been said that these works signify the "end of painting" in the sense that there is no longer either form or beauty. I think it is hard not to perceive that in these figures painting regained its path. In fact, the total departure from the academic tradition no longer admitted any possibility of return or of compromise; and no more did external nature offer any excuses for illustration. It was the conquest of the autonomy of painting, both with respect to plastic form and physical nature.

In the same spirit as the decorations of his house, Goya produced a series of etchings to which he gave the title "The Desperate Ones". One of them is reproduced here (Fig. 23): the dancing giant who frightens a couple. The irritation of the light transcends the image and inspires a panic ecstasy.

In 1815, Goya published the series of etchings "La Tauromaquia". The subject was particularly dear to Goya's heart, for he himself had been a *torero:* it combines the idea of cruelty with the idea of play. And yet the interest in the subject, the intention of illustrating with historic accuracy the most outstanding events that had occurred in bull-fighting, often deprives the artist of the requisite liberty. In this series too, the drawings are often more pictorial than the etchings; in the latter, space is generally sacrificed to the precise delineation of the protagonists and their actions.

In 1819, at the age of seventy-three, Goya learnt the technique of lithography, which obtains its pictorial effect in an easier way than does engraving on copper. And at Bordeaux

he made four big lithographs of bull-fights, free and pictorial, spacious and unified in style to a much greater degree than the engraved bull-fights. Note for instance the "Goring of a Picador" (Fig. 22). Goya realised that perfectly. He wrote to Ferrer on December 6, 1825, that he intended to make some new "Caprichos" without copying the old ones. "At this moment I have better ideas."

Nor is that a cause for wonder. His style had been perfectly moulded and offered infinite possibilities for the future. It was an open door through which all the best painting of the nineteenth century was to pass.

Chapter Two

CONSTABLE

I T IS DIFFICULT to imagine two characters, two cultures, two social positions, two destinies as artists more diverse than those of Goya and Constable. And yet, in spite of their disparate origins, in spite of the difference of their careers, we cannot help recognising that we have to place Constable by the side of Goya if we wish to understand in all its aspects the development of taste in the nineteenth century. In order to understand the forms of Goya, it is necessary to call upon revolutions and wars, peoples and kings, Christ and the Inquisition, all that is heroic or mean in the human spirit. In order to understand the forms in Constable's art, we need only refer to that feeling for nature which goes with the concept of the "picturesque". The life of Goya, tormented by the hurricanes of all Europe, is in utter contrast with that of Constable, attached so closely to his parental mill that it might be compared to that of the snail which bears its own house along with it. And yet it would be difficult to say which of the two, Goya or Constable, has had greater effect on the artistic taste of the nineteenth century.

The fact is that the pictorial "genres" had had their period of oppression during the centuries and their revolution as well, even if there were few to be aware of it. One of the æsthetic prejudices fraught with the greatest consequences for painting

has been that reproduction of the human figure and of action between human figures was considered the sole or supreme end of art. Inasmuch as painting is a human activity, they said, it must represent man: as though human activity were not also exerted over surrounding nature. That is a sophism, and yet it was seriously taken up by the human mind as early as Greek times, was finally destroyed in the nineteenth century, and has flourished once more in our day with delightful naïveté. Constable is the prime agent of that spiritual movement by which the aforesaid prejudice was abolished in the best painting of the nineteenth century.

It is well known how, during the eighteenth century, there was a new flurry of æsthetics, curiosity and interest in art in England. Italian painting was much studied, and Flemish and Dutch painting was better understood. Thomson and other poets loved to describe landscapes, referring to the way painters devised and represented them. Claude Lorrain for the idyllic landscape, Salvator Rosa for the dramatic, had become the fashion. And recollections of these painters accompanied English travellers amongst the ruins of Rome or the Alpine summits. In 1756 Burke had distinguished between the *beautiful*—agreeable, attractive, soft and pleasing—and the *sublime,* attached to sentiments of fear, to feelings about the infinite, about hardship and sorrow. To these two categories of the beautiful, Price added in 1794 the *picturesque,* the characteristics of which consist of roughness, irregularity, the continuous variation of form, colour, lights, sounds. This third category, already formulated by Gilpin, was derived from immediate experience, for not all that is appropriate to painting comes under the categories of the beautiful and the

sublime. That is to say, the English of the second half of the eighteenth century recognised that some landscape paintings revealed aspects of Nature that were neither beautiful nor sublime, and yet were able to become art. Such modifications of the beautiful induced Alison (1790) to deny all objectivity to the categories of the beautiful, and to affirm a sort of æsthetic relativity. But a disciple of his, Payne-Knight (1805), imagined that there were two exceptions to this relativity, colour and sound, which had a beauty of their own. And this beauty of colour, viewed apart from the objects presented, is picturesque beauty, derived from the Italian pictorial tradition, and particularly from Titian. This world of ideas existing in England between the end of the eighteenth century and the beginning of the nineteenth is the cause and at the same time the evidence of the historic phenomenon by which England, as the Continent did not, escaped neo-classicism. If the ideal of painting consisted of the picturesque and Titian, neither David nor Canova was able to lead pictorial tradition astray.

We must understand clearly, however, that before the picturesque there had been the pictorial. That is to say, the picturesque is a projection onto Nature of a mode of seeing inaugurated by the pictorial. To say that Titian is picturesque is absurd. But everyone understands you when you say that Titian's style is pictorial. That is, in Venice, in the sixteenth century, there had been created a form by means of colour. Instead of drawing first and colouring afterwards, as Raphael was wont to do, in Venice they sketched in masses of colour from which there gradually arose a form. But that form was not linear, it was a form by means of colour, it was a pictorial form.

33

The painters of the baroque period specialised in this. They no longer looked at the entire world from the pictorial point of view, but they chose such natural themes as corresponded best to that point of view. This selection proved profitable to Salvator Rosa for his landscapes. When the English of the eighteenth century awoke to this choice, they took pleasure in it, thought it over, and called it the picturesque. But picturesque art could at best be but an imperfect kind of art. Because of this subjection to certain aspects of Nature, there was a confusion between the style of the painter and the whim of the dilettante; the caprice of the dilettante was introduced into the independent harmony of artistic creation. In order to return to a complete and perfect art, it was necessary to reabsorb the natural motif into pictorial style, to turn from picturesque nature to pictorial art.

Style, linear or plastic, classical or neo-classical, however one chooses to call it, had achieved its greatest success in the human figure, conceived in complete abstraction from the atmosphere which that figure is yet obliged to breathe, from the natural objects that surround it. Pictorial style had arisen with the vision of the human figure immersed in the atmosphere and taking part in the environment in which it lived. The picturesque had made itself manifest through an æsthetic and moralising interest in landscape, in Nature. And the pantheistic conception of the world, which Shaftesbury had diffused throughout the eighteenth century, had rendered natural objects divine. So it was natural that the new pictorial art should concern itself with landscape, should lay claim to the category of landscape as being the aptest motive for the expression of the new mode of feeling. Therefore it was in the

logic of things that landscape painters should become the leaders of the new taste in painting.

The times were ripe. The greatest English landscape painters, Crome, Turner, Girtin, Constable, were all born between 1768 and 1776. Among them Constable is the purest artist, the most genuine artist, the absolute artist. He was pre-destined to carry the taste for the picturesque back to pictorial art, to re-discover in certain studies of landscape the pictorial absolute. When we rise from the pictorial effect to the spiritual conditions that have generated it, we perceive that, compared with a Wilson or a Gainsborough, Constable represents above all a new moral severity. The curiosity of the eighteenth century, the pleasing, the decorative, have disappeared. It appears that the study of landscape has for him the value of a national objective. The memory of the Roman campagna, of the sea-shores of Holland, or of German forests has disappeared. His is the *English landscape*. This moral purpose, if on one side it frees him from preceding mannerisms, on the other renders him more faithful to the natural phenomena, no matter how modest they may be. The mode of expression is endowed by the moral purpose with a certain anguish, a need for vibration and life, a tendency to clashes rather than to *nuances*. From which there flows a greater tendency to error, but also a greater profundity.

In the struggle between the neo-classics and the romantics Constable gave a new impulse to the French romanticists. However, he passed beyond romanticism, attaining to naturalism and beyond naturalism.

This naturalism of his is ingenuous, positive, close to the facts, as little sentimental as it is possible to be in painting.

35

According to the distinction between naïve and sentimental poetry, Constable must be classified among the naïve, *i.e.* among the classics. And yet he achieved his art solely with landscapes, which implies a conception of art foreign to the Greek or Latin classics, or to the Italians of the Renaissance. Setting forth from the picturesque and arriving at the pictorial, he based his conception of beauty on effects of light and shade realised by means of colour. He fought the prejudices of those who represented the "reversion to classicism", triumphant during this period in the name of a "return to Nature", which followed in the train of romanticism. With regard to neo-classicism Constable is therefore a romantic. The fact is that in the nineteenth century there were many neo-classical painters and not one that was classic, unless one be willing to admit that the real classics of the nineteenth century were the romantic painters.

Born in a Suffolk mill in 1776, it was the land that made a painter of him. With care and devotion, he studied the old masters and the scholastic models at the Royal Academy. Like a belated follower of Reynolds, he painted many portraits, but with a definite degree of success. This activity as a portraitist had a practical importance. It was the only way he was able to make a living. But he wanted to become a "natural painter", and studied, on his own account, trees, countryside, sky, sea. After 1802 until his death, which took place in 1837, he regularly exhibited at the Royal Academy. But his landscapes were little appreciated, partly because of the prejudice against *genres*. When in 1829 he was nominated to the Academy, the President, Lawrence, made it clear to him that it was by

way of a favour. The sole authentic success of his life occurred in the Paris salon of 1824. His life was full of private difficulties: first his father opposed his becoming a painter; then he fell in love with a young girl belonging to a class slightly above his own and succeeded in marrying her only after many years and against the wishes of her parents; his wife's health brought him many worries and in the end she died before him. His children's health also caused him much care. Though he never suffered from poverty, he became well-to-do only when, in 1828, his wife inherited a considerable fortune. From then on he painted no more portraits, but only landscapes. Entirely concentrated as he was on his painting, he was not a conversationalist, and thus had few friends; his life as a *petit-bourgeois,* with its limited horizon, did not, in spite of his natural urbanity, permit him to have contacts with the brilliant London world of the time. In the face of the cold reception that artists and public accorded his work, he knew his own justification and his own rightness, but remained serene and not unduly embittered. All the wealth of his affection he reserved for the meadows, the trees, the sky. And even for them his love was discreet: it sufficed him to bring home a memento. His devotion to nature was unlimited. In contact with nature he felt the infinite, which he was unable to discover in the worldly grandeur of society and its conventions. From this springs the rusticity his contemporaries saw in him, which he expressed in his work and which was the subtlety of an art innocent of artifice.

His literary education was sufficient to enable him to set forth in 1830 his theory about his own art, as a Preface to the *English Landscape,* a collection of engravings of his paint-

ings; and from 1833 to 1836 in six lectures, a few passages of which have been preserved.

Inglorious is the leit-motif of his quotations from Virgil and Thomson. He has no ambition to know nature; his greatest ambition is to penetrate into the shade beside a brook and give himself over to his dreams. His was the humility of the artist before Nature, balanced by the proud consciousness that his work is not mercenary, that it is accomplished for pleasure alone. He believes that landscape is the most attractive category of art. He wishes to increase the interest in, and promote the study of, the "rural scenery of England", even in the simplest localities, which abound in grandeur and pastoral beauty. He addresses painters especially, with the hope that they will understand the principle of the "chiaroscuro of Nature", the influence, that is, of light and shade on scenery, not only in its general effect and its timely stress on different parts of the painting, but also in its effectiveness as a means of representing the day, the hour, the sunlight and the shadow. He endeavoured to set down the most unexpected and fleeting semblances of chiaroscuro in nature, to reveal its effects in the most obvious fashion, to lend to a brief moment, snatched from the flight of time, a durable and static existence, to render permanent many of those splendid but evanescent phenomena restlessly taking shape in the transformations of exterior nature. Thus his themes are drawn from real places, with the aim of characterising the aspect of England, and the effects of light and shade are transcribed exactly as they occurred at the moment in which they were apprehended.

"In Art as in Literature, however, there are two modes by which men endeavour to attain the same end and seek dis-

tinction. In the one, the Artist, intent only on the study of departed excellence, or on what others have accomplished, becomes an imitator of their works, or he selects and combines their various beauties; in the other he seeks perfection at its *primitive source, nature.* The one forms a style upon the study of pictures, or of Art alone; and produces either 'imitative', 'scholastic', or that which has been termed 'Eclectic Art'. The other, by study equally legitimately founded in art, but further pursued in a far more expansive field, soon finds for himself innumerable sources of study, hitherto unexplored, fertile in beauty, and by attempting to display them for the first time, forms a style which is original; thus adding to Art qualities of Nature unknown to it before. The results of the one mode, as they merely repeat what has been done by others, and by having the appearance of that with which the eye is already familiar, can be easily comprehended, soon estimated, and are at once received. Thus the rise of an artist in a sphere of his own must almost certainly be delayed; it is to Time generally that the justice of his claims to a lasting reputation will be left; so few appreciate any deviation from a beaten track, can trace the indications of Talent in immaturity, or are qualified to judge of productions bearing an original cast of mind, of genuine study, and of consequent novelty of style in their mode of execution." (Preface to the *English Landscape.*)

Constable's letters and the passages from his lectures that have been preserved may serve as a commentary to this marvellous Preface.

The moral condition of art is humility. Constable writes: "The landscape painter must walk in the fields with an humble mind. No arrogant man was ever permitted to see

nature in all her beauty." *"I never saw an ugly thing in my life:* for let the form of an object be what it may—light, shade and perspective will always make it beautiful." So he loves nature, all nature; he does not choose from the things of nature according to the principles of abstract beauty, but finds in light and shade the beauty of nature herself. According to Lawrence, the painter, not being able to compete with nature, must select and combine. Constable admits that we can never hope to compete with nature, but "it may be added that selection and combination are learned from nature herself, who constantly presents us with compositions of her own, far more beautiful than the happiest arranged by human skill. I have endeavoured to draw a line between genuine art and mannerism, but even the greatest painters have never been wholly untainted by manner. Painting is a science, and should be pursued as an inquiry into the laws of nature. Why, then, may not landscape painting be considered as a branch of natural philosophy, of which pictures are but the experiments?" (Leslie 359.) Scientific precision was for Constable a mere whim. He wished to make his art legitimate, and he is distrustful of the "fine imagination which is generally, and almost always in young men, the scapegoat of folly and idleness". But he indicates his own task as "a pure apprehension of natural fact". Pure perception is not the work of a scientist. It is rather a summons which he (Constable) utters to the art of his age, similar to that which Wordsworth made to himself: the need to return from the abysses of idealism to reality. And, according to the English custom, he translates his artistic passions into moral concepts: "Lord Bacon says: 'Cunning is crooked wisdom. Nothing is more hurtful than when cunning men

pass for wise.' This is mannerism in painting." To be sure, when he wrote this he was not thinking of Turner: yet was it not a happy defence against the triumph of Turner as well as against Ruskin's criticism, which did him so much harm?

In spite of Fuseli's ironies and Ruskin's negations, it is indubitable that Constable discovered religious values in nature. In 1819 he wrote: "Everything seems full of blossom of some kind, and at every step I take, and on whatever object I turn my eyes, that sublime expression of the Scriptures, 'I am the resurrection and the life', seems as if uttered near me." And in 1835: "Even darkness is majestic, and I need not reproach myself with ever prostituting the moral sentiment of Art."

So it was from moral earnestness, and not from naturalistic pedantry, that Constable wanted to specify the day and the hour of his sketch, thus passing not only beyond romanticism but idealism as well, and arriving at an impressionist attitude. He used to say: "The world is wide; no two days are alike, nor even two hours; neither were there ever two leaves of a tree alike since the creation of the world; and the genuine productions of art, like those of nature, are all distinct from one another." From the individuality of natural creations he would go on to the individuality of artistic creations: "Every truly original picture is a separate study, and governed by laws of its own; so that what is right in one would be often entirely wrong if transferred to another."

A few ideal consequences derive from this individualistic conception of nature and of the work of art. First of all, the renunciation of panoramic effects. To individualise, it is necessary to limit the theme to a piece of nature. And in this

limitation was implied the idea that in every part of nature is contained the universal beauty, just as in every painting is contained the whole of art. Another implication: each place has a multiple physiognomy, and yet a variation of the natural light suffices to make of no matter what landscape theme a new *motif* for art. On the other hand, in order to feel at one with nature, in order to take part in the life of nature in all its complexity, he avoids the exceptional effects so dear to the romantics. And thus he protests against prodigious and "astounding" phenomena. He paints neither sunrises nor sunsets, does not care for autumn or winter. He prefers the spring, and he paints that continuation of spring which is the English summer.

With such a basis of simplicity and of moral austerity in his mode of feeling, he wishes to render durable and static the most fleeting and evanescent appearances. He writes: "What I aim at in my pictures is light, dews, breezes, bloom, and freshness; not one of which has yet been perfected on the canvas of any painter in the world." This is Constable's romanticism: the visual representation of the impalpable. But if we look at some of his canvases, who can say that he did not succeed? This is a typical case of the miracle worked by art.

His fidelity to the principle of naturalism is absolute. If he must renounce grandeur, he renounces it. "My pictures will never be popular, for they have no handling. But I do not see *handling* in nature. Whatever may be thought of my art, it is my own; and I would rather possess a freehold, though but a cottage, than live in a palace belonging to another." And yet it is probable that he realised how his restricting him-

self to a "freehold" was indeed grandeur. To be sure, this was not perceived either by Ruskin or by the other English critics, and for this very reason English art after Constable fell so low. But it was perceived by an anonymous French critic of the *Constitutionnel* (probably Thiers), who on seeing Constable's works in 1824 wrote: "The real cause of our inferiority in landscape seems then to come from our not imitating nature faithfully enough and closely enough, and from our not being willing to make simple studies. . . . We are not sufficiently *bonnes gens,* so to speak, to equal these masterpieces. In landscape above all, this disposition becomes apparent. We have never been ready to content ourselves with our own soil; we have always aspired to Switzerland or to Italy." This critic was worthy of Constable, and inasmuch as these ideas of theirs became common property, French painting soon found itself in a position to create its own marvels.

Constable's ideas on the history of landscape-painting are highly acute and objective. He recognises artistic value even in styles very remote from his own, and is able to discern the origins of his own taste. "It was at Venice, the native home of colour, and where the true art of imitation was first understood, that landscape assumed a rank and decision of character that spread future excellence through all the schools of Europe." On the other hand, he has a stick to beat the mannerists. ". . . *if the mannerists had never existed, painting would always have been easily understood."*

It is well known that the mannerists show their ability especially in mechanical precision. And Constable said about the work of one of his colleagues that "it had great merit as the work of a watch-maker".

If, after giving our attention to Constable's words, we pass on to his paintings we find two men in Constable: the realist, exact, diligent, tenacious, of the earth earthy, and the exalted and monumental romantic. Whenever one of these two natures predominates, the artistic value grows attenuated or disappears. Whenever, on the contrary, they coincide, and the realist is kindled in the romantic, and the romantic is actuated by the realist, then masterpieces come into existence. There is a brief period in the life of Constable, from about 1820 to 1825, in which this coincidence takes place with a particular spontaneity: it is the happiest period of his art. Before 1820 the realist was wont to prevail, after 1825 the romantic takes the bit in his teeth. Naturally, even in the minor periods, every now and then his genius gives us flashes of light.

There is, for instance, a water-colour drawing of 1803: "Warehouses and Shipping on the Orwell, Suffolk", in the Victoria and Albert Museum, in which the diligence of the draughtsman gives way to the freedom of the lyric poet, as the expression of a quiet, set-apart life. And the form is already impressionist, in the sense of adhering closely to the sensibility of the artist, without any residue of conventional mannerism. It is quite as free, with regard to form, as a drawing by Manet of 1870.

In 1809 a masterpiece saw the light: "Malvern Hall" (Fig. 24). It is a synthesis of the calm, diligent, objective style of the first period, and of the tormented, pictorial, lyric one of his maturity. Azure tones in the foreground and in the trees, pale blue in the water, pink and pale blue in the houses, grey in the sky. The effect of the dark spots in the foreground against the light background prepares for the lyric effect of

the pink house. It is an aspiration towards delicacy. The whole thing is incomparably fresh. Serene nature breathes in the reflections, all the richness of life, all the beauty of summer. And it is interesting to note that the place is a park, that the house is a country-seat, that Constable is a poet without yet having discovered his own particular world of humble, stark and uncultivated life.

The search for his own world was long and wearisome. In 1811 he painted "Dedham Vale" (Granville Proby collection), in which the panoramic interest prevails. A few Rubens-like tonalities in the foreground and a few refinements of grey-greens and pink-blues are not enough to cancel its character as topographical decoration.

The danger to which he was becoming increasingly exposed, as his technique matured, is evident in "Flatford Mill", of 1817 (National Gallery; Fig. 25). The skill is extreme: the natural scene appears evident, in the depth of its perspective, in its proportions, in the precision of its particulars. But the style is not unified. It would seem that the forms are seen by themselves, the colours and lights by themselves, and that the result is the chaos of nature, not pictorial style. The figures are drawn as though light and shade did not exist. The picture is smooth, to give precision to the forms, without regard for the contrasts of light and shade, which demand a rough surface. It is an impeccable page by a follower of Hobbema's, but it lacks personality, poetic afflatus. There is solidity, skill, conscientiousness: it lacks impulse, freedom, creativity.

A few views of sea-shores helped to form Constable's style. No more trees, less picturesque variety: the painter is attracted

45

by a synthesis, by an effect of the whole. The reproduction is easier. The painter is freer to think of his own way of painting. About 1819 he painted "Weymouth Bay" (Fig. 26). The beach is yellowish-brown, in the middle distance there is a green meadow, farther back there is a purplish hillside. Against a blue sky there gather strongly contrasted grey-black and yellowish-white clouds. There is no redundant detail in this reaction to the menace, which gives a unified value to his style.

In 1821 Constable wrote: "It will be difficult to name a class of landscape in which the sky is not the keynote, the standard of scale, and the chief organ of sentiment." He felt in the approach of the storm the expression of the tempest in his own soul.

"Harwich, Sea and Lighthouse" dates perhaps from 1820 (Fig. 27). A short, rocky beach, the lighthouse with its supports, the sea, the immense sky. Faced with the vastness of the sea and sky, Constable feels his own insignificance, his fragility, like that of the lighthouse. It is the individual facing the infinite, man facing the universe. Nothing remains of the picturesque tradition, nothing is left to caprice. The humility of man faced with nature has caused all the brilliant tradition of the eighteenth century to disappear. No natural object is any longer merely natural, it has become an accent of style.

On the afternoon of December 21, 1822, between half past one and four o'clock, Constable watched some white clouds passing over the sky, and reproduced them in two little pictures: "Looking Southward" (Collection of Sir Farquhar Buzzard). The wind was fresh, but not too much so, and it

46

brought a pleasurable feeling. Constable was taken with those clouds; he paid no attention to the earth, he painted only the clouds and the sky. The clouds were not threatening, they were white; at three o'clock they were scarcely denser than at half past one, and the sky was a clear azure. In this way the theme was cancelled, there remained only a serene and affectionate contemplation, of that white against the azure, of that remote life, of that fleeting moment. And the art flowed spontaneously from his brush.

A similar liberty taken by a painter is hardly to be found in all the preceding history of art. Constable made use of it for a series of masterpieces which lifted him to the level of an absolute artist. He painted great pictures, no longer finished according to the traditional laws of the art, nor according to the need for an objective reproduction of nature, but finished in accordance with his own style. When he had expressed all that his imagination demanded, when he had created the second reality parallel to the natural one, but independent of it in so far as it was a pictorial reality, he respected the accomplished work. He knew how to stop in time, without yielding to the extra-æsthetic demands of the artists and the public of his period. And yet he was not sufficiently rebellious not to pay his tribute to public opinion. He kept to himself, however, the pictures painted after his own style, and sent to the exhibitions of the Academy replicas, of equal dimensions, finished according to public taste. But Constable was thoroughly aware that his own great sketches were the real pictures, the real works of art: and affirmed this in letters which are still unpublished. The finished pictures for the public, on the other hand, were works of only a practical nature, pro-

47

duced to comply with a tradition, to ingratiate the critics. What wonder then, if the "sketches" are masterpieces of art, and the "finished pictures" are inferior paintings? And how sad it is that Constable could not explicitly manifest the consciousness of his genius, and thus was not able to place his imprint, by means of his real creative capacity, on European painting! Constable had a strong influence, but through the works painted for the public. And so, fifty years later in France, the battle for liberty from the "finished" had once more to be fought, the battle in which Constable could have engaged, had he dared. The first dual picture was painted in 1821, and is the famous "Hay Wain". The finished picture (Fig. 29)—in the National Gallery—was exhibited at the Louvre in 1824 and constituted Constable's greatest success. In spite of its homage to tradition, it was in fact considered as a pictorial revolution. The sketch (Fig. 28) belongs to the Victoria and Albert Museum.

In the sketch, the artist takes possession of space: space therefore is represented pictorially and not according to scientific perspective as in the finished picture. In the sketch, every image lives, inasmuch as it takes part in the light. Light is his unity of style. Light reveals or conceals, gives life or takes it away, pauses to caress or flees, in so far as the painter's heart is more or less fond, in so far as he is more or less moved. The finished picture, on the other hand, represents the things in themselves and, in addition, the effect of the light on them, with the result of attracting the observer's attention in two directions which never coincide. The one is an empiric or prosaic vision of a region, the other is a poetic interpretation of the light. It is all finished, in a fixed way that partakes of

48

death, and all the particulars in their objectivity reflect a general indifference.

Look at the roof. In the sketch, it is a mass in half-light, which partakes of the universe, which gives a sense of the infinite. In the picture, it is a series of tiles all by themselves, limited, finished, like the work of an artisan. And the same can be said of the water or of the human figures.

The colours, which in the sketch are the very material of which light is made, in the picture are the unnecessary veneer of a form existing of itself. The distant meadow is yellow: that yellow is a dead tint in the picture, but in the sketch it is a precious light. In the sketch, the silvery reflection of the clouds in the water mingles with the brown reflection of the shadowy earth. In the picture, the water is a gradation of grey-green, monotonous, without the quality of a liquid. In the sky of the picture, there are windless and stormless clouds, paper clouds, but in the sketch the sky announces a veritable storm, justifying the contrasts of light and shade on the earth, causing the ancient trees and the house and the water to live with its own emotion. There is no agitation, there is an emotion, within the unity of vision, which is resolved in the chromatic contrast.

Every stroke in the sketch expresses the sympathy of a heart for nature; in the picture, it is on the contrary the demonstration of a reality. Poetry and prose, love and indifference, infinite and finite, knowledge of the imagination and knowledge of the intellect, rarely are they opposed to one another with such clarity as in these two pictures. And yet even the finished work sustains a distant echo of the sensibility and the poetry that had helped in the creation of the

49

sketch. And this echo was sufficient to inspire French painters in 1824. This circumstance enables us not so much to appreciate the finished picture as to realise the miracle accomplished in the sketch.

Another duality is provided in the "sketch" and the "finished picture": "Salisbury Cathedral from the Bishop's Garden"; the one is in the collection of T. W. Bacon (Fig. 32), the other in the Victoria and Albert Museum (Fig. 33). They both date from 1823. The first is one of the loftiest pictorial flights known to history. It is a shading of browns and pale blues, from which irradiates a completely fantastic light. The trees, luminous as they are, have dark touches for the purpose of leaving the steeple in the highest light, and around that light the branches seem to dance with matchless airiness and grace. The world had to await Cézanne for a similar expression of altitude in painting. In the finished picture there is much insistence on the gleaming leaves, a purely practical indication. The leafy archway turns into a material bending of the branches. And the cathedral has lost its silvery lightness. The painting of it is reduced to an inventory of the triforium, the spires, the roof. The work of art has disappeared. There remains a topographical affirmation.

In another sketch-like picture of Salisbury Cathedral (National Gallery; Fig. 34) the contrast of lights and shades is very strong; it expresses torment, and is not lacking in raw touches, but it possesses a magnificent vigour, suggestive of the energy of nature, as though its will were iron. It is, to be sure, a stormy work; perhaps there is a new spurt of the picturesque; but the solidity of the composition, the sureness of the effect, are the catharsis of that agitation, and absorb the

picturesque in the pictorial. Besides, the richness of colour is remarkable: the trees are black in the shadow and red in the light, the clouds are white-and-red spots upon the background of blue, the shore is reddish brown, the water blue-black.

Another famous couple of pictures are those of "The Jumping Horse". The sketch is preserved in the Victoria and Albert Museum (Fig. 30); the finished picture in the Royal Academy (Fig. 31). They date from 1825. In the vicinity of a lock the painter had received an impression of the disorder introduced into nature by the work of man; he had perceived the dramatic effect produced and he had presented it by raising the foreground, lowering the horizon, accentuating the construction in depth, alternating the light and shade as in conflict with one another, accentuating the gloom in the mass of trees and clouds. He had reduced his palette to a minimum: everything is brown in the foreground, with gradations of grey in the water and the sky. But in order to vary the lights and shadows he had not only made the impasto of colour extremely thick, but he had also modelled it with his palette-knife in such a way as to enrich the reflections of the light colours and the dark colours with the reflections made by the natural light over a smooth surface. In this way he had rendered the chaos of the natural subject with a perfectly adapted order, and therefore with great evidence and effect. The new technical system is not without consequences. The material is more beautiful than in the "Hay Wain". The masses of colour assume a value in themselves, as of beautiful objects, for their corporeal effect, for their volume. But this realisation of the effect of light on volumes is dangerous to achieve. The airiness of the light disappears. The marvellous

technical effort absorbs too much the artist's activity. The balance between technique and art persists, but it already betrays a certain instability.

In the finished picture, the composition has deteriorated because the tree in the foreground, now moved to the centre of the picture, interrupts the effect of depth, but the contrast between form and colour has been accentuated. The intensity and the density of the colours are maintained, but a form has been introduced that is foreign to them. The density of the colours demands a summary form. If, on the contrary, this grows more precise, what was volume and style becomes an illusory reality, and therefore an error of taste.

Another comparison throws light on this problem. Look at "A Dell in Helmingham Park", from the collection of P. M. Turner, Esq. (Fig. 35). Constable painted it in 1823. A brook, two banks, a wooden bridge, a few old trees, are painted in shades of brown; only in the sky do you find whites and blues. The harmony of the two grades of tones— browns and blues—is perfect. The composition is concave, with a revolving movement, like a whirlpool. And the movement of the trunks has the greatness of Michelangelo, the severity of Rembrandt, the freedom of Constable.

And now look at what "A Dell in Helmingham Park" suggested to Constable in 1830 (Tate Gallery; Fig. 36). The sense of the monumental, the lyric values have disappeared. The skill consists in exciting physically by means of a colour-paste so dense as to give the material sense of the bark itself. There is no question of style, but of pictorial cooking. And it is precisely when the sense of the spiritual grows scarcer in him that Constable takes pains to proclaim it. The "Hadleigh

Castle" of 1829 (National Gallery; Fig. 37) presents us with a generic form which would like to stir us with the spectacle of a ruin facing the sea and a stormy sky. But everything is in a muddle. It is merely a page of romantic rhetoric.

Material illusionism and romantic rhetoric are the two dangers into which, after 1825, Constable falls. As soon as reality was no longer subordinated to the subjectivity of his style, illusionism at once put in an appearance. As soon as the romantic impulse lost contact with reality, it became rhetorical instead of lyrical.

After 1825 Constable still painted a few fine things, but the happy moments of his creativity had passed. The freedom and audacity of his genius awakened an ever-increasing re-action. Even his old friends accused him of not finishing. And the newspapers treated him as a madman. Now he would challenge unpopularity with the vivacity of his chromatic contrasts, now he would accentuate the skill of his execution in order to impose his art through the illusion of real light. But he could not avoid letting what was affected and exaggerated be felt, or prevent his prodigious technique from suffocating the immediate inspiration. After flinging himself towards the future to the point of realising perfect studies in impressionism, he descended to a pedantical mechanical realism, a declamatory romanticism.

Besides Constable, though in a minor key, another Englishman suggested new accents to French painting in the nineteenth century: Bonington. Born in 1802, dying in 1828, he studied painting in France, first with an obscure painter, Louis Francia, then with Baron Gros. He had been a friend of

Delacroix since 1816 or 1817, and lived in France until shortly before his death, except for two journeys, to England in 1825 and to Italy in 1826. His genius was truly a marvel of precocity. No one possessed a greater delicacy of pictorial tone than himself, a more agreeable harmony of colours, a clearer understanding of effect, a greater facility of execution. He remained foreign to the neo-classical art about him. In his figure-pictures he suggested the pleasure of rich colouring, the pomposity of which was corrected by a natural facility but by nothing else (cf. Fig. 38). In his landscapes he sometimes went so far as to feel, beyond the charm of colour, the beauty of a luminous atmosphere: for instance in the "Marine" of the Louvre (Fig. 39). All these gifts offered him an immediate success and rendered it easy for Delacroix and various French landscape painters to detach themselves from neo-classical taste. Hence his importance in the history of taste is very great. In the history of art his importance is minor, because his so naturally and ingenuously original vision was not accompanied by a new world of sentiment and imagination capable of completely absorbing the picturesque in a pictorial style. It is cruel to demand so much from a painter who died at twenty-six. But that is the cruelty of criticism. He knew how to skim over a variety of themes, rendering everything that he touched pleasant and delicate. But themes of his own he never created. His message was revealing, above all, because it was derivative. Every little fleck of his in landscape, every flicker of light in his interiors, is admirable in promises. After admiring them, we wait for more. Death seized him at the outset, made it impossible for him to fulfil those expectations.

54

Chapter Three

DAVID

IT MAY seem strange that the spiritual renascence—symbolised by the French Revolution—that accompanied the birth of the nineteenth century should have taken so long to produce a great artist in France. In Spain, it produced Goya; in England, Constable, but it was not until 1824 that a new and completely formed personality put in an appearance in France. And yet the causes of this phenomenon are easily explained. The Revolution had brought with it the fall of the "Republic of Letters"; that is to say, of that class of lovers of literature whom every writer was anxious to please. And for the same reason there also disappeared the "Republic of Art", for which there was substituted, first, a Parliament, then a dictator. Because of these social conditions, the break with the artistic tradition, known as the "return to antiquity", which was general in Europe, took on, in France, a more decided character than elsewhere.

This reversion must not be confused with that classical tendency, so alive throughout the eighteenth century, so capable of adjusting itself to all manner of caprices, so susceptible of evolving, through the identification of the naïve and the classic, into a more or less idyllic pre-romanticism. This tendency was represented by Fragonard in France, by Piranesi in

Italy; and they created masterpieces. No, the "return to antiquity" claims to correct the classical tradition, to make it more rigorous. Actually, it empties it of all human content. It is the work of Winckelmann, *i.e.* of archaeology, perhaps of philosophy and science; in any case, since it is anti-creative, it is anti-artistic. Once belief in the art of the age had vanished, once the conviction was established that a few Roman copies of Greek statues comprehended in themselves the very perfection of art, all that remained was to compose one's own pictures from fragments copied from ancient sculptures. All this had nothing to do with art. Not that the return to antiquity was, after all, so foreign to the life of the time as has been believed. Not only were Rome, which was extremely well known, and Greece, which was much less so, all the rage, as evidenced in the religious and political symbols, in the social life and customs, during the Revolution and the Empire, but in the same way, and quite irrespective of fashion, the deliberate process by which pictures were composed as mosaics of perfection, pieced together by "reason", corresponded, in its disingenuous character, to that other deliberate process by which art was set to serve political ambitions. With this aggravating detail that even the liberals, that is to say those who laid claim to overthrowing the political traditions of dictatorship, for instance Benjamin Constant, "employed a certain coquetry to safeguard" the literary and artistic traditions represented by the "return to antiquity". And they deserved the satire of Alphonse Rabbe, who, in 1823, is astonished that they "who back with the most courage and talent the general doctrines of modern politics" . . . stay obstinately "in the rearguard of an evolution of the arts", and insist on "wanting to

set the left foot forwards, and remain immobile with the other one."

Imitation from the ancients was often a pastiche of the ancients. When David was painting his "Brutus", not only did he take from ancient statues his figures of Brutus and Rome, but he also wrote to Wicar, who was in Rome, to find him the headdress of a bacchante, to draw it and to send it to him without fail, so long as it was a *coiffure de style*. This system resulted in some serious consequences. As Madame de Staël detected, it was incompatible with "natural original-ity": "Perhaps we are not capable, as regards the fine arts, either of being Christians or pagans; but if, at no matter what period, creative imagination is reborn among men, it will surely not be in imitating the ancients that it will make itself felt" (*Allemagne,* 393–4). Since what was left over from antiquity was sculpture and not painting, the painting that imitated antiquity represented, in fact, nude statues rather than human shapes clothed as they are clothed in life. As Stendhal observed, painting "can paint only bodies; it is de-cidedly incapable of painting souls". And further, as Guizot wrote: "Since sculpture almost always represents only an im-mobile and passive state, nakedness is far less improbable" in sculpture than in painting, where the scenes represented do indeed sometimes require action. "Purity of line" was, to be sure, a conquest of the new school, and represented "correct-ness of draughtsmanship", but inasmuch as purity of line led to a finish of detail carried to an extreme, what suffered thereby was the *whole,* as Guizot perfectly understood, and the whole of a picture corresponds to the "correctness of the idea". In short, the chief victim was colour. For a long time

David despised colour as the most material element in painting. And his best things, from the point of view of colour, are precisely those that have least colour, that are reduced to shades of neutral tones, as in the "Madame Récamier". However, towards the end of his life, in 1817, when he was an exile in Brussels, he wrote: "If I had had the good luck to come earlier to this country, I think I should have become a colourist." He was wrong; in 1824, when the "Mars Disarmed by Venus", in which David had wanted to show his new, vivacious Flemish colour, was shown in Paris, connoisseurs realised, and affirmed with the pen of Thiers, that the new colour was not adapted to David's style; it was the super-imposition of a chromatic abstraction upon a formal one, it was colourism and not colour; one had to go back to the "Horatii" to escape being disturbed by David's colour.

In spite of all these consequences entailed by the return to antiquity, it still constituted an ideal. Indeed, it identified itself, somewhat arbitrarily, moreover, with the "ideal of reason". What reason in art is, nobody has ever succeeded in finding out. One can be certain that if "la raison raisonnable" is helpful in art as in life, "la raison raisonneuse" has been deleterious for art at various epochs, but particularly at the epoch of the Revolution or of the Empire. David was wont to say: "The artist must needs be a philosopher. The genius of the arts must have no other guide than the torch of reason." And Quatremère de Quincy went even further: "Let us then treat art as science"!—"Instead of asking reality for visual impressions and the exercise of his trade for the means to translate them, the artist will with the aid of logical methods pursue the investigation of nature's secrets" (Benoit, 48).

Stendhal accused David's school of being "an exact science, of the same kind as arithmetic, geometry, trigonometry." But he exaggerated. First of all, the scientific and philosophical intentions of painters remain merely intentions. In addition, the scientific ideal of the close of the eighteenth century no longer looked so much towards the mathematical sciences as towards the natural sciences, which were then attaining their heyday. The natural sciences are less harmful to art than the mathematical, because of their, however slight, element of the observation of nature. David's "scientific" spirit led him to anatomic precision, but not to an interest in perspective. Unfortunately, it also led him to "typology" and to "symbolical composition". Maladies of the times, which were still able to contribute a little light, such as the "research into essence"! This affair, too, of "essence" in art is a metaphor: there is no real essence in art except art itself; in an image there is only the nature of the image. And yet when an artist seeks for the "essence" of a natural reality, he wishes to imply the synthesis of its truest aspects, or its most intimate aspect. And in this case, "research into essence" signifies "rigorous research", which is a moral attitude highly beneficent to art. From it derives, in David and his school, the desire to reduce the maximum of expression to a minimum of movement and gesture: which is a useful corrective to baroque taste.

The most salutary result of all this was a "masculine and vigorous prose" as Delacroix defined a picture of David's. But, after all, it is prose and not poetry. And the reason for its remaining "prose" was that it conceived art as a means and not as an end, as a means for attaining moral, social and political values.

In other terms, the artistic expression of the French Revolution was not free expression. It was necessary to wait a long time before finding once more a free art, because in art, as in life, when liberty is once lost, it is difficult to recapture it. We must, moreover, remember that, according to Tocqueville, the urge to political liberty was not among the main ones that prepared the Revolution. Much more important was the immensity of the passion for the public good, a passion which caused political and civil values to predominate over artistic ones. When, in 1792, the Academy, in order to save itself, invited him to take over a course of teaching, David answered: "I once belonged to the Academy. David, deputy to the National Convention." And all the illustrators more or less appreciated by Napoleon sacrificed at the altar of the practical. "Protesting against all confusion of the 'arts of genius' with the 'arts of luxury', they deny that the former have the right or even the power to suffice to themselves in the abstract sphere of beauty, and they impose on them the duty to produce work of 'usable application' in relation to the *positive* interest and the *practical institutions* of a nation. . . . Thus art will set up a utilitarian aim; not the particular utility of a privileged caste, but the general utility of the nation, that of the masses, rather, even than that of men of culture. . . . As in Greece, where they were the 'key and body of legislation', the arts must become among the moderns 'a vital institution, a mute and ever eloquent legislation', which elevates the mind and purifies the heart. What more sublime usage for the arts than this kind of *priesthood?*" (Benoit, 58).

It was, in short, the conception of art as "pure classical and indifferent beauty", derived from Winckelmann, and the con-

ception of art as "expressive, useful, social", such as the political life of the Revolution and of the Empire demanded. The two ideals were opposed. And numerous controversies arose between the critics. Typical was the one between Quatremère de Quincy and Émeri David. But David and his school confused the two ideals, supporting now the one and now the other of them and, indeed, they assimilated a neo-classical or expressive technique, according to their varying needs.

Some have thought that they saw in David a conflict between his theory and his temperament. With the temperament of a realist, he is thought to have been hampered by his neo-classical theory; except that David's theoretical contradictions are such as to cancel one another in turn, and to explain at the same time both the "Horatii" and the "Coronation of Napoleon I" (Fig. 42).

It is well known that David's first works were not neo-classical, but displayed that eighteenth-century mannerism the chief exponent of which is Boucher. Well, even in these early works, David reveals a certain lack of sensibility to colour and a very lively interest in the play of facial expression. A passage from Étienne Delécluze sets forth the question: " 'You see, my friend,' David said to Étienne, 'that is what I then used to call *antique tout cru* [antiquity in the raw]. When I had thus copied that head with great care and difficulty, I went home and did the one you see drawn beside it. *I seasoned it with a modern sauce,* as I used to say in those days. I just perceptibly wrinkled the brow, I raised the cheek-bones, I slightly opened the mouth; in short, I gave it what the moderns call an *expression,* and what to-day [this was in 1807] I call a *grimace.* Do you understand, Étienne? Yes—

and yet one is not a little embarassed, with the critics of our day', the master added, 'for if we were to act exactly according to the principles of the ancients, people would find our works cold' " (Delécluze, 112).

It seems to me, therefore, that the problem is clear. Even in 1807 David felt that pure imitation of the ancients was cold and lifeless. And he eschewed it in order to insert *expression,* without realising that, even when it was not a *grimace,* expression could never be an ideal or artistic expression, but was a facial play; that is to say, a rehearsed and rhetorical expression. Stendhal noticed it in 1824: "Do you want to know what we find constantly at the Salon of this year instead of expression? An imitation of Talma" (p. 47).

From expression to realism the step is short. The identical *artisan* urge that David felt in imitating the ancients he revealed as well in the imitation of natural objects. And in the "Distribution of the Eagles" a contemporary admired precisely in the various soldiers "a figure, a stature, the very thighs . . . which bear the imprint of their particular branch of the service, . . . a light-infantry *chasseur* . . . with the mobile bearing and the short legs indicating the men that are usually picked for this body" (Benoit, 70). It was a current realism, a transcription from reality, evident and precise enough, void of imagination and with but little sentiment. Hence the accusation of lack of humanity, formulated at the time and still reiterated against David's paintings. But the technical structure had an importance of its own. Blanche believes that this technique is art: "A direct art, facile even when it seems tense, a realistic art, a good workman's craft, conscientious after the fashion of a Jacob or a Riesener; something

'well-done' and discreet which flings no dust in anybody's eyes" (173). That is to say, Blanche does not understand the limitation of his own definition. He defines well enough David's production, but he does not realise that he defines it as a sure and facile prose, not as art. And indeed that realism, far from being art, was virtuosity, identical with the neo-classical production of *la beauté pure*. Antique statue or fragment of nature: the subjects represented changed. But the process was identical, the unerring and facile virtuosity of imitation.

And now, ponder the *motifs* suggested so far. David and his school have remained the symbols of a taste the essential *motif* of which is the "return to antiquity", as opposed to the classical tradition of the eighteenth century, as a moral reform. The "return to antiquity" brings with it a renunciation of natural originality, brings with it the subordination of painting to sculpture because the models of antiquity that have been preserved are sculptures, brings with it a purification of line, which is given too much to detail and sacrifices the whole, busies itself with bodies and ignores the soul. Art, at the same time, because of a presumed identity between antiquity and reason, is exhorted to acquire the certainty of science and the profundity of philosophy. And if, on the one hand, this request implies in the artist a new rigour of research, by which he can achieve a "masculine and vigorous prose", it also leads him to accept pseudo-moral, political, demagogical aims, by which he loses the autonomy of art. Once he has accepted such aims he must needs renounce the "frigidity" of the ancient statue and discover an expression, no longer imaginative and fanciful but *practical,* and hence attain to a realism that is solid and sure, but also vulgar. Both as regards neo-classicism

63

and as regards realism, the process remains identical in spite of the change of subjects, and it is a process for artisans, for virtuosi, not for artists. Moreover, it is this *virtuosity* that David bequeaths to nineteenth-century French painting—a virtuosity derived from the ancients and turned towards romanticism, which engages not so much perhaps the sensitive qualities of the human soul as the acumen of intellect and will-power.

"Of a taciturn character, of a spirit inclined to meditation, the young David kept aloof from his comrades. No gaiety, no grace, no outbursts. A precocious and singular maturity revealed itself in him (*David* d'Angers, 162). His ambition knows no bounds: because of his failure to win the "Prix de Rome" he wants to kill himself. His culture is extremely limited, and his attitude towards life completely lower-class. He can also be indulgent and cordial with people, exactly because of this lower-class character. But he wishes (and with success) to raise himself continually, with an obstinacy and a tenacity that at once give him the success of an artisan virtuoso. But precisely with this formidable will and with this lower-class outlook, because of a lack of cultural liberty, he does not succeed in achieving an individual conduct of art or of life. He dedicates himself, on the other hand, with blind enthusiasm, to the ideas that he meets on the way, and of them he makes a dogma. The æsthetic ideas of a Vien, of a Winckelmann and then of a Quatremère de Quincy, the politico-social ideas of Robespierre, formed for David one sole dogma. In politics, David seemed an undiscerning fanatic. When prison had cured him of fidelity to the memory of Robespierre, he

hit upon a "hero", and at once believed that it was his own "hero": Napoleon. And he did not discern that Napoleon was the hero of a reaction against the very ideas David had first followed. David's dignified conduct in exile, after the return of the King of France, proves that he had given himself to Napoleon not out of cowardice, but from lack of understanding.

Exactly because of this way of accepting ideas as dogmas to be obeyed, rather than as matter for intellectual labour, he was a fanatic in politics and a theorist in art. He wore the "Phrygian cap like a pontifical tiara" (Blanche, 175). He became, all unawares, a *tyrant* in his field. The friendship between David and Robespierre was not casual: both of them sacrificed little or much of their popularity to a learned, studied, aristocratic expression. Both to Robespierre and to Saint-Just "whoever attempted to speak the language of the people became promptly and naturally hateful: it seemed to them an attempt to cause the downfall of the Republic. They never saw her without the pomp of a Cicero and the majesty of a Tacitus" (Quinet, *La Révolution,* III, 2–3). David was instructed by Robespierre to compose the plan for the festival of the 20th of Prairial, "the cult of the Supreme Being". And he produced abstract allegories incapable of expressing that aspiration to a new religion towards which Robespierre was in vain striving. Both the religious allegory and the classical pomp remained forms void of content, remote from that life which David, Robespierre and the entire French people were actually living.

So there is no question of comparing David with André Chénier, as Thibaudet suggested. David's painting can, at

least, be set beside the most abstract of Robespierre's eloquence, his cult of the ancient hero, his inhuman search for purity, which led the dictator to isolation and death, and which threw David, alas, into the arms of Napoleon.

After a long study of Boucher and Greuze, Vien and Mengs, Caravaggio and Poussin, and, of course, of ancient statues, David painted, in 1784, the "Portrait of Madame Pécoul" (Louvre; Fig. 40). Given the type and the costume of the woman, nothing of the neo-classical is discernible in this portrait. From his study of classical form, David derives only ground for robust construction, which accentuates on the one hand the vigour of the life represented, and on the other the vulgarity of that life, vulgarity that the thick, winy colours carry to the limit of the endurable. The skill of the craftsman and the absence of the artist are both evident.

To the same year 1784 belongs the "Oath of the Horatii" (Louvre; Fig. 43), which constituted David's first real triumph, and is, without doubt, one of the signs that announced the Revolution. The military vulgarity of the oath, the melodramatic attitude of the father, the affected languor of the women make it impossible to discover in this work any artistic value whatsoever. But no one can forget that here for the first time plastic rhetoric was presented with simplicity, with truly Roman authority, with great skill in contrasting the valour of the warriors and the weakness of the women. There was thus an illustrative effectiveness that can easily explain the success of the picture. But, as regards the form and the colour, it is necessary to stress the fact that both are equally ugly, equally abstract, unfelt, not rendered individual, yet with this difference, that whereas the ugly form is based on a remarkable

knowledge of form, the ugly colour is the result of a total ignorance of chromatic values.

In 1784 David was thirty-six, having been born in 1748. He was destined to live amidst the honours, the prisons and the mortifications of the Revolution and the Empire. In 1816, as a regicide, he is obliged to emigrate to Brussels, and he dies there in 1825. His maturity as an artist was completely attained in 1784, in the two works we have just examined. The evolution of his style continues until the end, but its basis does not change. And since its basis is, as we have said, virtuosity, the analysis must be conducted along the lines of the enrichment of this virtuosity, with an eye to discovering connections between his skill and his artistic sensibility.

In his compositions, this connection would perhaps never exist. "The Death of Socrates" (1787) is perhaps the best-balanced of David's compositions: but this quality again belongs to the virtuoso. "The Lictors Bringing the Bodies of his Sons to Brutus" (1789) reveals a certain purity of detail, a still-life—the group of women—in which his very mannerism seems to become more sensitive, with a somewhat vague tendency to a form of primitivism. The colour is devoid of light and shade, and strives to become alive through its own strength. This promise is annulled, however, by preoccupation with the problems of the composition. "The Sabine Women Halting the Struggle between the Romans and the Sabines" (1799) constituted David's greatest success; he thus expressed his intention: "My purpose, in creating this picture, was to paint ancient customs with such exactitude that the Greeks and the Romans, seeing my work, would not have found me foreign to their way of living." We can smile at such an illu-

sion; it was certainly capable of becoming a motive for art, but David was not capable of it. The confusion of the background prevents the pauses required for the determination of pure plastic values, and the plastic values in themselves are too abstract to achieve artistic life. "Leonidas at Thermopylae" (finished in 1814, but begun in 1800), with its wooden nudities immersed in a misty grey-green, is a general aggravation of the artistic absurdities of the "Sabine Women". And when, in 1824, he painted "Mars Disarmed by Venus", in an endeavour to make use of brilliant colours, he piled Pelion on Ossa, as we have said before, but failed of his purpose.

Napoleon called David away from the antique to deal with himself, Napoleon. "The Coronation of Napoleon I" (1805–1807) changes the subject, but not David's spirit. Instead of offering a series of portraits of Greek statues, he offers a series of portraits of the Emperor, the Pope, and their courts. If you would appreciate David's portraits you must, however, not look at them as they appear in the "Coronation", or even in the "Distribution of the Eagles" (1810), where the portraits are confused with rhetorical poses; it is better to see them when they are individual. "Marat Assassinated" (1793: Brussels Museum; Fig. 41) is considered by such critics as Baudelaire and Thoré to be David's masterpiece. It is certainly a complex work, painted under conditions that were particularly favorable. David is a friend of Marat's. On the very day on which the news of Marat's death is brought to the Convention, David, who is presiding, receives the commission to immortalise the figure of the "martyr" of the Revolution. The day before Marat's death, David had seen him in that very bath-tub in which he was killed, and the attitude he had beheld was

projected on the canvas. So that everything, it would seem, should have contributed towards a work of art: the visual impression, the emotion of a friend, the dramatic grandeur of the event, the technical assurance of the painter. Baudelaire writes: "The drama is there, living in all its lamentable horror, and by a strange *tour de force,* which makes of this painting David's masterpiece and one of the great curiosities of modern art, it contains naught that is trivial or ignoble. There is in this work an element that is tender and at the same time poignant; in the chill air of that room, over those cold walls, about that frigid and ill-fated bath-tub, a soul is hovering." All this is true. But we end by asking ourselves whether this is really a work of art. That David must have been stirred by the tragic end of his friend, no one can doubt. It may be noted that in order to isolate the wounded body, and to center attention upon it, the bath-tub appears flat, without the requisite correspondence of volume with that of the body: whence a lack of balance that weighs on the composition. The script and the pose chosen, everything induces you to feel pity and admiration for Marat. The representation of the tragic event could not be more exact and it is painted with incredible decision. Everything is extreme: the yellow of the wooden bench, the green of the cover, the white of the sheet and of the paper, the cadaverous tone of the flesh. And everything assumes a pitiless precision. The great, black background is frightening. In short, there is an unquestionable iciness in the representation, which, far from being indifference, is the deliberate intention of an expressionistic means. David does not represent sorrow for a lost friend, he wishes to make you feel horror at a scene of bloodshed. He excites the nerves, not the heart. And if you

look for the primary source of this error, you discover it in that expressed form, perfectly dominated by David and therefore apt for an instrument of horror, but too easily dominated to be taken for the tremulous voice of emotion. So that you grow aware that David's powers of draughtsmanship may perchance be his artistic impotence. And yet, in the history of taste, the importance of this work is enormous. It has nothing to do with neo-classicism, and leaps outright over all the romanticism to come. By virtue of the energy and the lack of prejudice of the representation, it is a realistic work, an anticipation of Courbet. Never again will David have this force of prophecy. His "Marat" is perhaps the only picture that gives us, in some way, the form of one aspect of the French Revolution, and in this way it suggests to us what would have been David's taste, and the taste of the Revolution, if Napoleon and romanticism had not obliged them to deviate from their path.

A romantic portrait *par excellence* is "Bonaparte Crossing the Saint-Bernard" (1800: Fig. 44). "This equestrian figure has been a thousand times reproduced in bronze and plaster, on the pedestal of clocks and over the lintel of cottages, by burin and pencil, on wall-papers and on stuffs, everywhere. The pied horse, rearing on his haunches, scales the Alps like a Pegasus of war." Thus wrote Thoré in 1846, and it is impossible to specify better the natural success of the popular rhetoric that David succeeded in realising in this picture, even if the limits of that rhetoric as a work of art are somewhat restricted.

If you wish to obtain the most genuine view of David as an artist, you must not seek him in his classical or contemporaneous compositions, and not even in his realistic or romantic por-

traits. You must seek him in his moments of relaxation, when he was doing a portrait that did not engage him too severely, when he was painting for the pleasure of painting, and was not over-doing or finishing anything.

The "Portrait of Madame Récamier" (1800: Fig. 47) was happily interrupted when the natural facility of touch had not yet completely disappeared. David was captivated by the grace, the airiness of the youthful idol. And in spite of all the neo-classical apparatus, he did not deprive his fair sitter of her individual life. The grey of the background and the brownish grey of the pavement harmonise to perfection with the yellows and blues of the sofa and with the white of the classical dress. And the contours, because of their not being over-finished, de-limit the form without suffocating it. Over the work of the matchless creator hovers a sense of grace that has a true value in art.

Other portraits of women present a good-natured, though somewhat plebeian, grace that renders them attractive: that of Catherine Tallart (1795), in the Louvre, delicate in colour; the portrait of Madame Sériziat (1795), also in the Louvre, blooming in youthful smiles. A masterpiece of the last period is the "Portrait of Baroness Pauline Jeannin", daughter of the painter (1812), which belongs to the Countess Joachim Murat (Fig. 46). It is a mere sketch, but for the very reason that David is freed of his own prejudices, he has succeeded in ex-pressing all his satisfaction at the social level to which he has been able to elevate his daughter. And this satisfaction is ex-pressed not only in her smile and in her eyes, but in the very nonchalance of the pose and by the pictorial manner.

When this nonchalance and this personal satisfaction do not

transpire, and when David would like to attain to the extreme consequences of his realism, then terrible accidents happen. The "Portrait of Madame Morel de Tangry and Her Two Daughters", also known as "The Three Ladies of Ghent" (circa 1818, Louvre), is an example of the unheard-of vulgarity, the bad taste and the lack of style into which a mannerist can precipitate himself when he is not held back by some external restraint.

An exceptional portrait is that of "Comte François de Nantes" (1811: Musée Jacquemart-André; Fig. 45). The interest felt by David in the distinguished expression of the personage, and the beauty of the ornaments he is wearing, was so intense as to result in solid, bourgeois, poised, forceful dignity. This is a style that foreshadows the taste of Louis-Philippe and the art of Ingres.

In short, David's personal contribution to the development of taste was a kind of severity of decision, of certainty, of precision in the technique of draughtsmanship, a denial of the autonomy of art and a deliberate will to make of it a political and social instrument. In this way he has, on the one hand, helped to give France a consciousness of the necessity for a more rigorous schooling in draughtsmanship than the eighteenth century knew and, on the other, to take away the consciousness of the necessity to keep alive the sensibility to colour and light. Abstract form and abstract colour were for David two instruments for dominating reality, a brutal and empirical reality, outside of all artistic imagination. That is why he prepares the way for Courbet, but has no effect over the two greatest artists of the first half of the century: Corot and Daumier.

Goya is a poor courtier, Constable is a village conservative, David is a regicide. And yet he takes absolutely no part in the authentic revolution in art, in that conquest of liberty in painting which is the pride of the nineteenth century, and which Goya and Constable had the courage to initiate. Indeed, David appears just as revolutionary in politics as he was reactionary in painting. That is to say, his interest in art was inferior to that which he felt for practical life. For this reason he did not succeed, or at least only occasionally, in producing authentic works of art.

Chapter Four

INGRES

To the conception of art as "pure neo-classical and indifferent beauty," derived from Winckelmann, David had, after his own fashion, opposed an art that was "expressive, useful and social." The art of Ingres as a whole is a protest against the expressive, the useful and the social art—neo-classic indeed, but tending towards realism. And yet he is even further from neo-classicism than was David. Ingres is a romantic: his romanticism is highly personal and bizarre, limited by the confusion of the false pretence to classicism. This limitation is imperious and explicit in proportion to the interior bubbling of romanticism in apparent eruption.

From Montauban, where he was born in 1780, and from the Academy of Toulouse, which he had entered in 1791, Ingres passed in 1797 under the schooling of David. Here he shared that craving for primitivism which had touched David also, and which found its expression in the sect of the "penseurs" (thinkers) or "primitifs" founded by Maurice Quai. According to Delécluze, who was his companion in 1797, Ingres at seventeen was already skilled, serious, "without that iridescence of thought which in France is called *esprit.*" In 1805 Ingres painted the portrait of Madame Rivière which is one of his masterpieces, and showed it together with other pictures in 1806, arousing the ire of the critics, and of David him-

self, because of the "bizarre, revolutionary, *Gothic*" character of his style. In the meanwhile, Ingres had departed for Italy, with his eyes open to fifteenth-century Florentine painting, above all that of Masaccio, and his mind made up to "refurbish his style in conformity with the Renaissance fashion", to reform the painting of his age. He wrote: "The formless beginnings of certain arts sometimes contain, fundamentally, more perfection than the perfected art" (Delaborde, 120). The Middle Ages attracted him: "I have become convinced that the earlier history of France, from the days of St. Louis and others, is a new mine to exploit, that the costumes are very handsome and that some of them recall Greek things" (*Notebook* IX, 57 v). Later on, he gave up the Italian primitives and decided that the way to rehabilitate art was "the way of nature, through the Greeks and Raphael" (Lapauze, 223), and in 1836 he criticised some of his pupils because they studied in Florence rather than in Rome (Amaury, 151). Yet such was the "primitivist" fame of Ingres that when he opened a school in Paris, in 1824, the young men went to him to become primitives. The aspiration to the primitives' spontaneity and purity, the return of the religious picture as one of the favourite *genres,* the interest in the costumes of the Middle Ages and of the Renaissance, the desire for the plastic determination of detail and, above all, the taste for line appreciated *per se* and of a plasticity without rondures: this was the affirmation of Ingres against the neo-classicism of David, in unison with the German "Nazarenes", with the Italian "purists", and with the belated English "Pre-Raphaelites." It was a romantic affirmation.

Théophile Gautier not only saw in Ingres an Italian monk

of the Middle Ages, the most fervent priest of the religion of art, but he understood also that "when he paints an antique theme, he does it like a poet who, wishing to write a Greek tragedy, goes back to Aeschylus, Euripides, Sophocles, instead of imitating Racine and his copyists. In this sense he is a romantic." Now it is a fact that, in a generic sense, the same thing would hold true of David; but it is impossible not to feel that in Ingres this fondness for the ancients is more sentimental, more passionate, and therefore more romantic.

Even more than the Greeks and Raphael, Ingres considered nature his teacher. Sometimes he would point out that the Ancients "are themselves nature" (Amaury, 213), that "Raphael is himself only because in all simplicity he knew nature better than the others" (Amaury, 235). In 1827, at the Académie des Beaux Arts, Ingres contradicted Quatremère de Quincy: "He attributes to men the merit for the style of the *beau idéal,* a term easy to the tongue, extremely subtle, but false, erroneous, ambiguous, and which has caused more harm in the arts than Pandora's box. . . . I have at least a guarantee in those who came before me when I recognise no other style than that of nature, the possibility of saying: *Style is nature* (Lapauze, 270). These words of Ingres', moreover, are confirmed for us by his works. His best paintings are, as everyone knows, his portraits. Ingres would have liked to escape from portraiture in order to devote himself to "historical painting", but a stronger attraction held him to portrait-painting all his life. In 1845 he wrote: "Portraits weigh me down, they kill me." And it is easy to see that his immense pride suffered from having to deal with the difficulties, the formal contingencies, of the model. But in this very task, in this very

76

struggle, he found the reason for his greatness. What he always lacked was the imaginative faculty; and this critics were quick to recognise. As early as 1824, Stendhal spoke of the "material beauty", of the "depth of knowledge and attention" in Ingres. His affectionate pupil and admirer, Amaury Duval, defined Ingres as an "enemy of the ideal, a declared lover of nature." Baudelaire found that, contemplating the best pictures by Ingres, the evil thought came into his head, "that it is not Monsieur Ingres who sought nature, but nature who violated the painter." Silvestre wrote about his "contemplation of brute matter." And Chesneau protested against the current opinion which regarded as an "idealist a painter who was essentially a realist and a materialist." And Baudelaire discovered essential affinities between Ingres and Courbet. Thus, not only did he discover Ingres' romanticism in his love for the primitives and in the way in which he flung himself on the classics, but he too drew conclusions from his romantic premises. Realism is a product of romanticism. Courbet's realism has been called a second romanticism. Ingres' realism is of a nature greatly akin to it. And it is ridiculuous to "baptise with the term 'ideal' the refinements of the real" (Chesneau 286).

One last touch will complete the picture: the path that Ingres follows in order to get to nature is eroticism. "His libertinism is serious and filled with conviction. M. Ingres is never so happy nor so forceful as when his genius finds itself face to face with the charms of a young beauty. The muscles, the folds of the flesh, the shadows of the dimples, the hilly undulations of the skin, nothing is lacking" (Baudelaire, 81). And recently too Blanche recognised that Ingres "was a voluptuous

77

emotionalist . . . transported by a sacred rage as soon as he is face to face with nature." Ingres himself wrote in his *Note-book* IX: "It is good to *calamariser* women's eyes, observation made on nature" (fol. 61 v.). And we understand how Ingres' plastic strength is nothing but a sensual grasp of some frag-ment of reality.

And yet, beyond his taste for primitives, his undefined lik-ing for the past, his exasperated sensuality, lies the affirmation of a dogma which lays claim to being classic, but is above all a dogma. "Doubt itself is a reproach with regard to the mar-vels of the ancients" (Delaborde, 138). "To wish to dispense with the study of the ancients and the classics, is either folly or laziness" (*ibid.*). "There is no need to feel any scruples about copying the ancients. Their productions are a common treasure from which each can take what pleases him" (*ibid.*, 140). "There is nothing essential to be found in art after Phidias and Raphael, but even in studying them there is always something to be done, to maintain the cult of the true and to perpetuate the tradition of the beautiful" (*ibid.*, 148). Listen to his assurance: there is no use discussing, you must either take it or leave it. And, as a dogma, the classicist theory became an insuperable obstacle to Ingres' creative capacity. Thus constrained, hard put to it to breathe, it was incapable of taking the leap. Or perhaps Ingres clung desperately to the theory precisely because he did not feel sufficiently sure of himself, because he had not the courage to abandon himself to his natural sensibility.

The way Ingres accepts the classical dogma, without criti-cism or reflection, recalls the way Victor Cousin accepted ideal-istic philosophy. And a correspondence between Ingres and

Cousin in 1842 struck Doudan as curious: "Do you not find that M. Ingres has something of Cousin about him? I mean it quite seriously. I used to find that he had certain movements of the head that reminded me of an actor, and I ended by finding that the actor was Monsieur Cousin." Doudan's irony is venomous, but not unjustified. The high-priest of beauty and the high-priest of the ideal were in fact, in absolute good faith, two simple actors.

There was, accordingly, a force which set itself against the development of Ingres' artistic talents: namely, the classic dogma. But there was also a force which arrested the normal development of the man: and it was not a theory, but a destiny. Of immense precocity, already mature at the age of seventeen, he lived, for eighty-seven years, like a child. He had to struggle hard in his youth to make his living, and he revealed a desperate courage, a fidelity to his ideal that overcame every handicap. He never once sacrificed an iota of his ideal to a material interest, but he always confused, as though it were his sacred right, his social advantages and his qualities as an artist. He preached much and often, but he could never discuss; he affirmed with violence, and at the first difficulty he would withdraw from the fray. Then he would flee, even as far as Rome, to a place where he could retire into disdainful isolation. Every trifling success was to him the definite triumph; but this would be followed by discouragement and the desire to escape even from his success. For this reason he was permitted to triumph, but not to convince. "If he is contradicted he sulks and gradually growing angry shakes his fist, stamps his feet, storms, and finally offers himself as a sacrifice. Always on horseback in his sentiments, he carries on his disputes like

a weak woman, and ends by being in the right by sheer force
of being in the wrong" (Silvestre, 12). His hatred was un-
bridled, and revealed itself in ways characteristic of naïveté.
Beside the open grave of Vivant Denon, whom he detested
and whose seat in the Academy he hoped to occupy, he said:
"Good! Good! . . . it is good! He's in it this time, and this
time he'll stay there!" Fearful of being compromised by his
pupils, he would sometimes commit little acts of cowardice,
and gnaw his soul in jealousy. He was ready to be modest
towards dead artists, but displayed a ridiculous pride towards
the living ones, to the point of going into tantrums in 1855
because the gold medal, instead of being awarded to him alone,
had been given to others also. His attitude towards the men
of his time is that of an adversary and a detractor, with the pre-
tension that all had to kneel before him. In 1836 he refused
Thiers' invitation to decorate the Madeleine and commented:
"The occasion was very charming, because it all helped to
serve my passion: oh how sweet and voluptuous it was to me
to utter that *no!*" (Delaborde, 99). In 1857, when the official
world had already deified him, Ingres wrote: "We are like the
Jews in captivity who bewail their misfortune. We too weep
over the conquest of art, which is constantly misunderstood"
(Lapauze, 504). To someone who suggested to him that "one
must follow one's century", Ingres answered: "But if my
century is in the wrong? Because my neighbour does wrong,
is that any reason why I should be forced to do so as well?
. . . Besides, there are not two arts, there is only one: it is the
art that is founded on the limitation of nature, of unchange-
able beauty, infallible, eternal" (Delaborde 146–7). Evidently
Ingres never asked himself what right he had to set up as an

eternal measure the beauty of the Greeks and of Raphael. There you have the dogma, and there you have the belief in the dogma. And that belief was not harmless, because it led him to turn away from all the spiritual values of his time. "I do not belong and do not wish to belong to my apostate century" (*Notebook* IX, fol. 1).

Is it possible to create genuine art in such a condition of the spirit? Does art not spring perhaps from a happy correspondence between the temper of one's imagination and the taste of one's age? The *no* with which Ingres went counter to his century, the contempt for his contemporaries, the faith in an eternal beauty which is inconceivable in the life of the spirit, permitted Ingres to believe himself, and to induce others to believe him, a demi-god, but they arrested, stiffened, petrified his strength, in life as in art.

So we see that Ingres' romanticism was a *frozen* romanticism which took the name of *l'art pour l'art*. In 1846 this phenomenon was thoroughly understood by Thoré: "At bottom, M. Ingres is the most romantic artist of the nineteenth century, if romanticism be an exclusive love of form, an absolute indifference towards all the mysteries of human life, scepticism in philosophy and politics, selfish detachment from all common and socially unifying sentiments. The doctrine of art for art's sake is, in effect, a kind of materialistic brahmanism which absorbs its adepts, not indeed in the contemplation of things eternal, but in the monomania of external and perishable form" (p. 42). This is an analysis confirmed by Théophile Gautier himself, the father of the doctrine of art for art's sake, who thus wrote of Ingres: "Far from us the intention to blame the artists who fill themselves with the passions of

their time, and burn with the ideas that agitate their epoch. But we prefer beauty absolute and pure, a beauty of all times and of all countries, of all faiths, and that unites in one admirative communion the past, the present and the future" (1855, 143). "Minds attached to a religious system, politicians and philosophers will say, beyond a doubt, that Ingres is not at the service of any idea; that is where his superiority shines out: art is an end and not a means, and never was there a loftier one" (1857, p. 237).

It is well known that such demands were in part justified. After all, some sort of escape had to be found from the over-impassioned element of romanticism. But the road for this escape was not the opposition of art to the passions but the proper relation between form and content. Because this had not been understood, art for art's sake remained an empty formula. And that is why Ingres produced pupils "without great strength, having a faded sort of energy, a colourless individuality—a disinterested, distinguished élite." One of the most deplorable results of Ingres' influence was "the school of Neo-Greeks who turn the lighter part of ancient history into charades; they are to David what an operetta of the Bouffes-Parisiens is to a lyric tragedy, the *Orphée aux Enfers* by M. Offenbach to the *Orphée* by Gluck" (Chesneau, 292). All this would have lived but for an hour except for the aid of political complicity during the Second Empire. In applauding Ingres his admirers often confused the artist and the lover of order, of that order which was to lay a bridle on all free minds and which was welcomed in art even by personalities inclined towards political liberalism. "The Neo-Greek is identified with the Empire. The name Romantic, reserved solely to Dela-

croix's disciples, sounded in conversation a little like the word Orléaniste" (Dimier).

That is why Ingres was appointed a Senator of the empire, that is why Prince Napoleon, in 1855, affirmed that Ingres, "following the glorious tradition of the great centuries of antiquity, has consecrated his whole life and talent to the category which, in my personal opinion, is the eternal type of the beautiful" (Lapauze, 478). At Ingres' death, in 1867, it was declared in the commemorative speech in the Senate: "There was in M. Ingres a reflection and an inspiration from Homer, and Homer is the father of that ideal of perfection which the centuries have consecrated and outside of which art is nothing but a fashion and a caprice" (Merson, 93). Thus was artificially maintained the illusion of that unique perfection and that unique beauty of which Ingres had taken advantage, but which had already been fully destroyed for the more living part of the French people by Delacroix, Corot, and Daumier. When art can in this way isolate itself from the life of its epoch and identify itself instead with official ceremonies, it may well be said that its life is of short duration. And, in fact, three years after 1867 the War swept away, together with the Empire, every notion of the Neo-Greeks and almost every trace of Ingres' taste.

Ingres' creative process is extremely complicated: when he draws a nude the art that flows from his line is undoubtedly real art, that is, it is a sensitive line and you can find in it the absolute correspondence of art and beauty. But when he composes a picture his intellectualistic prejudices appear. As early as 1813 he wrote: "When one knows one's craft properly and

when one has properly learnt to imitate nature, the main job for a good painter is to *think* his picture as a whole, to have it, so to speak, complete in his head so that he can carry it out afterwards with warmth and, as it were, in one sole jet. Then, I think, the whole thing seems to be felt together" (Delaborde, 93). This requirement had already occurred to the mind of Leonardo and is justified, provided that *thinking* be intended as intuition rather than as reasoning. But another affirmation of Ingres' is less justified, that "the historical painter renders the species in general" (*Notebook* IX, 55 v.). In fact, the *species* belongs to science and not to art. Ingres, however, understood that one must not exaggerate in introducing science into art. "I am anxious that painters should have a thorough knowledge of the skeleton. I am less anxious for them to have the anatomical knowledge of muscles. Too much science, in such a case, is harmful to the sincerity of the drawing and can distort the characteristic expression, reducing it to a banal image of the form" (Delaborde, 129). And to a pupil Ingres said: "You indicate there something that I do not see: why point it out? Because you know it is there? You have studied anatomy? Ah yes, very good! that is where this frightful science leads, this horrible thing, that I cannot think of without disgust. So just copy nature quietly, quite stupidly, and you will already be someone" (Amaury, 39–40).

Between this requirement of abandoning oneself to reality and the other one of rendering the "species in general", there is the antithesis which, in Ingres' art, could be resolved only by perfection of form. And since this perfection does not exist, there was in Ingres a yearning for perfection that amounted to an artistic value. Thoré understood it very well: "M. Ingres

represents an essential element of poetry. He is ever in search of style, of correctness, of polish, of beauty. It is true that beauty, as he seems to understand it, is circumscribed in a strict combination of form, an abstraction made from all the other living and infinitely varied qualities of nature. The method, in our opinion, is radically vicious. But M. Ingres brings to his convictions so much violence and tenacity, that his work always retains character" (Thoré, 41). It is precisely through this violence and tenacity that the *species* in Ingres acquires an individual character, and takes rank as art; without these passions, form remains abstract. This tendency towards abstraction was, for Thoré, a defect, but by critics educated to cubism it has been considered as the true greatness of Ingres. In fact, Lhote puts the question to himself: How to seize the form, how to appreciate its plastic properties, if not by imprisoning it in geometrical lineaments?" (79).

And according to Bissière, Ingres was alone in having the "presentiment that a picture is a finite world, having its own laws and its own life" (*Renaissance,* May 1921, 269). So far no one has been able to tell us in what these laws consist, and since "laws" begin to exist when they are published we may ignore them and continue to believe that a form can be very beautiful even without having any relation to geometrical figures. Fortunately, Ingres' theory of form is less hermetic and more intelligible. He has written: "Draughtsmanship is the probity of art. If I were to run a 'School for Draughtsmanship', I am certain I should make painters. Draughtsmanship includes everything, except the colouring. Line is drawing, it is everything. Draw purely, but with breadth. Pure

and broad: there is your drawing, and there is art. Beautiful form, that means straight planes with rondures. We do not proceed materially like sculptors, but we ought to achieve a sculptural painting." All this is clear. As an instructor, he puts the accent on drawing; as an artist, he reduces the drawing to line. Because of this linear accent the form cannot be a plastic one, in the full rondure, like that of Michelangelo (to be quite clear), but a plane with a suggestion of depth. And the purpose of this plastic plane is to reduce painting to a semi-relief, as though it were modelled. Thus we do not have here a theory of art, but a preference in taste. And, as such, it is neither true nor false. It is either justified, or not, by the paintings of Ingres.

And let me add at once that it is perfectly justified. Already when Ingres was studying under David, the latter noticed a tendency to "exaggerate" revealed by Ingres in his studies. And Baudelaire, to explain Ingres' heteroclite character, analysed in this fashion his draughtsmanship: "He believes that nature should be corrected, improved, that a happy 'improvement', if it is agreeable and done with a view to the pleasure of the eyes, is not only a right but a duty. . . . Carried away by this almost morbid preoccupation with style, the painter often suppresses the modelling, or diminishes it to the verge of invisibility, hoping thus to give a greater value to the outline" (97). And similarly Gasquet saw in Ingres "reverie, meditation in drawing. He makes it copy his dream" (179). And, last of all, Lhote: "This adorable curve of the back, so free, so supple, so long, he will lengthen it even more, in spite of himself, the better to make apparent to others the inquietude it arouses in himself. He will deform it, he will enter into

86

a contradiction with what his mind knows, in order to express what his heart has just learnt" (66).

Precisely so. And because it is so, the preference of Ingres' taste is justified. It has allowed him to realise an outline as though it were the body's sheath, a scabbard which presses it so sensually as to transform it, to make it lose its naturalness, to subject it to the imprint of the imagination. That imagination is diseased, it is *morbid*. Ingres is "obsessed by an ideal which mixes in an irritating adultery the calm solidity of a Raphael with the tricks of a *petite-maitresse*" (Baudelaire, 96). This is the limit of Ingres' imagination, the limit of his style: a narrow limit, but one within which Ingres is safely master. Delacroix is right: Ingres' work is "the complete expression of an incomplete intelligence." And yet in his happy moments Ingres' line attains to the absolute of art, elsewhere it does not even succeed in bringing together the figures in his pictures, but loses itself in infinite molecular preciosities. And then the details interfere with that same vision of the whole to which, in theory, he attributed so great an importance. If we keep before us the morbid character of Ingres' imagination, his ending in *l'art pour l'art* will be more easily understood. His sensual impulse towards nature gave Ingres the opportunity for a few masterpieces, especially in drawing. That is to say, certain images sensually contemplated were actually transformed into art. But frequently, and more or less in all his compositions, that sensual impulse, instead of being metamorphosed into imaginative contemplation, was caught up and crystallised in the name of a particular concept of form accepted as dogma. The sensual impulse, however, was frozen at the very moment when it was most exasperated.

The dogma, all the more dangerous the less it was hampered by a natural strength of intelligence, stamped upon it an empty form and an erotic intention. The classicist *repression* of his romanticism found an outlet in the erotic raving of art for art's sake. The plastic form, rather than representing a natural sensibility, became the symbol, idolised for its own sake, of an impotent torment. Is it for this reason possibly that the cubists are so favourable to Ingres?

Composition by surfaces was preferred by Ingres, as a necessity of his art; in order to harmonise the accentuated line of the contour with the form, the latter must be imagined as a whole of "flat planes with rondures." This is the method, for instance, of the Egyptian bas-reliefs, which gives us the feeling of the plastic material better than do any Greek or Italian bas-relief. But for a bas-relief painted by Ingres to take on the beauty of an Egyptian bas-relief, it was necessary for Ingres to return to the elementary and material conception of the Egyptians, not only giving up all perspective, but all the effects of light and shade which the art of almost three thousand years had evolved. Now, with all his desire for isolation, Ingres could not go back to a taste so remote in time. Hence the compromise, hence the frequent contradictions. He himself criticised Amaury Duval: "It's a little flat. It lacks half-tints. I have made pictures like that. Now I 'sculp' it" (82). In this very transition from the "flat planes" to the "round ones" there was a possibility for great discoveries, as there was also for blunders because of incoherence.

The "flat planes" offer favourable terrain to the laying on of colour as Ingres conceived it. "The essential parts of colour are not in the entirety of the clear or black masses of the pic-

ture; they are rather in the particular distinction of the tone of each object" (Delaborde, 133). It was impossible to reject more clearly the whole colour-tradition from Giorgione on, the entire experience of colour-*values*. But, for Ingres, this was consistency. To the materiality of the plastic plane, there had to correspond a colour reduced to a tint. "The drawing includes everything, except the tint" (Delaborde, 123). "The colour, the animal part of art" (*Notebook* IX, fol. 53). Ingres knew perfectly well that the vision of the colourists was irreconcilable with that of the linearists. "You cannot demand of the same man contradictory qualities, and the rapidity of execution required by colour, if it is to preserve all its prestige, does not go with the profound study required by the great purity of forms" (*Notebook* IX, fol. 59). Therefore Ingres' chromatic strength consists either of half-tints or of the juxtaposition of coloured zones, harmonised with one another without any suggestion of light and shade.

Nevertheless, Ingres was incapable of complete abstraction from light and shade, and indeed often strove to atone for his indifference towards colour by the multiplicity of striking tints, glaring and excessive, and in consequence disastrously discordant. In these cases "his colour transforms his draughtsmanship. The falsity of the tones struggles against the correctness of the lines, the persons advance or recede contrary to what is natural, and the spectator shrinks perforce from the improbable representation" (Silvestre, 25). It is therefore quite impossible for me to explain how a painter, Blanche, can have written that "Terburg, VerMeer van Delft, Giorgione, Titian, in short all the most prodigious 'virtuosi', have been excelled by the raphaelising J. B. Ingres" (195). This

seems to me an instance of strange blindness, which in no way vitiates universal experience. Ingres succeeded in finding his own consistency of style, by adopting colours as tints, as material facts; he understood that colour might be a spiritual fact, but he rejected it as antithetic to his line and to his form of "flat planes."

In the rooms of the Museum of Montauban, which contain innumerable drawings by Ingres, you receive a clearer impression than elsewhere of the artist's personality, of his weaknesses, of his anguish, of his greatness.

In general, the projects, the drawings for an ensemble, are the weakest; abstract, void of life. When he is drawing for a work of art, he is very careful, but he does not feel emotion, and communicates none. When he imagines a primitivist motive, he loses all energy of execution: for instance, in the "Paolo and Francesca" (Lapauze III, 115). When he exceeds in the precision of line he takes delight in details, overcharges the image with ornaments, in a real perfection of bad taste: see the drawing of Monseigneur de Latil (Lapauze II, 84). Purity of line is often for him a motive for abstraction: the line becomes so pure that it ends by having no content at all. Sometimes, on the contrary, he breaks the line to the point of making it pictorial, in order to reproduce light and shade, and reflections of satins (Lapauze II, 69): but it is a steely pictorial, because of a lack of the requisite airiness and "esprit". There are, however, intermediate moments. The contour is then no longer abstract but reveals a body with volume, and adheres to the body like an integument, with cold and somewhat disconcerting passion. Or else the hand grows restless,

almost as though it discovered life at some point in the contour, and yet the line, without being lost, grows delicate, to the point of becoming a tremolo of colour. In these moments there reveal themselves a sincerity, a superiority to theories, a natural facility, that recall Raphael, and sometimes even a titianising Raphael. Then Ingres' drawings become incredible masterpieces. These are generally studies from the nude (for instance Lapauze I, 37; II, 111; III, 140; III, 149). But sometimes they are also studies for portraits (I, 43), studies of hands (I, 18; III, 118), even studies of textiles (II, 112). If Ingres, before 1806, showed, in his drawings, only diligence and energy, already in his first Roman period (1806–1820) he had reached the fullness of his style, indeed the highest level of his art. And from that time on the masterpieces become more and more frequent, along with his numerous studies void of artistic value. A particularly felicitous series is that of the drawings for the *Golden Age* (1843–1848).

A study for "Ruggiero Liberating Angelica" (Fig. 48) is full of grace, of a somewhat feminine sensibility, but so exquisite that it completely vanquishes. This grace is spiritual tenderness. Theories, controversies, defiant isolation: all that is far away. Ingres creates, with caresses to the contours, and knows when to stop, omits the continuation of the lance or of the left leg, elements which would trouble the perfect balance of line. Nothing, alas, of all this beauty remains in the Louvre picture (1819. Fig. 49). Notice how, in the picture, Ruggiero's face loses even its expression of attention, because it is too formally set; notice also how the right hand is awkwardly deformed, in order to give a greater plastic vigour to the back, and loses its function of grasping the lance, a function which,

in the drawing, it fulfilled to perfection. These two elements are enough to show that the magnificent form of the drawing has, in the picture, become abstract formalism. The particulars, besides, of the armour, the wing, the fluttering mantle, which confound and disconnect the figure, are the result of a desire to over-do. And for the same reason the dragon's head becomes a carnival mask. Moreover, as a homage to romanticism, with the horror of the rocks and the black colours and the foam of the sea, Ingres wishes to instill terror, without perceiving that these effects of light and shade clash with his conception of form. Instead of wrapping the figures in a dramatic atmosphere, these effects isolate the nude body of Angelica and petrify it.

Since any development in Ingres' style scarcely exists at all, we may jump from 1819 to 1863 and attempt, without making necessary a change of terms, a similar comparison. Compare, for instance, a study for the "Bain Turc" (Fig. 50) with the finished picture (Louvre: Fig. 51). I shall barely call attention to the spontaneous, sleepy abandon, so well realised in the drawing, and quite gone in the painting, but prefer to dwell on the formal values. The outlines of the drawing are hazy, and that haziness perfectly expresses the delicacy of the artist's contemplation, which feels and reveals the *morbidezza* of this naked flesh. In the picture, on the contrary, the same figure, because of the precision of outline, becomes an object, detached from the artist's spirit, an object that has been manufactured and consequently is devoid of life. Here you have a desire to be lascivious, whereas in the drawing there is only the warmth of a sensual contemplation. But there is more than that. Even from the point of view of plastic representation, the superior-

ity of the drawing is evident. The right arm, which descends along the flank, closes the image, renders it compact, and makes natural the fore-shortened pose; the left arm protrudes in order to throw the head back and to make it appear on the same plane, which undulates down as far as the knee. In the picture, on the other hand, the right arm raised over the head, to isolate the outline of the torso, and the left arm sunk into the cushion, to bring the face forwards, give to the image a quality of contortion, of artificial exhibition.

To be sure, if "Ruggiero Liberating Angelica" is an absolute failure, the "Bain Turc" is one of Ingres' happiest pictures. All these naked bodies constitute a general neutral tone in which the brief zones of blue, red and yellow mingle like gems, faintly veiled and agreeably harmonised. And in the presentation of so many beauties of form, Ingres succeeds in overcoming his inclination towards sensualism, and confers upon it a legendary value.

Of all the nudes painted by Ingres under the name of "Bathers", "Odalisque", "The Source", *etc.,* that known as "The Bather of Valpinçon" is certainly the best (Louvre: Fig. 54). It was painted in 1808, when Ingres was twenty-eight and the contemplation of the beautiful back of a woman moved him sufficiently to prevent any exaggeration technically. So there is an undulation of half-lights and penumbras on the bather's back which is wonderfully delicate and graceful. And even the colouring, though elementary, is not without charm: the green curtain, the soft wood-like yellow of the body, the white of the sheet, the white and red of the kerchief, are spread over the same plane, harmonised like an intarsia. And if the greys of the wall, which seems to recede into the distance, seek to escape

93

from the chromatic accord of the foreground, they none the less do not disturb it. There is an uncertain equilibrium of colour, which is absent later, for instance in the "Grande Odalisque" of 1814 (Louvre: Fig. 52), in which the intense blue and the yellow of the background clash with the chiaroscuro and the pink of the body. Incidentally, the form too has lost a good deal of its sensibility, and has become a sort of fire-works of abstract beauty. Similarly, the weakness of "The Source" lies precisely in the realism of the background, which accentuates the mannered abstraction of the form of the nude.

"Jupiter and Thetis" of 1811 (Museum of Aix-en-Provence: Fig. 53) may well serve to indicate the value and the limitations of a composition by Ingres. Take away the figure of Thetis and there remains merely an academic picture of extreme rigour in the realisation of detail. The rigour of the theory and the exceptional facility of drawing coincide: but from such a coincidence as this, art is not born. Fortunately, there is the figure of Thetis. The mannerism is evident, the colouring has no value and yet, in laying down those "flat planes with rondure" of the body of Thetis, Ingres experienced an emotion. Not only the arms but the entire body is extended like a caress; it is the physical symbol of a no longer sensual but aesthetic surrender.

A kindred critical problem is offered in the "Stratonice", which Ingres painted twice, in 1840 (Museum of Chantilly) and in 1866 (Museum of Montpellier). I give the version of 1866 (Fig. 56); it strikes me as better because the details are fewer and the composition is more on the surface, which is an advantage in the case of Ingres. The version of 1840 won a great success, for the historical fidelity of the appurtenances,

the truth of the expressions, the perfection of the drapery and the 'virginity' of the tones. George Sand insinuated: "Charming, but of a bizarre silliness." In both versions there are really exquisite individual tonalities, but the neutral grey of the whole does not raise these tonalities to potency of colour. For the same reason the archaeological details interfere with a vision of the totality, and the gesture of the psychologist-physician is of a melodramatic "fidelity." But by good luck there is Stratonice. With her extremely bright flesh, her sky-blue cloak over a white shift, Stratonice is one of Ingres' most felicitous images, in which the mannerism is imperceptibly transformed into an undulation of beauty and the silliness into the creative naïveté of a dream.

Ingres' religious pictures are among his ugliest productions, for the very reason that in them he pretends to a religious sentiment of which he was utterly devoid, and which he confounded with the worst of ecclesiastical rhetoric. And, in the same way, the famous "Apotheosis of Homer" is another failure—and his contemporaries were aware of it— because it shows how ignorant Ingres was, how incapable of even approximately conceiving the poetry of antiquity, how he confused it with a series of examples out of a school-book. On the other hand, he was very familiar with the Sistine Chapel and with the ceremonies that were held there. So that when in 1820 he painted "The Sistine Chapel" (Louvre: Fig. 55), he created an agreeable *genre*-picture. His prejudice concerning classical beauty had no opportunity here for making itself felt. The faces and robes of the prelates were unable to serve as ideal forms. On the other hand, the human figures are reduced to slight dimensions, to the size of little spots. The

colours are warm and pleasant, even if their harmony is indifferent. That is to say, in this picture Ingres wished only to accomplish an objective delineation of an ecclesiastical ceremony. It had for him no emotional content, and so the scene is just as accurate and correct as it is indifferent.

In spite, therefore, of his aspiration to be the painter *par excellence* of "history in the grand manner", Ingres' compositions become works of art wholly, or in part, only when he has been able to make an idol of a female image, naked or clothed.

Even Ingres' adversaries admitted the beauty of his portraits. That of M. Bertin is certainly his most popular work. In times of financial difficulty he managed to scrape along by drawing portraits. And the appreciation of his portrait-drawings has increased with time. Beyond a doubt, the greater part of them are exceptional creations: pure, precise, sure, perfect in their way.

I reproduce that of two English girls—"The Montague Sisters"—(Fig. 57: Earl of Sandwich, Hinchingbrooke, 1815). It is truly marvellous how Ingres has succeeded in harmonising the individual character of the faces with the purity of classical beauty, how he has been able to take advantage of the picturesque dresses to give life to the whole, and to carry to an extreme the refinement and finish of line without falling into pedantry. In short, the perfection of the execution is overwhelming. And there is even, in this love of perfect execution, a certain ingenuousness on the part of the craftsman which lifts itself all unawares to the level of art. After having said this, however, I beg you to compare this double portrait with the study for "Ruggiero" and with that for the "Bain Turc".

You will notice that they belong to an art that is purer and more spontaneous. In them Ingres does not need, in order to attain to art, to pass through the perfection of the craftsman. "The Montague Sisters" is a work of art, of a kind of art that in a certain sense has been rendered frigid by the perfection of the craftsman. Ruskin, à propos of primitives, Chesneau à propos of Ingres, both protested against this pretension to perfection in art. "Imperfection is a providential law without which the world would long ago have come to an end. . . . Let us admit for an instant that no protest is raised: the absolute beauty of each form has at last been discovered: what will be the consequences of this happy discovery? Being inevitable, they are easy to deduce: immediately, art is immobilised" (Chesneau, 274).

When Ingres painted portraits, the certainty of his line diminished because he had, to a certain degree, to struggle with colour, which he despised. And from that struggle sprang a more complex artistic life.

The "Portrait of Madame Rivière" (Louvre, 1805: Fig. 59) is certainly one of his masterpieces, even as regards colouring. The flat opaque tints are harmonised as in a mosaic, the forms are displayed as though to receive them and at the same time finely suggest a relief without shadows. The flesh and the drapery are of white ivory and constitute the zone of light, whereas the blue of the chaise-longue constitutes the zone of shadow. Both are, as it were, let into the black background. These three tones are sufficient for the general effect which is unchanged by a few variants of red and yellow. Individuality of life and simplicity of expression, wisdom and naïveté, contribute to the exceptional effect of grace.

The "Portrait of Granet" (Museum of Aix-en-Provence: Fig. 58) and the "Portrait of Madame Devauçay" (Chantilly Museum: Fig. 60) both date from 1807. Ingres has only recently come to Rome, in the fullness of his youth and creative energy. Their formal quality in no way detracts from the individualising energy of the portrait. And the tones, reds or yellows or blacks, contribute by the force of their contrasts to the liveliness of the representation. Later on, Ingres painted more complex portraits. He never painted more beautiful ones.

The "Portrait of M. Bertin", the founder of the *Journal de Débats* (Louvre: Fig. 62), was painted in 1832 after various poses had been sketched, one of which is preserved in the Montauban Museum (Fig. 61). As soon as it was seen, the picture was at once recognised as a masterpiece, and since then it has become popular. Gautier, for instance, exalted it as "the physical portrait, the moral portrait '. . . the revelation of a whole epoch . . . the authority of intelligence, wealth and a justified confidence in oneself. . . . Such as he is, he is the *honnête homme* under Louis-Philippe" (1855, 164). And all this, and a great deal more besides, can certainly be found in it, carried out with undeniable finish or, rather, perfection. In the drawing there is more spontaneity. The everyday aspect of the man is perhaps better caught. In the picture, by sheer force of engraving and underlining, there appears a personality supremely capable, and capable, precisely, of revealing to us the spirit of an epoch. It is true that the motive is merged in the individual so completely that it is difficult to distinguish them. And yet it exists. And it explains the effectiveness of the work as a plastic model of history. The character of Bertin and of the period of Louis-Philippe thrusts itself upon the

98

observer with exceptional liveliness, but it is an intentional liveliness, an imposition, an act of power which accompanies the work of art and tyrannises over it in order to dominate it by force. The colours in no wise disturb the form, because they are neutral and because they harmonise with the contrast between the dark image and its light background.

The importance of the portrait of Bertin consists of this, that, in connection with it, it is quite impossible to speak of art for art's sake. The form is not empty, indeed it contains nothing less than the meaning of a whole period! But just that is Ingres' destiny. Save for the exceptions we have indicated, he either falls short of or transcends the work of art. His image can be either an empty symbol or the symbol of a world; but it is not the free realisation of an individual imagination.

Last of all, the "Portrait of Madame d'Haussonville" (Collection of Comte d'Haussonville, 1845: Fig. 63) is one of the best instances of Ingres' later taste as an apostle of grace, a lover of elegant detail, the whole thing being somewhat affected. But the execution is so prodigious that one's critical doubts fade away.

Numerous are the portraits by Ingres that deserve comment and appreciation. But those already mentioned may suffice to convey an idea of Ingres' qualities and limitations in his best pictorial moments.

We admire Ingres as a prodigy, but we do not love him as we love a great poet or a great painter. We admire his superhuman efforts, but we do not hear him utter one word of humanity. His is the typical case of a form deliberately classical superimposed on a tendentiously romantic content, with-

out the form and the content being ever completely fused. Nor
do we know whether to attribute the fault of this lack of fu-
sion, this lack of synthesis, to the absurdity of his aesthetic
principles or to the flabbiness of his moral temperament.

Chapter Five

DELACROIX

AVID achieved a revolution in painting by a return to the ancients, the Greeks and the Romans; Ingres by a return to the Middle Ages tempered by the ancients and by Raphael. Delacroix achieved his revolution without returning to any past. He drew his inspiration from Rubens and from other painters of a baroque taste, but to say that his style is baroque would be an error: the error, namely, of confusing a secondary element with the whole. David and Ingres, in order to justify their personal style, refer back to their real masters. Delacroix justifies himself in the name of his personal passion. David is a man of politics, but when he paints he is first and foremost the leader of a school. Ingres creates a dissident school. Delacroix, isolated as a man, takes part in full as an artist in the stream of contemporary passions, and, at least in his youth, is identified with them. Born in 1798, he belongs to the same generation as Lamartine, Balzac, Hugo, de Vigny. Educated by the Revolution, all these men share a revolutionary mysticism; they cannot tolerate a neo-classical form for their romantic passion, they need a new form, a "modern" form. "To call oneself a romantic and to be constantly concerned with the past is a self-contradiction" (Baudelaire, I, 8). Delacroix, as a critic, can afford the luxury

of exalting the ancients and Raphael, so immune is he from a taste for them. The romantic character of Ingres' painting is peripheral to romanticism. At the centre, the most typical romantic painter, and the noblest and greatest, is beyond a doubt Delacroix.

In order to understand what the romantic in pictorial taste is, we must first of all go back to the theory of reason as the arbiter of art. This was a theory that derived from seventeenth-century Rome, from Bellori, and which first became "scientific" with the neo-classicism of Mengs and Winckelmann. It renounced whatever art owes to sensibility; and inasmuch as the science of the plastic form was well known and was called geometry and perspective, whereas the science of colour was very little known and wandered in uncertainty, it sacrificed colour to plastic form; and inasmuch as it believed that Greek sculpture, known by way of Roman copies, represented a unique, eternal, perfect beauty, the tradition of modern painting was sacrificed to the models of ancient sculpture. To overthrow these conceptions was the task of romantic painting: it freed sensibility from the true or presumptive "laws" of reason, endeavoured to feel and thus to grasp all that escaped a rational knowledge, tried to raise the veil of mystery, made use of dreams, did not hesitate to give free vent to the imagination, and its myths were no longer pseudo-concepts, they were myths of feeling. In the place of stasis it put movement, to the too-finite it opposed an infinite which often became vague. To an art too rigorously objective, it opposed an exasperated subjectivity; to the solid, atmospheric effect; to things, effects of light; to a perfection ever equal to itself, eternal change. Colour once more took up the task of directing painting, absorbed

into itself plastic form, and rejected the models offered by sculpture. Reality, no longer permitted a choice between the beautiful and the ugly, was absorbed in its entirety as the substance of art, with its infinite variety, with its passions and contingencies, freed henceforth from the fetters of the classical "law."

In short, romanticism was above all an act of faith in the power of sensibility and imagination to create art. If by genius we intend the creative aspect of a work of art, and by taste the *fren dell' arte**, we may well say that the confidence of romanticism in genius created a new taste, as opposed to the old traditional bridle of art. For this reason, instead of looking to the past, it created the conditions for an art to come.

If this be romanticism in painting, it is personified in Delacroix. As early as 1824 he wrote: "I think that it is imagination alone, or else, which amounts to the same thing, this delicacy of the organs, which makes one man see where others do not." For him, the task of the artist was to "draw from his imagination the means to render nature and natural effects, and to render them according to one's own temperament."— "A handful of naïve inspiration is preferable to everything else."—"The finest works of art are those which express the pure fantasy of the artist."

All this was said in opposition to the theory and practice of David. Today, of course, we realise that David's system was not as rigid as it was then believed to be and, above all, that David's contemporaries did not submit to his yoke without a murmur.

It will suffice if I recall Prud'hon and his taste for very in-

* The bridle of art.

tense shadows, for moonlight effects, for a pre-romantic senti-
mentality. As early as 1807 the painter Taillasson had pub-
lished a critique of David's school, which he took to task for
its coldness, its pretentiousness, its abstract correctness, where-
as he praised the realism and the vitality of Jordaens, the
Venetians and of Watteau.

David's favourite disciple, Gros, paid much more attention
to the question of colouring than his master had. It is true that
the intenser Gros' colours were, the less they harmonised. And
yet they were capable of producing a warm atmosphere, one
suggestive of passion. And in the "Napoleon at Eylau," painted
in 1808, Gros succeeded in creating a composition with unity
of light and shade, a dark crowd of people against the snowy
light of the background. It was this type of composition that
inspired Delacroix in his "Massacre of Chios."*

More audacious and genial than Gros was certainly Géri-
cault, who died in 1824 at the early age of thirty-three. He
knew how to combine Gros' theoretical impetuosity with
great formal certitude, an exceptional grasp of reality, and a
rough energy in the movement of figures and groups. Under
the influence of Bonington and other English painters he also,
in the last years of his life, learnt how to harmonise his colours,
tone on tone, in brown. Many of his studies from the life are
really excellent. His principal work, the "Raft of the Medusa"
(1819: Fig. 64), is important because of its controversial
intention (directed against the government of the Restora-
tion), the effectiveness of its dramatic rhetoric (which is meant
to convey the surge of passion), and the expressive energy of

* Known erroneously as the "Massacre of Scio"; this old-fashioned alternative
spelling for "Chios" being quite obsolete, we can see no reason for perpetuating
it in the title of this picture.

each figure. The choice of a realistic subject and the vigour of his images prove that he was approaching realism—that is, he directed his romantic afflatus towards the conquest of reality. But, of late, the importance of Géricault has been greatly exaggerated. He was a magnificent promise, neither more nor less. Thoré was right when he observed that in the "Raft of the Medusa" Géricault had too minutely delineated "the violent physiognomies and the clenched hands", without conveying the sensation of the implacable sea—that is, of the totality of the tragedy (1847: p. 78).

To Gros, as to Géricault, Delacroix offered his admiration. To Gros he dedicated an article, in 1848. "Gros has elevated modern subjects to the level of the ideal . . . he has seen his heroes through the lens of his enthusiasm."—"The most general characteristic of genius is its temerity and its confidence in the strength of its conceptions." In spite of the defects derived from David's school, "he owed only to himself the strong and original qualities that place him at the head of our school of painting" (Delacroix, *Works,* II, 163 *et seq.*). As for Géricault, Delacroix has recorded that "although he received me with familiarity, the difference in age and my admiration for him placed me, with regard to him, in the position of a respectful pupil." His enthusiasm for the "Medusa" was immense. And it is not a mere chance that Delacroix's first great work was "The Bark of Dante" (Fig. 65).

The art of Goya too was particularly present to Delacroix's mind. In 1824 he planned a series of lithographs on *Don Quixote,* as "polemic caricatures in the genre of Goya". In 1832, describing his arrival in Tangiers, he concluded: "All Goya breathed around me." And the "Executions of the Third

of May" suggested the crude contrasts of light and shade in the "Twenty-eighth of July". If to this we add his friendship with Bonington, and the influence of the latter both for harmony of colour, and for the manner of interpreting historical scenes, and lastly the influence of Constable, especially his way of drawing from brush-touches and from the thick and rough impasto of the colour a greater intensity and richness of light, it will be evident that the "revolt" of Delacroix was based on an abundant tradition. This tradition was by some praised to the skies, and detested by others. When Delacroix, in 1822, at the age of twenty-four, exhibited his first picture—"The Bark of Dante"—Thiers at once recognised a "great painter", of a "dawning superiority which re-enlivens our hopes somewhat discouraged by the over-moderate merit of all the rest" (Gautier, *Hist. d. rom.* 210).

Praises to which Delécluze, faithful to David, countered with the opinion that the picture was nothing better than a *tartouillade*, a daub. This clash of opinions lasted all through Delacroix's life, and even after his death, as though to crystallise the revolutionary aspect of his art.

The conflict was between the ancient and the modern, between the ideal and the real, between form and colour. David Gros and Géricault were all on their way towards realism. But like Ingres, Delacroix was not satisfied with realism, in fact he was its convinced opponent.

In 1832 he visited Morocco, and it was a revelation to him. "These people have nothing but a blanket . . . and yet they look just as content as Cicero must have been with his curule chair. . . . Antiquity has nothing more beautiful. . . . The Greeks and the Romans are there, ready to my hand. I have

had a good laugh at the Greeks of David" (Escholier, II, 5–7). Delacroix's entire style was modified by this vision. The moral expression of energy and of human dignity was useful to the artist and helped him to achieve a deeper formal construction. It was a true stroke of genius bringing the ideal of antiquity back into everyday reality, even if that reality was exotic. And yet even in this discovery lay a hidden danger, the danger of exaggeration in making the pictorial over-coincide with the picturesque. And in fact it sometimes did happen that Delacroix did not sufficiently absorb the natural detail in a coherent pictorial style. Even when he treated classical subjects, the classical dignity that he had learnt in Morocco was expressed in a parade of picturesque details that were useless and consequently harmful. That is, the realistic Orient took the place of the ancient statues, not only as life properly taking the place of the academic, but also as something picturesque seeping into art.

The recognition, however, of a classical value in the living Arabs strengthened in Delacroix his liberation from the prejudice of the beautiful. "When Rembrandt created the portrait of a beggar in rags, he obeyed the same laws of taste as did Phidias when he modelled his Zeus" (Delacroix, *Œuvres litt.*, I, 33). And it was precisely this freedom from the prejudice of the beautiful that annoyed the French public and many critics, who accused him, for instance, of painting with a "drunken broom", of drawing with the irresolute hand of a sleep-walker. Against them he would roar: "The ugly, the sovereign-ugly, these are our conventions and our petty arrangements of grand and sublime nature" (Michel, 99). Unfortunately, even the critics most favourable to him, such as

Baudelaire and Chesneau, who defended him by praising the "sorrowful, sick and modern" beauty of Delacroix's women, or citing the examples of Shakespeare and Michelangelo, were not altogether conscious of the independence of art from what is customarily considered beautiful.

Delacroix himself set up nature against abstract beauty, but he required that nature to be "grand and sublime". In realism, he saw only an imitation, not an ideal interpretation of nature. "Eh! cursed realist, do you imagine, by any chance, that you can produce an illusion in me?" (Delacroix, *Œuvres litt.,* I, 59). This was lack of courage: he needed an ideal, and he sought for the ideal outside of reality. The need for drama, for convulsions, for heroic monumentality at all costs, for subjects interesting in themselves, the intrusion of literature into art, the reduction of history to the anecdotal, all the negative sides of Delacroix's painting come from his lack of courage in laying siege to the whole of reality.

Various influences pushed Delacroix towards the choice of dramatic moments as those most adapted to his painting. In Michelangelo, as opposed to the serenity of a Raphael, he felt the character of a Titan in revolt. In Dante and Shakespeare he sought inspiration for representing the horror of death. He illustrated *Faust,* and Goethe honoured him with the assurance of his appreciation. He took pleasure in the thought of Byron as a torrent of Molochism, of savage cruelty. Among contemporary events, he preferred to choose his subjects from disasters and revolutions. In the Orient he chose the ferocity of struggle or the sensual atmosphere of the harem. He took an interest in tigers, lions, in the unbridled fury of horses. In short, Delacroix carried with him the whole luggage of the

romantics, including a good deal of trash that tended to estrange him from art.

His thirst for spiritual values to be infused into painting led him to underestimate pictorial realisation. "The merit of a picture is indefinable: it is precisely that which escapes precision: in a word, it is what the soul has added to colour and line in order to reach the soul. Line, colour, in their precise significance, are the gross words of a gross canvas" (*Journal,* II, 402). Here is evident an exaggeration in reducing to pure symbol that which is on the contrary the reality of a work of art, and hence follows the excessive importance given to the imagination.

At times it almost seems as though Delacroix did not distinguish between imagination and feeling. In 1818 he wrote: "In life we preserve the memory of those feelings only that move us; all the rest becomes less even than what has actually occurred, because nothing any longer lends it colour in our imagination." Or else: the memory of a father's death is "immortal in your imagination" (*Correspondance,* I, 19–20 and 62). This way of looking at things led to a more corporeal imagination, more superficial feeling. His yearning for solitude, on the other hand, seems to have favoured the development of his imagination: "Solitude is far from weighing on me as much as does the cold rain of common-places that greet you in every salon. . . . As it is my imagination that peoples my solitude, I chose my company" (*Correspondance,* II, 60).

Such circumstances, even if they were sometimes favourable to art, contributed to a confusion between the literary subject and the pictorial theme. Delacroix believes "that it is better to sacrifice everything to convention and to the actual expres-

sion of the subject."—"It is an obligation, for a painter, to dispense with a model."—"The living model never exactly renders the idea of the figure that one wishes to represent: it is either paltry or incomplete or of a beauty so different and superior that one is tempted to change everything" (*De Planet*, 35, 36, 49). To the beauty suggested by the model Delacroix preferred the painting of stories. This is no cause for astonishment, because in fact, in romanticism, the story predominates. But in a picture a story is an obstacle to free painting. Even in Delacroix's entourage this danger was noted, and sometimes also the importance mistakenly attributed to the subject. "It is easier to find a subject for a scene well-arranged after nature, than to arrange the scene of a subject found in a book. The proof of this is that there is never any title behind the pictures of the ancients, and that one can usually find two subjects in them rather than one. It is deeds, actions that should be represented, not stories" (Madame Cavé, 77 and 83). And in spite of his admiration for Delacroix, Thoré notes: "The greatest men in the republic of art take as subject for their creation only what is common property . . . The subject is of absolute indifference in the arts" (Thoré, 1847, 64).

It was quite natural, moreover, that the romantic subject should influence the treatment of the historical painting, in which history was debased to a series of anecdotes. Painters "paid more attention to Hamlet's cloak than to his terrible mission" (Rosenthal, 177). The anecdote, that is, has, in historical painting, the function of the picturesque as opposed to the pictorial, not only because it accentuates the particulars as against the whole, but also because it is a patchwork of naturalistic themes, interesting in themselves but not because

they have been absorbed and transformed by the imagination. All this, which was the fundamental defect of romantic painting, is barely observable in Delacroix. He is transported by his imaginative flight beyond the limits of any romantic subject whatsoever. And, on the other hand, we cannot avoid admitting that the immersion of painting, as carried out by Delacroix, in the world of historical, literary and musical culture, was helpful as an antidote to the art-for-art's-sake idea. We have already seen to what aridity specialisation in the category of beauty, so much vaunted by Ingres, led. Nevertheless during the last years of his life, when Delacroix re-elaborated his old subjects, towards which he had become absolutely indifferent, as simple pretexts for painting, he did not fall into art for art's sake. That "pretext" was sufficient to give echo to a world of sentiments, fancies and vital experiences, and the art to which it gave rise was consequently the imaginative expression of a content, not the scholastic and presumptuous abstraction of *l'art pour l'art*.

"If one understands by my romanticism the free manifestation of my personal impressions, my antipathy to the types invariably copied in the schools, and my repugnance towards academic recipes, I must avow that I am a romantic" (Silvestre, p. 61 of the old edition). With these words Delacroix stressed the essence of his art: liberty.

The impression of liberty that sprang from Delacroix's painting was fully felt by his contemporaries. As early as 1824, à propos of the "Massacre of Chios", the *Globe* said: "Art should be free, and free in the most unlimited fashion." Consequences of this new consciousness of artistic liberty were the recognition of individuality in art, and the independence

asserted by the artist towards the so-called "laws of art" and towards nature itself. In the *Album National* of 1829 one can read: "It is well-recognised that in the century at which we have arrived the first condition of any kind of talent in no matter which art, should be, not, as they claim, originality, but in truth individuality" (Rosenthal, 107). The distinction was a happy one. Originality so-called is an abstraction from the tradition and the taste of the time, an act of controversy, of an intellectualist character. But individuality is at the same time creative and created, it arises from the spiritual desires of all and dominates them and leads them towards new tendencies. The work of artistic individuality is subjective, but not arbitrary, not detached from the world; it is necessary because it partakes of the universe. The theory of art as creative imagination corresponded exactly to this need for individuality, for unlimited freedom. And artists like Delacroix were thereby encouraged to reject any limitation derived from the imitation of ancient statues. As we have seen, liberals in politics and civil life had, for a long time, been denying, in the name of a classical ideal, all liberty to artists. Their error lay in not seeing that artistic liberty, just as much as political liberty, is a religion. The liberated artists' spiritual impulse was unable to respond to a form established before that liberation had yet been achieved. Instead therefore of seeking a classical form for a romantic content, it was necessary to discover the new form of the new content.

And since, through a pure chance, such as that of the conservation of Greek statues rather than paintings, the artistic form of painting had always been regarded as a plastic form, it was now superseded by a pictorial form which became a

condition of art to the same degree as had the plastic form
before it. And since human beauty had always been judged
according to certain proportions conceived for the plastic form,
the principle of the relativity of the beautiful was created. And
since the new consciousness of the unity of the arts invited
the imagination of painters to participate in poetry and music,
(and the latter, music, dominated the taste of the age), the
dream of Delacroix as a painter was to free painting from
what he considered the too-material element of the plastic
form in order to permit the harmonies of colour to compete
with the "peerless nuances" of music.

Out of these circumstances and aspirations what we call
form-colour issues completely renewed.

The public was flabbergasted when it no longer found in
Delacroix's work the "formal correctness" of the school of
David. Théophile Gautier affirmed that Delacroix's drawing
"is extremely skilful in spite of visible inaccuracies which the
veriest tyro can point out." Amiable contradiction: the draw-
ing is at the same time skilful and inaccurate. Few had the
wit of Ricourt, who answered the malicious question as to
what one saw, the breast or the back of the figure, in "The
Taking of Constantinople by the Crusaders": "Neither the
one nor the other, you see painting" (Gigoux, 72). Victor
Hugo tells how, when he asked what a certain figure of Dela-
croix's held in its hand, the latter answered: "I wanted to
paint the lightning-flash of a sword."—"Now, [says Hugo]
painting the lightning-flash of a sword without a sword, that
is no longer his art, but ours" (Tourneaux, 34). So we see that
Hugo was familiar with the "boundaries" of the arts as set
forth by Lessing, and since his day repeated a thousand times,

all the more proudly, the less they have succeeded in convincing anyone. The fact is that even to-day many people worry about these boundaries", but they are people who don't count. Delacroix was intent on expression. He confessed to his pupil Lassalle-Bordes: "If I tried to make corrections, I should lose a part of my harmony and movement; the important thing is not so much the finish of a foot or hand, as the expression of a figure through movement . . . A hand, indeed—but a hand must speak like a face" (Escholier, III, 7). And yet before coming to such a decisive solution, Delacroix was tormented by the alternative: should one above all study outlines, or draw intuitively and impulsively? (*Journal,* I, 82; III, 427). Even in Raphael, fortunately, there are inaccuracies to be noted. And yet Raphael's linear harmonies are such that Delacroix is dismayed, and relegates Titian to a lower ranking (*Journal,* III, 428; I, 193, 202). This is in 1847; but ten years later he has understood: Titian is not only a great colourist, he is also the first of draughtsmen, if by draughtsmanship we mean the natural form; he is the closest to the "spirit of antiquity", even if he is remote from the external forms of the ancients. "If one were to live for one hundred and twenty years, one would prefer Titian to everything" (*Journal,* III, 57–59, 2–3). Towards the close of his life he clarifies for himself the spiritual value of technique: technique emphasises ideas and gives them worth; there is no beauty without extreme audacity; as they give up the simplicity of the ancients the moderns find new sources of beauty, "form and concept are fused".—"Go on studying untiringly; once you are at work, make mistakes **if** you must, but you must design freely" (*Journal,* III, 55, 53, 40, 41, 28; II, 447). You seem to

hear the voice of destiny pushing the reluctant Delacroix, who clings to his examples and to his culture, towards a new pictorial form.

Baudelaire understands the value of Delacroix's draughtsmanship, protests against the harsh, despotic and cruel line, affirms that the drawing should be alive and agitated like nature. And he finds this admirable definition: "The great quality in the draughtsmanship of supreme artists is verity of movement" (Baudelaire, I, 107, 25). And Silvestre echoes him, negating all antitheses: "The best draughtsmen are the greatest colourists, the greatest colourists are the best draughtsmen" (I, 18, 21, 22).

The fusion of form and concept, free and passionate execution, drawing with movement, drawing with colour, all are steps towards *pictorial unity*. For its sake Delacroix desires the sacrifice of detail. He reproaches Géricault for not having sought unity, and finds the element which binds everything together and fuses it in a general harmony to be atmosphere (*Œuvres*, I, 110; *Journal*, II, 415; III, 41).

If the aversion from Delacroix was wide-spread, it concerned his form, not his colour. Agreement as to the fact that he was a great colourist was general; at worst it was said that being a colourist was not enough for being an artist. Moreover, it is beyond dispute that he was the first French painter of the nineteenth century who forced the problem of colour on the attention of his colleagues and of the public, the first who sought the scientific laws of colour, who studied nature and discovered that the shadows of white are violet, and that two tints which neutralize each other when they are mixed reinforce each other if they are juxtaposed in such a way that

their light is fused. On the part of the most recent French painters, admiration for Delacroix's colour seems unanimous. The greatest theorist of French divisionism, Paul Signac, begins his utterances in the name of Delacroix, whom he considers the founder of the new culture of colour. The observations jotted down by Delacroix himself in his *Journal,* marking the various stages of his discoveries, and an essay by René Piot (*Revue de l'Art,* 1930, LVIII, 57) supply us with unquestionable proof of the part that Delacroix played in promoting and developing the taste for colour. In a recent exhibition of paintings by Gros and his disciples, after seeing such colours as cried to Heaven for vengeance or were entirely indifferent, the "Massacre of Chios" was a revelation. Its colouring is of an intense vitality, and this intensity finds a higher harmony in the distribution of the zones of light and shade.

And yet when we observe the greater part of Delacroix's works after the "Massacre of Chios", we perceive that the colouring is indeed harmonised, but in an almost lifeless fluidity, without strength of local colour. Naturally there are exceptions, but exceptions, we know, confirm the rule. "The Stove" of the Louvre (Fig. 66) is coloured not only with a perfection of tone, but with a loving sensibility that recalls Chardin. And the fact that Delacroix gets full chromatic realisation in a still-life suggests the seriousness of the divagation or distraction caused by a romantic "subject". When Delacroix composes his scenes, his colouring is "fluid", that is, it is an excellent means for achieving an aim which lies beyond colour. Delacroix's imagination creates by means of colour; it does not create colour.

Signac, too, moreover, makes certain reservations, recog-

nising that Delacroix's paintings are less luminous and less prismatic than those of his followers, and he explains how this comes from the excessive use of "dark and earthy" tints (Signac, 40–44). Concerning the function of such tints we have the precise testimony of his pupil and collaborator, Andrieux: "Delacroix's aim was to get, by the mixture of adjacent colours, neutral tones upon which the livelier colours might be made to harmonise" (Escholier, III, 106). Now those tints which the mixture has rendered neutral bear, to the intense colours, a relationship of contrast, but not of fusion. Tiepolo, Cézanne, Matisse are true poets of the neutral tints for the very reason that they succeed with their aid in isolating and exploiting an intense colour. Delacroix's "harmony", on the contrary, produces a confused mélange of elements in which the vivid colours lose their strength. In fact, a real harmony is found to have been reached only after the vivid colours lose their strength and the light and shade are fully realised in the movement of the neutral tones. Then, "instead of placing the right colour in its place, brilliant and pure, he mingles the tints, breaks them and, using his brush as a shuttle, attempts to form a texture, the many-coloured threads of which cross and interrupt one another every instant. Delacroix called this kind of operation *flochetage*" (Villot, in Escholier, II, 274).

It is natural that this *flochetage* should have pleased the divisionists even more than it did the impressionists. The divisionists applied the law of division with scientific method: for this reason they did not get any artistic value from it. But the impressionists, amid so many divisions, did not forget to place "the right colour in the right place"; and this very thing

117

permitted them to realise, through that colour, a work of art. That is, Delacroix studied colour with incomparable intelligence; he secured, by his study, the basis for contemporary taste; but did not profit by it himself, because he was seeking his poetry outside of colour.

He drew instinctively and with passion, but used colour scientifically; for that reason he has been considered a bad draughtsman and a great colourist. Today, on the contrary, we realise that to use colour scientifically, important as it may be as an achievement of taste, as an impulse towards the art to come, was an obstacle to the free expression of the artist's personality, and needed to be swallowed up in the simple effect of light and shade. So that precisely Delacroix's form (that deformed form, free of all naturalism, and subordinating colour to itself) gave to the entire work his own unity, renewed in itself his creative impulse, was itself the imprint of his imagination, the expression of his genius.

Baudelaire and Silvestre have described Delacroix's character on the basis of an antithesis: the savage with the mask of a sceptic; passion wed to cold-blood. And although this may be true, their indication does not perhaps go to the root of the matter: this mask of a sceptic, this cold-bloodedness, is the defense of timidity. And Delacroix's timidity pervades his *Journal*. "You need much audacity to dare to be yourself" (*Journal,* III, 363, 248). His life is an aspiration towards audacity, all the intenser because he knows that his resolutions fade away when faced with action. Towards the end of his life he meditates complacently: "To be audacious when you have a past to compromise, is the greatest sign of strength" (*Journal,* III, 221). In spite of this continuous aspiration, we

do not find any acts of audacity in his life; very many, on the other hand, in his art. But the result of audacity in a timid temperament is well known: it becomes foolhardy. And all his art, except during his last years, oscillates between the intoxication of unheard-of creations and a falling-back on abhorred conventions. His always delicate health, his painful, inordinate sensibility, which gives the impression of unlimited nervous force coupled with a very weak muscular construction, his feminine tendency to caressing, insinuating, capricious manners, all this explains the oscillation between timidity and audacity. Only during his last years is this oscillation moderated. "It is rare indeed that great men are *outrés* in their works" (*Journal, III, 263*).

He is not so much passionate as he is "passionately in love with passion". He sincerely aspires to a religious conception of the world, without having, however, any religious sentiment. Inasmuch as he expresses amazement and sorrow, Delacroix, after a fashion, interprets the ideals of his age. Except that, without being a misanthrope, like Ingres, he is too jealous of his own liberty; he falls back too much on himself to be able to abandon himself to the life that is stirring about him. Thus he personifies the worth of the eternal aspirations in which humanity can sublimate itself. But the ideal is so lofty, and the forces at his disposal are so uncertain, that realisation is, perforce, intermittent and limited.

"The Bark of Dante" (1822: Fig. 65), the work which first drew attention to Delacroix, contains in germ his entire style. And as an affirmation of novelty it is tremendous. Shadow has been replaced by light as the protagonist of expression, not

only to illustrate the subject, but above all to answer to the desire for colour. If you compare it with the "Raft of the Medusa", in which the forms are drawn in accordance with tradition, though they are darkly tinted and violent in movement, "The Bark of Dante" appears as a harmony of light and shade, juxtaposed on one plane and created in colour. All the nude dead tend, with their contortions, towards a pictorial form. And in the nude stretched out in the foreground the face is perfectly pictorial, the livid tone is tinged with red, and the touches in contrast make the form lose its roundness.

"Scenes from the Massacre of Chios" of 1824 (Fig. 68) is the masterpiece of Delacroix's youth. It is not the representation of a dramatic action; it is a presentation of misery and pride. You must keep this fact before you if you wish to understand the composition. It has neither a representational function nor a formal order. As an expression of misery, it is laid down on the surface with clear, intense colours, which stand out against a dark zone. And the dark spaces, in their turn, stand out against the distant light. Thus it is a chromatic composition, and as such it is complex and adequate. A few fragments of reality thrust themselves upon the observer. The wallet abandoned on the ground is realised to perfection with dense, brilliant, exquisite colour. Rarely did Delacroix feel so fully the poetry of reality, or express it with equal felicity of colour. The shadows accentuate the intensity of the colours that are in the light. And the surface, all rough from touches which have left clots of pigment, allows reflections to stress the local colour. In the old woman to the right, who is the image of despair, exceptionally energetic, the form is broken in order to be perfectly fused with the chromatic tone. In the couple

to the left, even the sunburnt flesh grows livid and opaque. In all the penumbra you divine the tonal richness. The distant background, immobile in spite of bloody reflections, echoes the passing of death. Lapses from moderation are not lacking, hence a certain theatricality, not due to the gestures, but to an excessive insistence on the exposition of the figures: too much insistence on each one of the single images, because of which the whole is less comprehensible; a sky which, with dramatic intent, over-weighs and does not allow sufficient breathing-space. However that may be, Delacroix's moral reaction to a dreadful human catastrophe, which occurred in his own time, has succeeded in impressing sincere feeling even on excesses of expression. Hence the power of the picture.

But as much cannot be said of the "Death of Sardanapalus" (1827), in which mannerism shows its cloven hoof, in the forms of the bodies, and in the colours—the pink of the bed is a tint and not a colour—and especially in the composition, which attempts to compass space in depth and succeeds only in accumulating butchery.

The full mastery of his technique urges Delacroix on to the conquest of the real. When he paints himself in 1829 (Louvre: Fig. 69), he constructs his own face solidly, with perfect anatomical knowledge and grasp of chiaroscuro. It is only upon such a formal scaffolding that he places his pictorial touches. In this way he succeeds in achieving an exceptionally realistic liveliness but a limited artistic effect.

The July revolution tears Delacroix away from the allurements of history and legend. Once more he is forced to face the dramatic reality before his eyes. And he paints "The Twenty-eighth of July, 1830" (Fig. 67). He anticipates the

Gavroche type of "Les Misérables", he anticipates a realism using strong contrasts of light and shade, which will be the realism of Courbet. Gavroche, the man with the top-hat, the man dragging himself towards Liberty, the dead man in the foreground, have a realistic effectiveness that Delacroix will never attain to again. The colours have no intensity, they are completely subordinated to light and shade, thereby greatly enhancing the total effect. Unfortunately, the allegorical figure of Liberty is a dissonance in the midst of all this realism; she is meant to be the voice of the ideal, but succeeds in being merely a kind of exalted rhetoric. In any case, Delacroix reveals in this picture his greatest contact with the life and the passions of his time. He is thirty-two years old, he is in the vanguard of romanticism and of realism, he senses his approaching triumph, he can go on his way exultant. Instead of which he draws back, wishes to absent himself, to be normalised, or else to ask of the Orient the selfsame inspiration as that which Gavroche had given him.

In 1831 he painted, in a sketch and in a picture, the scene in which Mirabeau, on June 23, 1789, apostrophised the Marquis de Dreux-Brézé, come to dismiss the States-General. The picture belongs to the Glyptothek Ny Carlsberg of Copenhagen (Fig. 71), the sketch to Dr. Viau (Fig. 70). The sketch is a masterpiece of spontaneity, vibrant, with few colours, with contrasts of light and shade which alone reveal the fury of the drama. The picture is finished with pedantic nicety; it has become dry, petty, mean, gossipy, inexpressive. Even the relation between the figures and the background has disappeared. Look at the columns: in the sketch, Delacroix reveals the *lightning-flashes*, not of swords alone, but of columns as well;

in the picture, these are degraded to that "architect's drawing" which he himself, and Baudelaire in agreement with him, detested. Before carrying out the sketch, Delacroix notes: "This emotion, which animates an entire assembly as it would animate one man, must be expressed absolutely" (*Journal*, II, 284). In the sketch, indeed, all are as one man, but in the picture they are too many, and each has his place assigned to him. In the sketch, there is the drama figuratively revealed; in the picture, the comedy mediocrely enacted.

History tells us why Delacroix ruined his invention. The finished picture was destined for a competition in connection with an order for a big decoration in the Chamber of Deputies. With painful clearness Delacroix explains to us what is meant by a competition: "The artist, shut up in his study, inspired, to begin with, by his work, is full of that sincere faith which alone produces masterpieces, but if by some chance he happens to let his eyes wander out onto the boards where he is to figure or towards his judges who are waiting for him, immediately his brio ceases . . . he changes, he is spoiled and exhausted, he wishes to civilise himself and polish himself so as not to displease" (*Correspondance,* I, 272).

So Delacroix, following a happy inspiration, made the sketch for himself; he made the picture for the jury, and did not even succeed in winning. Eternal vicissitude of the man of genius who does everything he can to renounce his genius, to lower it to the mediocre level of taste that surrounds him, and yet does not succeed well enough to please these others, and perhaps a little too well to please himself.

To understand the limitations of Oriental inspiration it will suffice to examine the big picture, painted in 1845, represent-

ing "Muley-Abd-er-Rahman, Sultan of Morocco, Leaving His Palace at Méquinez, Surrounded by His Guard and His Principal Officers" (Museum of Toulouse: Fig. 72). According to the words of Delacroix himself: "This picture represents exactly the ceremonial of an audience at which the painter was present in 1832, when he accompanied the royal mission extraordinary to Morocco." So that Delacroix's purpose in painting this picture was realistic; and since he had believed he would find in the Arabs the greatness and the dignity of antiquity, it is only natural he should have thought that in this picture he had caused antiquity and reality to coincide. And he aroused the enthusiastic admiration of Baudelaire. But to-day the picture leaves us cold. It lacks atmospheric realisation; the colours are strong but without unity of tone. The violence of the Moroccan sun caused Delacroix to forget that every tint needs penumbra if it is to become colour. To the material nicety of the tints corresponds the exaggerated precision of the contours, the rigidity of the military alignment, the excess of detail. The result is a military parade, not void of dignity, indeed, but mediocre in its expression and disagreeable in its colouring.

To understand all the freedom required by Delacroix in order to achieve a unified style, it is necessary to compare this picture with another on the same subject and of small dimensions, painted in 1862, towards the close of his life, when, down in the hermitage of Champrosay, without financial cares, without further interest in theoretical quarrels, he went back to his favourite subjects, in order to browse among old memories and to satisfy himself. This replica of 1862 is now in the Cornelius Vanderbilt collection in New York (Fig. 73).

It no longer has intense colours, but bituminous half-tints, which serve only for effects of light and shade. The chromatic unity is fully achieved, and the whole thing has a perfect coherence. The emperor's *barracan,* which is more luminous than the rest, is the spiritual centre of the picture. Dark tones and light follow one another, in alternation, with advancing rhythm. The continuous nervous undulation of the line pervades all the forms, traverses them, superimposes itself upon them, constitutes with its vibrations the order of the pictorial "confusion". The distant ranks of the soldiers are no longer a line, but a tone. The walls have lost their material character: they are masses of open form, of magnificent light and shade. Even the parasol, with its nebulous contour, has succeeded in becoming a splendid effect of tone against the brilliance of the sky. The horse's mane has destroyed the beautiful continuous line of the neck, which is no longer separated from the emperor's *barracan.* The form of the horse is no longer planted with wooden solidity on the ground: in order to conform to the movement of the whole, it bridles, curbed to an abrupt halt, still quivering, contorted, full of life. In the picture of 1845, the emperor's right arm is a disagreeable academy piece; in the picture of 1862, it is all a movement of rough surfaces in light and shade, worthy of Rembrandt. The composition is still in depth, based on masses undulating in the same direction (from above on the left downwards towards the right) rather than on crossed lines as in 1845: and yet the composition is well-adapted to give us the disorderly flow of a crowd towards the edge of the picture. And this crowd is moving along ground seen from above, with magnificent volume, with no gap, no figure seen from the rear to modify

its direction or its movement. In this way, the arabesque of passion is developed without obstruction, pulsing and powerful, with a natural agitation that amazes. The work of 1845 is a failure; that of 1862 is a perfect success.

When the Arab scene is painted not in the open air, but in the interior of a room, the colours are more easily harmonised. "Women of Algiers in Their Apartment" (1833: Louvre: Fig. 75) is perhaps the most famous of the pictures on an Oriental theme painted by Delacroix. It is not difficult to understand, as one looks at this picture, what enthusiasm the mystery of the harem aroused in Delacroix and his contemporaries. Today, we note that the penumbras are well felt and delicate, that the forms are an uncertain compromise between the plastic and the pictorial, and that love of the picturesque has caused too much insistence on details worthy of an antique dealer's shop.

From the point of view of chromatic inspiration, "Jewish Wedding in Morocco" (Fig. 74) is certainly superior. The green and white of the wall is a harmony which foreshadows Manet. And the forms are more pictorial, more tactile, despite traces of the picturesque in the detail and the artificial agitation of the figures. The longing of Delacroix to discover classical antiquity in the Orient was not a superficial desire. Delacroix wished to achieve a genuine classicism different from David's neo-classicism, informed with dignity, greatness, sublimity. And in a few historical or legendary subjects he attempted to fulfill this dream.

The "Medea" of 1838 (Lille Museum: Fig. 76) has by some been considered Delacroix's masterpiece. The group is very skilfully composed, both in the way it fills with its mass the

three-dimensional space and in the way it encloses in one contour a sense of the approaching drama. There is in the "Medea" the wild beauty of look of a hurt animal. But quite taken up with his well-conceived group, Delacroix contents himself with setting off the flesh tints against the surrounding darkness. He makes use of the chromatic medium, but he does not achieve colour. The only exception is the face of the little girl, upon which certain penumbras and the blonde hair confer life. The rest is a spent fire, is tainted with mannerism.

"The Justice of Trajan" of 1840 (Rouen Museum) is composed with very great skill. The figures are posed and opposed with the function of dominating space. The ample space, the distribution of light and shade, the grandiose gestures are very effective in expressing grandiloquent agitation. But it is easy to feel the rhetorical character of all this agitation and the artificial nature of the whole composition.

The year after, 1841, Delacroix painted "The Taking of Constantinople by the Crusaders" (Louvre: Fig. 77) in a composition intended as a return to arrangement according to light and shade, light zone set off by dark zone which, in turn, stands out against the light of the background. It is the same type of composition as the "Massacre of Chios". And the group of Crusaders, dark against the light, has a penumbral force of great pictorial effectiveness. Yet a comparison with the "Massacre of Chios" is distinctly favourable to the latter picture. In the "Crusaders" the colour-effect is not realised: there is a stream of neutral tones within which, sporadically, float living colours. The brown of the warriors, the blue of the sea, the grey of the city are by no means harmonised with one another. There is an isolated still-life in the left fore-

ground, which is much more superficially conceived than the wallet in the "Massacre". The archaeological picturesqueness of the helmets and standards is arbitrary without being absorbed into the style. And the famous episode of the two dead or dying women in the right foreground is also isolated; in spite of their undeniable charm, they do not wholly escape a mannerist sentimentality. Of the "Lion-hunt" of 1855 (Fig. 80) only a fragment remains, in the Bordeaux Museum. But it is a fragment of rare beauty, of exceptional energy. Reds, browns, sky-blues, bluish blacks, brownish yellows are set off against a neutral green. And the forms are masses that bend and adapt themselves to the mélange of colours. The perfect correspondence between the theme of the raging wild beasts and the artist's burst of creative energy contribute to the creation of a masterpiece.

Decoration on an heroic scale attracted Delacroix during a long period of his life, from 1833, when he began the pictures in the Palais Bourbon, until 1861, when he finished those in the church of Saint-Sulpice. Delacroix's enthusiasm was immense; he thus satisfied "the need for the grandiose which, once you have tasted of it, becomes excessive" (*Correspondance,* II, 4). Thus he wrote in 1838; but in 1850 he had changed his mind. He paints big and little pictures "with the same pleasure; and I truly believe," he adds, "that one can put into a small canvas just as much interest as into an entire monument." In fact, in 1853 he wrote: "I have still a residue of resentment against painting in the grand manner, to which I owe my latest disappointment." And in 1855: "I should gladly fill medium-sized spaces, but no more cathedrals or vast surfaces for me! You have no idea of the boredom and

fatigue of such tasks. They take your whole life from you and in no wise reward you for all that with the results they yield" (*Correspondance*, III, 36, 134, 298).

In all or almost all his frescoes, Delacroix scattered with full hands the treasures of his genius. But, as he himself felt, the result was not commensurate. It would seem as though, from the beginning of the nineteenth century up to the present hour, painting on the heroic scale was synonymous with the rhetoric of tradition. By a destiny not easily explained, the modern masterpiece may be grandiose, but hardly grand. When he decided to go back to medium-sized or small paintings, Delacroix had the right idea. In any case, his experience with "la grande décoration" induced Delacroix to indulge in a greater freedom of brushwork, forced him to have more confidence in prompt and rapid execution and to assume a greater independence with regard to plastic form. If we add the greater familiarity with the grand and the sublime which big painting suggests, we can understand how the artist, as soon as he succeeded in enclosing his measureless aspirations in restricted dimensions and in realizing them with freedom and rapidity of touch, produced his best and happiest work.

"A Landscape of Champrosay," painted in 1842 (Fig. 78) and preserved in the Senn collection, was one of the visions familiar to the artist, and yet how full of passion it is! A restless whirlwind agitates everything. But no literary element, no "gesture," no "realistic piece" interrupts the pictorial expression. The trees are brown, the meadow is green, the sky is violet, everything in a chastened tone. The effectiveness of these tones consists in their broken pigmentation which, while it reveals the fury of passion, reduces everything to a unity of

style. And from this unity proceeds the feeling of grandeur, which exalts and renders lyrical the passion of the elements.

In 1859 he painted "Ovid among the Scythians" (Fig. 79), very different from, indeed superior to, the fresco on the same subject, and considered by Baudelaire and Chesneau one of the master's masterpieces. Certain imbeciles, on the other hand, greeted it as a symptom of progressive senile decay. Colors have disappeared, but the form flowing along the undulating curves of light and shade is perfectly realised. Here we may see how the reproach, often aimed at Delacroix, that he is more agitated than moved, is justified in fact and false as criticism. The figures do not move, but everything moves, just as stones and mountains appear to move when the light enfolds them. The flow of the luminosity is exact in form and line: it is a formal interpretation of light. Having thus reduced color and light to form, Delacroix's imagination roams easily along the neighboring banks and the distant hills, over the human figures and the animals, with a natural and profound feeling for primitive life amid a sublime nature pervaded with the sense of universal being.

The "Chess-players in Jerusalem," of the Chicago Art Institute (Fig. 81), is not dated. (The catalogue of the Louvre Exhibition, 1930, no. 74, groups this picture with works of 1834, but that might be a mistake. The style of this picture seems to place it as painted before 1850.) But even if it does not belong to the later years it reveals the pictorial form, the quiet and meditation, which characterised those years. If you compare it with the "Jewish Wedding in Morocco" (reproduced at Fig. 74) you will see the artistic difference between a trivial agitation in the gestures and a cosmic movement,

between a gossipy curiosity about Oriental life and an ecstatic contemplation of a natural mode of living rooted in the earth, for which the subject of the Orient is merely a pretext. In the "Chess-players" Delacroix's imagination is stirred in a manner worthy of the Bible. The colours too, in spite of their vivacity, are carefully harmonised: the red, yellow and blue robes toning in with the green and yellow of the walls.

"Horses Emerging from the Sea," in the collection of Madame Emil Staub at Maennedorf (Fig. 82), dates from 1860. The group, which reveals itself as a perfect arabesque of passion, is a dark conglomeration of greys, reds and browns, harmonised over a brownish green background. The contrast between the group and this background is stressed, but not too much, because the rapid, unexpected movement stresses it magically. The group presses close, with its sudden charge of movement, and evokes far off, like an indistinct echo, the movement of the clouds, of the waters, of the light on the hills.

"Arab Horses Fighting in a Stable" (Louvre: Fig. 83) also dates from 1860. The colour is disappointing, but the light and shade are realised in a manner worthy of Rembrandt. And the fury of the horses is expressed by luminous lines, independent of the natural pose of the animals, in a way that is almost miraculous. Whoever remembers the rearing horse in the "Massacre of Chios" will recall how much turbid rhetoric there was in the Delacroix of 1824, and how it disturbed without moving the onlooker. In 1860 Delacroix's brush runs lightly, master of itself, never insisting, never growing turbid, and evokes from the penumbra of a stable not two horses but truly the *lightning-flashes* of the horses.

Thus, towards the close of his life, after intense struggles,

always sustained by a great nobility of feeling, Delacroix succeeded in merging his qualities as man and painter. In order to affirm his taste, to impose his overpowering personality, he had filled immense canvases, achieved monumental decorations. But all that was inherently artificial, affected, forced, in the taste of the age, had, because of the necessity of the struggle, filtered into his work. When, on the other hand, he withdrew from the fray, painted from need of painting, and succeeded in renouncing not only the joy of beauty but the science of colour, then, in a few small pictures, which were so many *conversations with himself,* his violence became vision, his spasms became a profound melancholy, his passion meditation, and his form attained a spirituality rarely witnessed in all history.

Chapter Six

COROT

THE name of Corot brings to mind a very personal style, linked to a few famous masterpieces, and many mannered works, sentimental, feeble and easily counterfeited. This contrast between unity of style and unevenness of quality is complicated by the heterogeneous tendencies of taste revealed within a style that is unique. Corot lived from 1796 to 1875 and was educated according to the principles of neo-classicism, to which he remained faithful during the greater part of his life. And yet he shared in the romantic life of feeling and the romantic conception of nature in such a way as to become, after a fashion, its typical representative. And his respect for nature, no less than the extremely restricted limits of his inventive imagination, led him to a spontaneous and debonair realism. In fine, at his death critics and artists recognised that he had opened the road to impressionism, which was just then getting under way. Neo-classicism, romanticism, realism, impressionism, the principal tendencies of taste in the nineteenth century, are all, despite their mutual contradiction, found harmonised in Corot's style, without, however, giving us any ground for classifying this painter as an eclectic. Indeed, in his style each of these tendencies is found in attenuated form, never carried to extremes, and no one of them dominates the other. They are all neutralised by

other tendencies, as though Corot, instead of personifying one or more of them, gave them but an occasional cursory glance, with the centre of his attention elsewhere. His religious ideal consisted of a devout pantheism; his social ideal was a kindly and beneficent human solidarity. Not the shadow of a political ideal, unless it were the desire to be left in peace. Modest, submissive to his parents, who never understood him, admirer of artists inferior to himself, resigned to the indifference or pity of others, ingenuously happy when fame came to him, his personality as a man is as limited as his personality as an artist is rich. Ingres and Delacroix seem giants by comparison. Corot himself called Delacroix an eagle, comparing himself to a lark. Faced with the aggressive realistic movement of Théodore Rousseau, Corot declared that he was content with his own *petite musique*. And yet think of the limitations of Ingres' taste, swallowing all neo-classicism and timidly tasting of romanticism. Think of the taste of Delacroix, coherent, rich in possibilities, and yet limiting itself to the romantic ideal. And of Théodore Rousseau, who struggled all his life to realise his romantic conception of nature. And now return to Corot, to his revelation of a sun-bathed Italy of which we can hardly say whether it is more classical or more impressionistic, to his idyllic chants of the soft light of the North, in which an entire chromatic world is comprised in a nuance of grey, to his figures, in which appears a whole new conception of the human image, which may be called the landscape-conception of man. If you look, in short, at the results, you must somehow admit that Corot surpasses his contemporaries both in the felicity of his creation and in the breadth of his themes. His art is extremely civilised, refined, complex. And yet over all

this refined world is reflected the personality of Corot the man, who has the personality of a peasant, of whom his mother despairs because he seems so "common", who remains even in old age a lost child in the city and happy in the solitude of the fields. There you are: he has the soul of a ballad singer, with a natural readiness for assimilating all the most refined artifices. But if art is to come into being, it is necessary that these artifices be placed at the disposition of the ballad singer. Then what is artifice becomes a miracle of natural facility, the miracle of the artist who creates as the almond-tree blossoms. And he, Corot the man, assumes a new attitude, with which he confronts the mother in despair at seeing him so "common". "But you don't know then that since the beginning of the world, there have been only three wise men on the earth: Socrates, Jesus Christ and . . . myself?" In this very myth of the "wise man" who is content with so little, who finds his greatness in his humility, in his resignation the consciousness of his human dignity, who gives to rocks and trees a part of his Christian love, who declares his love for nature rather than representing the things of nature, who has a keen eye for discerning all her movements, and knows how to transpose her life into his discreet harmony of style, a joyous life even when articulated in themes of melancholy: in this myth of the wise man lies the key to Corot's art.

Only at the age of twenty-six was Corot able to obtain leave from his father to give up business and dedicate himself to painting, studying first under Michallon and then under Jean-Victor Bertin, two landscape-painters of a definitely neo-classical tendency. The latter was a pupil of Pierre-Henri de

Valenciennes (1750–1819), the theorist of neo-classical land-scape, author of *Elements of Practical Perspective for the Use of Artists,* followed by *Reflections and Advice to a Pupil Concerning Painting and Particularly the Genre of Landscape,* published in Paris in the year 1800. Valenciennes' advice will serve very well to explain the first orientation of Corot's taste. It affirms the dignity of the landscape-genre because landscape too can be a historical picture, as occurs when you look at nature with "poetic imagination". There is the other way of looking at nature: "as it is", and that is the "picturesque" genre. In the "studies from nature", there is the danger of not finishing; but you can finish later on, when "the weather is overcast". Then there are "studies from memory, based on those which you will have made every day." You should avoid "a dark mass to make the background recede," and which in painters' slang is called "repoussoir." You should avoid rationalistic speculation and the dramatic genre, to which the sad and melancholy genre should be preferred. The landscape-painter should travel, to the Orient, to Greece, to Italy, to Switzerland. Switzerland is cited as a compliment to Rousseau, but the country is not sufficiently open. Italy is the ideal. "Italy! Italy! this is the goal of all artists who begin to sense the beauties of their art, and who are possessed by the enthusiasm of the talented." If your money is not sufficient to take you farther, you must content yourself with France, where Grenoble may recall Switzerland and Provence re-echo Italy.

It is not necessary to show how this advice represents, even in a slightly caricatured fashion, Corot's own "programme." But Valenciennes gave Corot something more and better. The Louvre preserves a few "studies from Nature" painted by Val-

enciennes in Rome and vicinity. For example, the "Farm-house with Cypress Trees" (Fig. 84). Four of these: "Studies of the Sky at Monte Cavallo," "City in the Environs of Rome," "Villa Farnese," "Porta del Popolo," not only are authentic works of art, and reveal an extraordinary sensibility to colour, but they also construct form by a firm and crystallised contrast of light and shade in a way very different from the traditional, and greatly akin, even if somewhat more schematic, to the manner of Corot in his youth.

From Valenciennes, then, either directly or through Michal-lon and Bertin, Corot learned to visualise in zones of con-trasted light and shade, and above all he learned the "mores" of the landscape-painter.

In 1825 Corot leaves for Rome, where he is received by various colleagues as though he were an amateur. But in De-cember of that same year he paints a little panel, "The Colos-seum Seen through the Arcades of the Basilica of Constantine" (Fig. 86), now in the Louvre, and Aligny notices that the "amateur" is more of an artist than all the others and recom-mends him to the consideration of his comrades.

This particular painting is a masterpiece. A few gradations of brown turning to grey, a few zones of dark tender green stand out against a grey sky which just barely lets the blue show through. There is no beauty of theme, composition or form. But a sensibility to matter, not found in France since Chardin. And this sensibility is nothing else but love of tone and of tonal relations, a sensitive affection for the subject, by means of which the Roman arcades have become a refuge for the soul. Think of Pannini and Hubert Robert, painters of Roman ruins, and recall how superficial and artificial they

are. Think of Canaletto and you will realise the limits imposed by the objective view on his undoubted sensibility. In these small pictures of Corot's what has disappeared is, precisely, the "view." Corot painted many Roman "views," and he has repeated only too often his "Castel Sant'Angelos" and his "Roman Forum," in which he demonstrated his finesse in composition and his sensibility to light. But in this little panel there is another motive. The subject is the Roman ruins, but the motive is the painter's humility, his tenderness, his loving attachment to the refuge he has found. He is unable to compose because his tenderness projects itself into the arches, even while he is not aware of their details, but only of their tonal mass, as though they remained at an infinite distance, the distance of dream.

Another aspect of the "Basilica of Constantine" (Fig. 85) is shown in a little picture in Lord Berners' collection in London, painted 1826–27. The subject is picturesque, but the picturesque is absorbed in the pictorial by means of tone-effects in the sky, through the sensitivity of the inert matter, through the contrasts of light and shade, which are the co-ordinating element in the chaos of the ruins, and, last of all, through that distant tower of the Capitol, which rises like a luminous lily against the sky.

Corot's first Italian journey lasted from 1825 to 1828. The masterpiece of this period is the study from nature of "The Bridge at Narni" (Fig. 87). The yellow of the bare earth and the green of the trees and the grass are very low in tone. The river Nera is turbid and sandy until, under the shadow of the bridge, there appears the clear blue of the water. Then there follow grey-greens and blues until in the distance we see the

blue mountains veiled in mist, under the pale blue of a sky interrupted by white clouds. With a few intense blacks the painter participates in the battle of light and shade over the broken ground and the ruined bridge, a battle echoed in attenuated form in the distant azure. From the present tumult of life to the distant, yearned-for peace: this is the theme of the picture.

The pictorial process has been explained by Corot himself in this fashion: "It has seemed to me very wise in preparing a study or a picture to begin by indicating the strongest values (supposing that the canvas be white) and to continue by following in order up to the highest key. I should establish, from the strongest value to the most delicate, a series of twenty. In this way, your study or picture will be well ordered. This order should in no wise trouble the draughtsman or the colourist. Always the mass, the whole, that which one has found most striking. Never lose the first impression which has moved one."

As is well known, Corot does not always paint in this way; in fact, the contrasts of light and shade will give place to an uncontested domination of nuance. Whatever is lost in robustness and energy will then be gained in delicacy and grace. For the force of his contrasts he is indebted to the sun of Rome, as Silvestre has already noted; and these sharp contrasts serve as a necessary antidote to a certain slackness which is the danger that springs from this artist's simplicity and good-nature.

An important consequence of the vision by masses of light and shade is that the painter renounces the natural foreground. By bringing into the foreground of the picture a point far away in reality, he interprets rather than reproduces nature,

he takes part in the life given to things by light and shade rather than materially recording their details. He effects the transposition of things into life-values. Since the value is the infinite and the object is the finite, in order to rediscover the infinite in the finite he requires detachment, a vision just as distant materially as it is near spiritually. He does not lead the spectator by the hand into the picture, but he presents him with an object, seen in surface, in which there is something near and something far, but seen as a whole detached from the observer. Both the near and the far belong to the world of the infinite, the world of art, distinguished from that of reality. That is why a little rough earth and moving water, a broken bridge and a few distant hills have become an absolute of beauty, a wonder of the world.

This need for a distant effect in the foreground of the picture brought with it as a consequence the "unfinished". If we reflect on the way the finished was interpreted during the neo-classical period, we shall see that it was natural for Corot to feel every image becoming material, step by step, and in proportion, as it became finished. Whence the uncertainty and even the awkwardness of his execution which seemed every time as though he were trying to finish according to the wise advice of others. His timidity did not permit him to rebel openly against the finished, he contented himself with evading it. With a lack of conscious theory there was, fortunately, in Corot an overbearing will to go his own way. He himself has told how in Rome he freed himself from the advice of his teacher, Bertin. "I came to the decision never again to return home without work done at a stretch, and attempted, for the first time, a drawing by mass, a rapid drawing, the only kind

possible." Baudelaire was the only one, or almost, who as early as 1845 refused the prejudiced view of Corot's "awkwardness", who distinguished the *finished* from the *made,* and who affirmed that a work of genius is always sufficiently executed.

And now let us ask ourselves what there is in "The Bridge at Narni" that is neo-classical or romantic or realistic. This work is not neo-classical, because one feels in it no pre-established order prejudicially imposed on our vision. It is not romantic, because it is neither sentimental nor passional, nor heroic nor dramatic. It is not realistic, because nature, from whom comes the inspiration, has been totally transferred into a world of the imagination. What, on the contrary, we note in this picture is the intense participation in the life of light and shade, an immediate participation, made up of sensibility and imagination according to the first impression, which Corot himself advised us never to lose. In other words, this picture is made according to an impressionist conception. The difference between it and the works of the Impressionists of 1876 consists of a more restricted effect of light and shade, due to less knowledge of the possibilities of colour. That is, in 1826, alone, without any programme, in the most natural way possible, Corot jumped fifty years of painting, and passed from the neo-classical to the impressionist.

And if fifty years were required to awaken, by means of Corot's creation, a taste which afterwards conquered the world, that is due to the fact that Corot did not theorise his creation, did not presume to affirm that this "study from nature" was a masterpiece of perfect art. This is so true that when he wanted to send a sample of his art to the Salon of 1827 he made from "The Bridge at Narni" a finished picture (Fig. 88).

There is a foreground, there is an effect of perspective, there are beautiful trees, and a balanced composition which pushes the bridge into the distance; and there is the memory of Claude Lorrain. The lost lamb has returned to tradition. There is only one trifle that is missing: art. Constable's destiny was being repeated by Corot to a "t."

The masterpieces follow one another with astounding rapidity during these years. Corot painted the banks of the Tiber at Acqua-Cetosa (Fig. 89), a picture French admirers have called "The Promenade of Poussin", as though Poussin were a romantic meditating on the desolation of the Roman Campagna. Here too the colouring is muted, but it is richer than in "The Bridge at Narni." The earth is greyish green and violet, the river is a steely blue, the sky is cloudy and white, yellow and violet, with a few touches of pale blue. The malarial solitude, the abandonment, the aridity, the desolation, a kind of panic stupor felt by the painter, are expressed with an intensity and a vigour that are hidden under the low tones and the rudimentary forms. There is the universality and the infinitude of contemplation. But there is by no means the definition of any one kind of particular feeling. Nothing heroic, nothing dramatic, nothing "associated" with historical or legendary events; nothing, even, picturesque. In the extreme poverty of the subject the loftiness of the artist's flight of imagination is exalted.

There you have it: the new fact in the history of taste is the extreme diminution of interest in the subject for itself. Claude Lorrain is essentially contemplative, and yet even he requires a worth-while occasion: something, building or tree or sea, which in itself seems worth contemplating. And in that some-

thing there is still a physical residuum as a condition of his spiritual activity. Hobbema and Constable loved in their countries certain physical flaws which are of moral beauty; and in their art there is a residuum of a moral programme. Corot's poetry is purer because it is simpler and more spontaneous. It is a simple whisper of desolation.

While, in the footsteps of Valenciennes, French landscape-painters continued to travel in Italy and to conceive, even when they were in France, classical or Italian landscapes, certain Englishmen took an interest in the picturesqueness of the French countryside. Among others, A. Pugin and J. Gendall published, in 1821, coloured plates entitled "Picturesque Tour of the Seine from Paris to the Sea."

On his return from Italy in 1828, Corot roams about France, and paints many aspects of it, always according to the point of view he had learnt in Italy. A typical example is given in the "Chartres Cathedral" (Fig. 91) of 1830, in the Louvre. The contrast of the greys, especially in the Cathedral, evokes the enchantment of a fairy-tale. Meanwhile in the clouds all movement is suspended in order to fix the contemplation. The mastery of style is already complete, already you feel the menace that it may diminish the artist's emotional response to his subject.

In 1834 he goes back to Italy and paints there, for instance a "View of Volterra" (Fig. 90), in which the contrasts of light and shade in the rocks are associated with the vast pictorial mass of the woods and the roseate delicacies, worthy of a fairy-tale, amongst the greys of the distant city. Considered as a finished work, this is truly a great picture, with monumental scope. By this time Corot knows how to maintain, even in the

works that he dedicates to the Salons, the style of his studies from the life, with their contrasted masses of light and shade, their evasive foreground. Hence the unity of style which prevents the view from taking on the character of a panorama, and leaves no room for the curiosity of detail.

In 1836 Corot goes to Provence and paints various views in Avignon and its environs, which are masterpieces. I reproduce one of these, the city of Avignon as seen from Villeneuve, preserved in the Tate Gallery. The energy of the lights and shades, the chromatic richness of the greys, the moderated mood of passion which enfolds the whole, show that he has recovered his subtle equilibrium between the full new assurance of the craftsman and the sensitive and imaginative qualities of the artist.

Meanwhile, familiarity with French landscape gradually modified Corot's vision. The trees of the North, the more tenuous lights, the gradations of shadow, the more intimate themes of field and forest, afforded an opportunity for lessening his contrasts, for achieving a greater delicacy in relations. In 1843 Corot went on his third journey to Italy; he created new works of absolute art, in a spirit different from that of his earlier days, finer, more pictorial, but of less creative vigour.

From 1827 on, Corot exhibited in the Salons with great regularity. At first he attracted little attention, then he was classified among the neo-classics and was criticised for lack of execution, finish, delicacy. They saw that they had to do with a poet, but they did not wish to recognise a painter in him, and they kept setting up the poet as over against the painter until they had quite lost their heads. The masterpieces of his youth were, moreover, kept hidden by Corot himself, and the public

144

got to know them only when they were sold at his death. When, between 1840 and 1850, Corot's fame was established, it was founded on works of a style very different from that we have examined so far. And the works of his youth were forgotten by everyone. Ernest Chesneau still wrote, in 1880, that Corot had always been an artist, but that he became a painter only from 1848 on. The sole exception to this opinion was found in Thoré, who, though not grasping Corot's exceptional greatness, wrote in his *Salon of* 1847 that he had seen, from the brush of Corot, "exquisite sketches frankly painted at a stroke, and so right in their effect, with their soft light, that they can hold their own beside more vigorous and startling paintings." But no one paid any attention, and the Corot whom people discussed and appreciated continued to be the Corot of the pictures sent to the Salons.

When, in 1826, he painted his "The Bridge at Narni" (Fig. 87), Corot was an unknown youth; when in 1864 he painted the "Recollection of Mortefontaine" (Fig. 92), he was at the height of his popular success. Compare the two pictures, and you will see how they reveal two different worlds. In the meantime a revolution had taken place in the manner of conceiving painting, landscape-painting in particular, and with regard to that revolution Corot had undergone varying reactions.

Under the influence of Jean-Jacques Rousseau and Bernardin de Saint-Pierre, the country, the trees, the mountains had taken on an increasing importance in the life of the soul. Chateaubriand preferred to describe landscapes rather than to analyse feelings. Nodier and Pivert de Senancour behold in the land-

scape the mirror of their own melancholy. Lamartine goes further: he sees in the visible world the image of the divine and makes of it the direct intermediary between the soul of the poet and the Supreme Intelligence. Nature reveals itself to him without its details, with vague, fleeting shadows or, rather, reflections. The impression it makes on him, whether of tender joy or of meditative melancholy, is expressed with that mysterious force that comes from suggestion.

This mode of feeling depended on the imagination of the poet rather than on the character of nature. No longer was it necessary to seek for a classical or Oriental landscape. No matter what river-bank, no matter what tree was sufficient. The idea of nature lost its heroic character, and took on a rustic intimacy. Sainte-Beuve loves neither mountains nor abysses, "but a field, a bit of murmuring water, a cool wind causing a tremor in delicate branches." And Delacroix confirms this: "The poorest avenue, with its straight leafless saplings, in a flat dull horizon, says as much to the imagination as the most spectacular view."

With full faith in nature as an inexhaustible fount of poetry, with outbursts of love towards nature as though towards their veritable God, the romantic landscape-painters marched onwards to the discovery of the land of France. At first they were influenced by the English, Constable especially, and then by the seventeenth-century Dutchmen, above all, in what concerned fidelity to nature, renunciation of all attempts to better it, and the study of effects of light and shade in colour. But their spiritual content was new, a lyric impetus threatened to distract them from reality in the direction of the fantastic. Also, the neo-classical era had interrupted the colourist tradi-

146

tion, even in its elementary technical data. Corot had in-genuously rediscovered it, not only because of an exceptional sensibility, unique indeed in its time, but also because he had limited himself to seeking for colour values through the me-dium of grey. The romantic landscape-painters were unable to content themselves with grey; they were hot for colour and they fell, now into a colourism without tone, now into dark bituminous spots. For them, neither the example of Constable nor that of the Dutch was sufficient: a colour tradition, once it has been destroyed, is slow to rise again. There was the same difficulty with regard to form. In a landscape the problem of form identifies itself with that of finish. Guided by a poetic impulse, Corot knew how to check his hand in time. His non-finish was the only possible landscape-finish. And so he was accused of not knowing how to execute. The romantic land-scape-painters did not have Corot's sovereign poetic impulse. And often they over-finished, they sacrificed, to the evidence of things, the value of the image. In this way they led the romantic landscape on towards realism. But rarely did art flow from their brushes.

Georges Michel, Paul Huet, Théodore Rousseau, Jules Dupré, Narcisse Diaz, Alexandre Decamps, François Millet, Charles-François Daubigny possessed, in varying degrees, pic-torial qualities, and each of them created a few authentic works of art. But, for one reason or another, none of them raised himself to the level of an absolute artist. The value of their personalities, taken in the aggregate, belongs to the history of taste rather than to the history of art. Théodore Rousseau, for instance, was a convinced and obstinate in-vestigator, completely to the detriment of his artistic realisa-

tion, which often reveals technical effort and insufficient natural sensibility (Fig. 93). The personality of Charles-François Daubigny was much more sensitive and ingenuous. He sometimes achieves work of absolute value (Fig. 94). Too often, however, he is satisfied with a mediocre objectivism.

Neo-classicists and romantics had one point in common in their conception of landscape: the image of nature was to be the expression of a state of mind. The divergence began afterwards, when the neo-classicists wished to subject nature to a pre-established order of composition and to link it with historical subjects, while the romantics sought for the state of mind in the impression received from nature as it is, or else modified it, not according to preconceived ideas of beauty, but according to the impulses of the imagination.

About 1840 there was, incidentally, a moment of hesitation among the romantics, which to some appeared to be a return towards neo-classicism and which ended by being a decided step towards realism.

As early as 1835 Corot had exhibited his first historical landscape: "Hagar," and had obtained success. If he had overstepped the limits of the neo-classical school, that had not been, as we have said, by way of rebellion. He had done this spontaneously, almost unconsciously. He took no part in the romantic movement, he had therefore no reason for not seeking success by means of the historical picture. If in Italy, or in his studies on French soil, his creative impulse had sufficed him, it had not enabled him to counter the exigencies of the public of the Salons with the rigorous critical conscience which he could not have been expected to possess. On the other hand, he was too much of an artist to limit himself to the genre of

the landscape, and, even if for a long time he did not dare to exhibit his figure-pictures, he was happy to be able to prove his completeness as an artist by exhibiting landscapes with figures.

We shall see, in the following pages, that Corot painted a few masterpieces with figure-subjects and continued to paint masterpieces with landscapes where figures are lacking or are represented by simple spots. But his historical landscapes or, in general, his landscapes with figured representation are not among his best things.

From among the heroic or Poussinesque landscapes painted by Corot I have chosen "Homer and the Shepherds" (Fig. 95: Museum of Saint-Lo), shown in the 1845 Salon. The inspiration comes from André Chénier; the Homer too much resembles, as Baudelaire noted, the Belisarius of David, the shepherds are superficial and empty academic studies, the arrangement of the landscape is theatrical. To find a trace of the real Corot in the picture you have to examine the background for a few sensitive touches of light. And yet an André Michel has seen fit to write with regard to this picture: "What he had dreamed during his first studies in Italy, here you find it again. The hour of his emancipation had come." It is only too true that this was an attempt to free himself from art in order to achieve a sort of literary rhetoric.

"Macbeth and the Witches" (Fig. 96) in the Wallace Collection in London, painted in 1859, reveals another aspect of Corot's literary deviations. From the classical historical landscape he passes to the romantic historical landscape, with the nonchalance that is typical of absent-minded skill. And, unfortunately, when he is reduced to pure skill Corot gives us

nothing. He has forced his blacks but that, of course, is not enough to convey tragedy. However, this work met with success.

Neither the landscapes with religious scenes, nor those with a decorative aim (for instance the decoration executed 1840–42 for M. Robert, in Mantes, preserved to-day in the Louvre), are of any artistic interest.

And this leads us to grasp the limitation of Corot's art. His best works are his studies from life, either of a landscape or of a human figure. He never lapses into pure realism, because he can feel and reproduce, through his imagination, whatever he sees. And he is able to find in reality his ideal of beauty, in the harmony of the composition or in the delicacy of the forms and colours. Yet every subject taken from reality is transformed through an exceptional severity of style. There is more than enough for perfect and absolute art. But when Corot tries to add to what he sees, not his way of feeling but some element drawn from history or legend, or in any way derived from an association with elements extraneous to his personal vision, then he commits blunder after blunder. Inasmuch as he transforms reality into art he has creative imagination. But he is absolutely devoid of inventive imagination. He accepts the cultural donnée without feeling it, and thus juxtaposes it to his vision in a way that sometimes becomes ridiculous, as is the case for instance with his "Macbeth".

Only one cultural theme is, in his hands, saved from being ridiculous, because it is in greater harmony with his way of feeling. He reads Virgil, Theocritus and loves Gessner. The trees, the waters, the light mists of the Ile de France, people themselves with images that are "classical" because they are

nude, since this means they represent nymphs, or modern if they are clothed. All this becomes a silvery grey, in the "Recollection of Mortefontaine", for instance (Louvre: Fig. 92), which was painted in 1864 and is certainly one of the most delicious of Corot's idylls. After admiring it, savouring it, almost as though it gave a physical pleasure to the eyes, a sweet repose, we yet cannot help noting the extreme superficiality of such an art. Corot has confused his artistic transformation of reality with the myth of silvery grey and, under the pretext of painting trees and water, women nude or clothed, he repeated these greys a hundredfold. He repeated, his contemporaries used to say, always the one picture. And he had only to spread over it his grey-greenish shroud, for a buyer to appear. Corot, a heart of gold, gave away the money that he thus earned, and saved from misery many unfortunates, among others the great Daumier. Or else he had pity on the painters who forged his pictures, and added to the forgeries a few touches, a faint film, a signature, and so made them authentic. Kindness if you will, but somewhat too much for the responsibility that lay on him as a man of art. These are the reasons why the greater part of the idylls that he painted are not authentic works of art.

Besides his three journeys to Italy, and his frequent tours through France, Corot visited Switzerland between 1840 and 1845 and Holland in 1854. His life ran on peacefully without incident, amidst a crescendo of fame and popularity. He had considerable success at the World's Fair in 1855, and between 1860 and 1870 he touched the summit of his fame. His masterpieces were all studies from life, produced whenever for one reason or another he experienced a new and strong impression.

In 1851 he visited La Rochelle, and brought back a series of creations which rank among his happiest. The old harbour buildings, the mirror of the water, the sailing ships, filled him with enthusiasm. His impressions were as fresh as in his early years, the joy that light and its reflections gave him was intense, his colour sensibility was richer than ever before or afterwards. The complete view of the port (Fig. 97: L. de Rothschild Collection) reveals a very lively memory, on Corot's part, of his Italian style. The exceptional preciosity of colour lends intense life to the forms crystallised in the planes of light and shade. The colour is worthy of Ver Meer and, in addition, there is a spontaneous and fervent love for every created object, which Ver Meer did not dream of. The painting of the entrance to the harbour (Fig. 98: Louvre) has an even greater vivacity; an absolute lightness of brushwork is used to represent the reflections of the boats in the water. Corot offers with pure spontaneity the sympathy he himself feels for the evanescent lights. He offers neither the boats nor the harbour but an interpretation of things in the name of light. I do not believe Corot ever painted a more impressionist picture than this one: note that its impressionism lies precisely in the detachment of the luministic vision from the objective reality of things. The colour is always restricted to grey, pale blue, black and brown, but their tonal relation suggests a much vaster scale.

"The Belfry of Douai" dates from 1871. But it is very akin to the La Rochelle pictures of twenty years before. There is, in addition, a vivacity of touch which intensifies the effects of light and shade.

Between 1860 and 1865 Corot painted a little picture: "A

River" (Fig. 99: collection of A. Schmid in Küssnacht). The canvas happily terminates in a way which does not permit us to see where the composition begins and reality ends. Silvery greys in the river, a little light brown in the foreground, greens and blues in the background, blue-grey in the sky. A tranquil flow of water, a lovely dark spot near it, a delicious gleaming of distant lights: all this is highly simple, it has a casual appearance, and it is sufficiently a creation to awaken rapture.

The silvery grey which gave Corot his popularity and stirred tender souls for two generations was not revealed in skilful and mannered idylls only, but in a few genuine masterpieces also. When Corot did not paint the poetry of memory, but poetically painted an impression received from reality, then he achieved his best things. And this he did most often precisely in the last years of his life. There is in these works, to a certain degree, a return to the period of his youth, not, to be sure, to the style of his youth but to the vivacity and freshness of impressions worthy of those he had felt in Rome in 1826. The expression of these new impressions was much easier, more rapid, richer in transitions, with an entirely new air of lightness and grace. But this lightness and grace is based on energy of composition and realisation, on a sense of space and volume, on a total domination of vision. So that all mannerisms, all superficial facility of effect disappear.

Examples of such masterpieces are easy to find. For instance, "The Thatched Cottage", in which is manifested a perfect correspondence between the rustic feeling of the painter and the simplicity of the theme, between the joy experienced at the clear light and the realisation of the space seen in perspective.

"The Beach at the Foot of the Cliffs at Yport" dates from

1872 (Fig. 100). It is a superb masterpiece. The simplicity of treatment gives the picture an extraordinary monumentality. The discreet and delicate greys, the light touch, the perfect realisation without need of "finish", unite in giving to all elements of the picture an intense life.

"The Village on the Shores of the Sea" (Collection of Baron Napoléon Gourgaud, Paris: Fig. 101), which dates from 1870 to 1872, is an incredible masterpiece, one of those that because of their very simplicity are indescribable. In this picture you may note how during his last years Corot painted with an ever-growing unity as regards the whole and with growing contrast in the details. The effect is lively and evident, yet the touch is free and pictorial. The *morbidezza* is infinite, but it is not effeminacy, because it is precious in every stroke. The absorption of the form in light and shade is complete. This unity of style is precisely what is called beauty.

"The Bridge at Mantes" (Fig. 102) has for a long time been considered one of Corot's masterpieces. There is in it the refinement of silvery grey carried to an extreme, but it is saved both by the energy of the pictorial effect and by the complete grasp of reality. It is less impressionist than the pictures of La Rochelle, "A River", "The Thatched Cottage." His ideal of beauty has led Corot to limit the pictorial effect to the simple superimposition of the grey-and-black trunks on the silvery grey of the water and sky. So that this work is a synthesis of all his aspirations, a synthesis of the artist's personality in all its complexity: neo-classicism, romanticism, realism, impressionism. Of course, all this is absorbed and re-created, because his art here shows itself in all its perfection.

Very rarely did Corot paint the interior of a house or court-

154

yard, and always most felicitously. I reproduce "The Tanneries of Mantes" (Louvre: Fig. 103), which dates from 1873. All in grey, rather dark, with a few touches of brown and red. But the very obscurity enables Corot to achieve a greater range of nuance than usual. Hence an exceptional tonal richness in the precious material. It is probable that the theme was inspired in Corot not only by reality, but also by the memory of similar rustic themes painted by Alexandre Decamps. But if you compare a work by Decamps with one by Corot, you at once feel the difference between a craftsman and an artist, or rather between a mannerist and a creator, a difference that impresses itself on every particle of pictorial matter.

Corot's contemporaries, except for a few rare exceptions, did not appreciate his figure-paintings. And they were wrong because, as may be noted in the illustrations that follow, several figure-pictures by Corot are great masterpieces. Today, on the contrary, art-lovers and critics are inclined to over-value Corot's figure-pictures as compared with his landscape-pictures. But I think that is the result chiefly of the renewed prejudice in favor of figure as against landscape-genre. Inasmuch as Corot is a great artist, and has painted figures, the modern art lover chooses the genre he prefers.

It seems to me that, before resolving the question, it is wise to ponder what Corot thought about it himself. In 1827 he wrote: "I have only one goal in life, which I desire to pursue with constancy: to paint landscapes." In 1874 he would not consent to the exhibition of one of his figures, lest he "seem to be soliciting the recompense obstinately refused to his landscapes." Let it be clearly understood: this does not mean that

he under-estimated his figures, but that he regarded his land-scape-painting as the centre of his activity. On the other hand, to-day we know there are 323 of Corot's figure-pictures; of these he exhibited only the "Monk", in 1840 and the "Woman Reading", in 1869. The reaction of his contemporaries must certainly have had some effect in this regard, but there is significance also in the fact that Corot thought to overcome indifference or opposition by staking everything on his landscapes.

His great passion was living in the country, in contact with nature in the open air. During his first journey to Italy, when he discovered, in his own way, Rome and the Roman Campagna, he forgot to visit the Sistine Chapel. His peopling his landscapes with figures, à propos of the "historical landscape", was certainly not a happy experiment. When, in his old age, he had to give up living in the open air, and precisely between 1865 and 1874, he painted the greater part of his figures, and, what is more important, his best ones. So that to understand his figures we must keep in mind the fact that he came to them after his experience in landscape-painting. And this is a new phenomenon in the history of taste, this is the secret of the peculiar charm that is exerted by Corot's figures, this is the reason for the immense influence that they have had on the subsequent development of taste. Hippolyte Flanderin was the first to perceive it, when, in spite of the contrary opinion of his master, Ingres, he said that "this devil of a fellow gets into his figures something that the specialists have never been able to put into theirs." To-day, in the Louvre, the figure called "Woman with a Pearl" (Fig. 106) is exhibited near the "Bain Turc" by Ingres (Fig. 51). This makes it easy to grasp the

difference between the two conceptions. Corot's approach to the figure comes from the outside: he begins with the vague, with atmosphere, in order to arrive at form. Ingres creates from the inside, not from what he sees, but from what he knows and imagines, and he comes last of all to the surface of the flesh: it is the last stroke that gives him his delicacy of effect. Corot's last stroke, on the contrary, gives him his solidity. And that is why Ingres' image lives in a rarefied air, whereas Corot's is impregnated with a dense atmosphere. Rarefied air or dense atmosphere are here not only two elements of vision, but symbols of two ideals: in his abstract ideal of beauty Ingres barely succeeds in suggesting life, whereas by his natural sensibility Corot creates his beauty at the very heart of life itself.

In confirmation of this let us recall that Rousseau wrote in 1884: Corot's figures "have popularised the study of the figure in the open air." His nudes "have the dull, healthy whiteness of life, and those light but solid shadows which alone can render the density of the flesh." And, in 1900, Geoffroy wrote that Corot "paints his models like his landscapes; he gives to naked women, to faces set in shadow, the same ingenuous charm that he gives to the skies of morning, to waters at evening." Even those who thought that Corot was a "poor draughtsman of the human form" because he did not give evidence of anatomical knowledge, as Lostalot thought in about 1880, are obliged to admit that in Corot's figures "their anatomical imperfections are redeemed by great charm of colouring and, above all, by exact observation of their luminous value in the entirety of the picture."

We have no prejudice as regards the artistic value of

anatomy, and are convinced that when the effect of light and shade is correct, it has its own coherence which frees it from the necessity of being judged according to anatomical standards. And therefore we notice anatomical flaws only when Corot's sensibility is distracted and he does not achieve his light-effect, as occurred for instance in the shepherds of his "Homer", that is, when Corot, in homage to the prejudices of his age, wished to present abstract, rather than his own concrete, form.

We can, therefore, admire without reserve Corot's self-portrait, in the Uffizi Gallery in Florence (Fig. 105), painted in 1835, a prodigy of vivacity, energy, volume and, at the same time, serene, sure, of surprising lightness of touch. This likeness is in every sense worthy of his finest landscapes of Volterra and Avignon.

Less convincing, on the other hand, are his religious figures (for instance the St. Sebastian, the enthusiasm of Delacroix for which is not easy to understand) and his nudes. No doubt we cannot refuse our admiration to Corot's efforts to rediscover the beauty of the female form by means of planes of light. And no doubt "The Bacchante" of the Corcoran Gallery (1855–60: Fig. 104) is a pleasing picture. Yet we are forced to ask ourselves whether the ideal of beauty that Corot wishes to present to us was not imagined by a taste, by a cultural world, too remote and alien for Corot to have been able to realise it completely. Compare it with "The Bather of Valpinçon" by Ingres (Fig. 54): with all the sympathy we feel for Corot, we cannot help admitting that Ingres is the more coherent.

On the other hand, in "The Reaper's Family" (Fig. 107), Corot is at last completely in his element. The adjustment of

the human figure to the style in which the trees, the harvest and the cottage are painted is perfect. Everything lives and everything is revealed in terms of light, laughs as the light laughs, has something holy about it, like the light in its purity; something monumental, like the miracle of genius.

"The Atelier" (Louvre: Fig. 108), painted between 1865 and 1868, shows how the "plein-air" entered into his studio, that is, how *plein-air* is veritably Corot's style. The full skirt, the hand in shadow, the hair-ornaments, the objects on the wall, all obey the same rhythm of the appearance or disappearance of light, a rhythm that dispenses life, grace, imagination. No one can think, looking at this picture, what was thought and said when contemplating the nudes of Corot, that one feels the model too much. Which is, moreover, a way of saying that the object represented, or the programme of representation, has been incompletely absorbed into the artist's style.

A series of masterpieces is offered us in the female figures conceived by Corot during his last years. "Melancholy" (Glyptothek Ny Carlsberg, Copenhagen: Fig. 109), painted between 1850 and 1860, is an illustrative and sentimental subject. But with what facility Corot succeeded in freeing himself from the subject, giving us an image of grace, in which melancholy is a mere accent, as if by way of play! A few tonal relations, pure grey and pure buff or pink, are enough to reveal this grace, without insisting—just in passing, as the light passes.

"The Interrupted Reading" (Chicago Art Institute: Fig. 110), painted between 1865 and 1870, is perhaps the masterpiece among Corot's figures, something that corresponds in his work in figures to "The Bridge at Mantes" among his

landscapes. The composition recalls Corot's neo-classical origins, the theme is romantic, the aim is realistic, the execution comes close to impressionism. And all this is spontaneously fused, in such a way that it is difficult to distinguish what is ingenuous from what is consciously created. The colours murmur as though muted: greyish yellow in the skirt, reddish grey in the carpet, white-grey-pink in the flesh, white-grey in the smock, black in the hair and bodice, grey-brown in the background. The "finish" of the face is typical, all transparent glazes, nuances, delicate gradations: a refinement of skill that coincides with the candor of expression, a curb that becomes the free play of creation. From the subordination of the colours to the greys in the transitions, is born the grace that is typical of Corot.

"The Greek Girl" (Metropolitan Museum of New York: Fig. 111), painted 1868–69, is richer in colour. It is a portrait of Mademoiselle Dobigny, whom Corot has dressed in Greek costume in order to play with colour. Before a high wainscot of purplish marble and a grey-green wall there passes the figure of a blonde girl clothed in garments of white and gold, with a white-red-and-brown kerchief. Yet the various colours are accessories: the form, the volume, the very expression are due to the nuances and the glazes in grey. And if this is no longer a model or an academic study, but an image of grace, goodness, exquisite civilisation, subdued modesty—in short, if it is the image of Corot's soul—we owe it to those few nuances of grey.

At the same time, Corot painted the figure known as "Woman with a Pearl" (Louvre: Fig. 106). It is a girl wearing a crown of leaves, and one leaf casts a shadow on her forehead.

The public took this to be a pearl. The error is, in itself, a happy critical judgment: to be sure, any shadow of Corot's is a pearl! And the whole figure irradiates that spiritual beauty which is grace, which is grace for the very reason that it is natural, that it is born as a blossom is born on a tree.

These are not merely the aged Corot's dreams of beauty, they are the eternal gifts which he left to humanity, of a creative elevation rare in any period of history.

Chapter Seven

DAUMIER

IT IS impossible to talk about the art of Daumier without recalling the importance and the fame of his caricatures (these took up almost all of his time, numbering as they do more than four thousand) and his desire not to draw but to paint, accentuated with the passing of years and by the judgment of his contemporaries, now ferocious, now enthusiastic, but always and only directed towards his caricatures. One recalls also the revelation, at the World's Fair of 1900, when the artist had been dead for twenty-one years, of Daumier as a great painter, perhaps the greatest of his period, certainly greater as a painter than as a caricaturist however celebrated. A few contemporaries, Michelet, Balzac, Daubigny, did not permit themselves to be misled by prejudice: they realised that Daumier, of the stature of a Tacitus, a Michelangelo or a Raphael, had come among dwarfs. To-day, many believe that Daumier's lithographs never were intended as caricatures at all. But the people who had received his moral whip-lashings saw in him a "savage thirsting for blood". The critics ignored, or late and feebly understood, that his art, born of political passions, and capable, for the first time since Michelangelo, of attaining to the level of a moral symbol for the nation and for humanity itself, had then succeeded in freeing itself of all preoccupations and passions and in creating a new

form, fecund for half a century, or more, of painting. The errors and the misunderstandings, which even to-day have not quite disappeared, are based on widely spread prejudices concerning the whole art of the nineteenth century, concerning the genres of caricature and monumental painting, the beautiful and the ugly, the social nobility or popularity of inspiration, the everyday impact of reality in its relation to the eternity of art, concerning the classical and the romantic, the finished and the not-finished, plastic form and colour.

It would be stupid to-day, after recognising, as we must, that the artistic genres are not categories of judgment, to ignore the fact of the caricatural origin of Daumier's art, which is the precious symptom of the state of mind concealed in the genre, and of the historical conditions amid which the artist's imagination was developed. It is also useless to indulge in subtle distinctions concerning Daumier's lithographs, as to whether they are caricatures or not, since it is not possible to set over-exact boundaries to the categories, and since, moreover, we recognise that a caricature is not necessarily connected with the comic, but is attached, as we have already said in speaking of Goya, to the general concept of the *characteristic*. A danger to art was, of course, involved also in the concept of the characteristic, understood as a physical and psychological study of the objects represented (an intellectualist way of getting to know the individual), whence the empirical advice not to lose oneself in detail, and the unilateral but well-directed suggestion to abandon oneself to the whimsical, to play, and to that lightness of spirit without which we can have no art. Even his enemies, when they were intelligent, under-

stood that the intellectualist defects of the characteristic cannot be imputed to Daumier, and that his reality had intensity of such a degree as to reach the level of the fantastic (Goncourt). With much less intelligence, certain critics lamented that they did not find in Daumier's work the "beautiful woman", who would have been nothing else but a compromise with that *beau idéal* which it was Daumier's essential merit to have excluded from modern art. That, moreover, does not signify that he has not felt the charm of womanhood.

A task similar to that accomplished by the characteristic in evading the tyranny of pure beauty was achieved by the concepts of the *comic* and the *sublime*. Their theoretic value has been denied, and discredit has been thrown on the myth of humourism as a law of romantic art; but the historical function of a way of feeling common to an epoch and to a people is another matter. The comic has acquired controversial effectiveness sufficient to rob the gods of artistic and moral rhetoric of all authority, and by its desire for liberation has opened up new vistas to the imaginative faculty. Naturally, in order to reach this goal it too has had to purify itself, either by the contrast between two perceptions or images or ideas not susceptible to reduction by synthesis (Dumont), which is, in short, the intellectualist contribution of comedy, or by the feeling of superiority, or sudden pride, in the presence of defects or weaknesses in others (Hobbes), which is the moral contribution of comedy. But if this contrast is overcome by affection, and if this pride is corrected by benevolence or regret, then comedy loses its unilateral character: it is called humourism (Croce) when it assumes a poetic delicacy, and grotesque (Baudelaire) when it loses its character of tendentious imitation and

takes on that of free creation. All Daumier's lithographs reveal the sentiment of the characteristic; many, not all, also reveal the comic sentiment, now violent and aggressive, now, on the contrary, indulgent or even tender, resulting in a dignified humourism and arousing a kindly smile. After 1848 a great part of his production, in lithography as in painting, is free creation, therefore pure grotesque—if we assign to Baudelaire's conception a broader scope, freeing it of laughter. For indeed pure creation does not awaken either laughter or tears; or else combines laughter and tears in a loftier mode of feeling, which is the unique mode of art: ecstasy.

In Daumier, from the comic to the sublime is but a brief step (Klossowski). If this step was in the air, so that romantic comedy was theorised as a sort of topsy-turvy sublime (J. P. Richter), in the case of Daumier's work the introduction of the sublime was felt and expressed in varying ways: as the force of nature, the enormity of the real, the Michelangelo of caricature, the tragedy or the the generosity of the comic, the totality of feelings in an accord made up of discordant elements. All this gives one the effect of superhuman power, and yet as of something without terror: the sublime. The necessity of the sublime is thoroughly realised when we remember that at the root of Daumier's activity lie the French Revolution and the Napoleonic era. Stendhal wrote that "the passionate man does not laugh", "the republic is opposed to laughter", and indicated that the French tradition of laughter was bound up with the pride in what is "proper" and the condemnation of what is "improper", characteristic of the court of Louis XV but forgotten under Napoleon. These statements cannot be generalised, but, within their historic limits, they

are correct. And we should add that Daumier, the son of a poet-glazier, belonged to the people and loved only the people (Banville): he possessed their primitive force and moral sanity.

In 1830, at the age of twenty-two, Daumier had the soul of a revolutionary of the type of those who had matured under Napoleon and had lain low under the Restoration; and, after the July revolution, he thought he had a right to lead a full and brilliant life. Instead, as Tocqueville described it, the bourgeois spirit then prevailing was "often dishonest and usually pedestrian, timid by temperament, moderate in everything (save in a taste for well-being) and mediocre." We may add that the governing class lacked artistic culture, had but rudimentary and meagre taste and encouraged the worst kind of art. Daumier's rebellion, as man and artist, was inevitable; he opposed to these sentiments—petty, timid, mediocre, cruel through fear—a vision of things immense, authentic, heroic, free. But a new reality had to be created: for, after 1830, to go on singing the heroes of antiquity, as David had done, would have been an act of ill faith; to lose oneself in medieval and Oriental dreams, as did Delacroix, would have meant evading the serious concerns of man. And striking at the lies, the cowardice, the cruelty of the enemy—which were, after all, necessary polemical outlets—this too did not mean creating a new reality for art. It would have been necessary to encounter a friend, and to pour out to him the fullness of one's affection: that friend was the people. That the people was heroic, more heroic than the profiteering bourgeoisie, who could deny it, after the days of July? In this way Daumier intuitively grasped the heroic nature of the people. With regard to Louis-Phi-

166

lippe's policy, one may to-day have an opinion different from Daumier's, but moral truth is on his side: he represented, against all political opportunism, the impetus of generosity; against the suggestions of money-makers, or legal quibbles, the rights of freedom and human dignity; in him resounded the heart of the people, and success could not fail him. But after the revolution of '48, the emphasis was on social revolution; the people or their representatives carried the struggle back to class warfare. Moreover, in ethics, every man of the people is a conservative, and Daumier was repelled by socialism's new ethics, rebelled against them: but his voice was not always sure and its echo was much less than before. All that remained for him was to withdraw, to retire into himself, and this he did, giving up all his oratorical successes, to the definite advantage of his painting. From a journalist of genius he became an artist.

In his work as an absolute artist he shows the advantages of his journalistic origin. We know how in France, since the great revolution, the newspaper has taken the place of the salon as an artistic and intellectual guide, suggesting as material for art immediate reality, the everyday actual, free from the artificialities of exclusive circles. This imposed the duty of having something to say before learning how to say it. A difficult revolution in taste, because the schools, tradition, the so-called ideal were unanimous in boycotting it; so much so, that about 1840 the critics (who ingenuously believed they saw in the pictures of the "Salons" a mode of execution capable of performing miracles) felt the drawback of the lack of content, of the body without a soul, of this pastime for idlers (Rosenthal). Nor did anyone notice Daumier, the caricaturist,

the journalist, who obeyed the dictates of his own passion, and by its means, almost unawares, attained to art.

The new content required a new form, which was made easy for Daumier by various circumstances. First of all, the art of landscape—a refuge for all those who wished to evade the rigours of the neo-classic figure, its plastic form, its doctrinal abstraction—had drawn from the picturesque character of its themes a new consciousness of pictorial form. It was a familiar form (realised for centuries, as early as the Venetian Renaissance) even for the human figure, and Rembrandt's paintings, so well suited to the new needs, provided famous examples. Nor were more recent examples lacking, in the paintings and etchings of Goya, who had given up the aulic, formalist style of his official portraits the better to express the horrors of war and revolution, and popular scenes in general. From Rembrandt as from Goya, Daumier drew a beneficent influence. Less important is the relation between Daumier and the romantic pictorial movement in Paris itself, under Delacroix's influence. In spite of his greatness, there is in Delacroix something uncertain, tenuous, striving, in conception as well as in realisation, that contrasts with the certainty, the vitality, the passionate force of Daumier. Duranty was quite right in indicating a cultural current parallel with romanticism and yet distinct from it, based on the observation of reality, strictly adhering to truth, the first representatives of which were the landscape-painters. The journalistic-caricatural origin of Daumier's art permitted him to follow the same path in his representation of the human figure. The technique of lithography had been recently invented when Daumier started to make use of it, and that too was a circumstance favourable to his pic-

torial form; the soft crayon, in fact, facilitates blurred outlines, nuanced penumbras, velvety blacks. It had already been used with the same intention, a few years before Daumier, under the Restoration, by Decamps and Philipon as well. Philipon was, moreover, the first to appreciate Daumier's genius, to make use of him to further his controversial and political ends, and, under the impetus of caricature, to start him towards his success, and (partly because of the liberty necessitated by caricature with regard to plastic form) towards the glory of his pictorial form.

Concerning this, Baudelaire has said the final word: "His drawing is naturally coloured. His lithographs and his woodcuts awaken ideas of colour. His crayon contains something besides black, good for defining contours. He makes you guess at colour as he makes you guess at his thought; now, that is the sign of a superior art, and all intelligent artists have seen it in his works." Yet the problem of Daumier's pictorial form has, because of certain contradictory impressions of his critics, become complex. Baudelaire notes that Daumier draws like Ingres and perhaps "better than Delacroix", and Fontainas observes that Daumier's colouring has a sensibility and a delicacy unknown to Delacroix: and everyone knows what is meant in French tradition by the Delacroix or Ingres diapason. On the other hand, Duranty affirms that "the colourist, so remarkable in Daumier, was a product of the draughtsman. It is with the white and the black of his pencil that he has so intimately absorbed the splendours of light and the depths of shade." But we know, thanks to Baudelaire, that precisely these whites and blacks suggest colour. Here are contradictions which cannot be resolved unless we keep in mind that colour-

ing, like plastic form and draughtsmanship, is, in art, a *mode of feeling,* that it changes according to time, place, and the individual. There is the mode of feeling draughtsmanship as a suggestion of colour, as colour synthesised in light and shade, schematised in white and black; and there is the mode of feeling draughtsmanship as contour spread out, graduated in order to give the effect of relief. The first mode leads to the pictorial form; the second, to the plastic form. And the first is Daumier's way. There is, therefore, no sense in saying that in Daumier the colourist is born of the draughtsman; the truth is that the draughtsman Daumier has perfectly realised his colouring. Similarly, Delacroix or Ingres cannot serve as standards, either for Daumier's draughtsmanship or for his colouring. There is an historical conflict between Delacroix's colouring and Ingres' draughtsmanship: a conflict due to the will of the two artists. And yet in spite of the greater affinity with Delacroix, Daumier takes no part in that historical conflict. With his pencil, just as well as with his colouring material, Daumier realises a synthesis of light and shade that is all his own (even if influenced by Rembrandt and Goya) and in which the scheme of the colourist counts as an antecedent and the scheme of the draughtsman as a distinction. Because this had not been understood, elementary as it seems in the history of modes of seeing, it was malignantly whispered that Daumier did not know how to finish his pictures (Goncourt), and even recently his presumed lack of finish offered the pretext for an argument limiting the importance of Daumier, no longer an absolute artist but only a journalist of genius (Scheffer). Worse still, in recent times the statement has been made that Daumier, poor devil, had no opportunity to learn

170

the "elements of painting" (Rim). It is hard to carry any further the absurdity of such prejudices. As though painting were a science that any good Beaux-Arts student could learn in two years, and that a genius like Daumier, with his readiness, his assurance, was unable to master, in spite of thirty years of activity as a painter, because he did not study in an academy! Rim adds that Daumier's heavy contours might be justifiable if the colours were intense but not with his half-tone colours. As though a rule existed to show when contours are permissible, and as if contours did not depend on the coherence of the style, that is to say, on the personality of the artist! On the other hand, Rim admits that "Daumier as a painter is truly himself. . . . One finds in his pictures a sad gravity, a robust philosophy, at times an ineffable bitterness which could not have been contained in most of the lithographs which he drew to amuse the populace." The technique of oil painting is not something independent of the inspiration and the temperament of the individual creator, something that can be learned in the schools and may be repeated mechanically. It is not the critic who should teach Daumier how he ought to have painted. Let him rather try to understand why Daumier painted in the way he did.

It will, however, be necessary to stress the experience of the entire history of modern painting, which is that the perfect finish of pictorial form cannot be measured by the finish of plastic form. With conventional academic self-assurance Gigoux affirms that "Daumier was far from having the precision of Gavarni": but this is precisely Daumier's glory, that he did have, as no one else in his time, the precision of expressive or concrete or artistic (call it what you will) draughtsmanship, as

against the academic or abstract precision of it. Daumier expressed his soul to perfection by means of light and shade, and that is his perfect finish. On rare occasions he would add some plastic precision, and then he committed an error of taste, through lack of a coherence of style; for instance, during the years of his youth, when the demands of caricature made themselves too urgently felt, and his drawing grew harsh under the drive of his will; or even at times in his later years, through an ingenuous indulgence towards technical skill (as in his "Don Quixote"). These are rare exceptions; the rule is that in his lithographs, as in his paintings, Daumier's style asserts itself by its absolute consistency, obtained by exemplary courage, beyond all concessions to prevalent taste. Because of this consistency he excludes all decorative distraction from his work, as from the studio where he lives; by its means he makes everything, even the most insignificant object, share in the state of mind he is expressing. "It was he who first drew nature and material objects out of their anonymity, obliging them to take part in the Human Comedy, where sometimes trees share in the absurdity of their proprietor, or, in the midst of a domestic scene, the vases on the table start snarling with ironic rage" (Banville).

Among the various portraits of Daumier that have been preserved, is a photograph which reveals his character (Escholier, 179): the eye of a sage and the spirit of a child: the more acute, penetrating and self-assured is his glance, the more good-natured, simple and ingenuous are his other features. His Marseillais and child-of-the-people origin, the poverty from which he suffered in his youth and the humiliations he experienced as a lawyer's clerk, are the circumstances under

which his natural goodness was developed. The implacable Forain said: "Oh! Daumier, he was something entirely different from us. . . . He was generous." We know how he refused to persecute Louis-Philippe in exile; indeed he pictured him on the shores of England confronting Guizot, with a benevolence not devoid of admiration. And Duranty probably is right: "Spurred on by the enraged Philipon, Daumier flung himself into politics with a sort of fury, but none the less I believe that his instinct for artistic emphasis and his fiery utterance carried him further than partisan rage and hatred did." It is thanks to his goodness, to his moral soundness, to his plebeian simplicity that he traversed the acute period of French romanticism without suffering from the *mal du siècle*. Nothing is more remote from Daumier than the "genius sick with genius" (said by Baudelaire à propos of Delacroix); indeed, all through his life he encountered with Herculean calm the disorderly agitation of the cheaper romanticism. From the prison of Sainte-Pélagie, where he was a prisoner in 1832, he wrote: "So here I am at Pélagie, charming spot where not everybody enjoys himself. But as for me, I do enjoy myself here, if it were only in order to be in the opposition." His immense lithographical output was so poorly paid that material difficulties accompanied him all through life, yet no one ever saw him despair; at most he would confess that the "cart was hard to draw." Sad but not despondent, when he had lost his sight and was left entirely to himself, he still appeared capable of inspiring serenity in his rare visitors (Alexandre). As opposed to certain romantic fashions, there is in Daumier an entire absence of eroticism and, in consequence, a calm feeling about woman as a companion in life and as mother, very rarely

expressed by the art of his period. But, above all, Daumier's work is a spontaneous negation of the myth of Hamlet, chosen as its symbol by a romantic sentimentalism. Whether he contemplates knowledge, feels moral values or realises an artistic image, one sovereign note dominates: his certainty. "You, you have the gesture," Ricourt said to him in 1831, and that gesture, the capacity to synthesise a human character in a gesture, was doubtless the reason for the tremendous success of the caricaturist. In every personage of his there is a strong passion that becomes the sole reason of every one of his acts, absorbs into itself all his life; there is an absolute coherence in which all fits together: "tel nez, tel front, tel oeil, tel pied, telle main" (Baudelaire); in the name of this passion everything is rigorously subordinated to the action, gesture, movement of the ensemble. Many have suggested the comparison of Balzac with Daumier; it may be justified, but with all due reserve, under the aspect of the subordination of character to the rigour of passion.

In order to achieve a synthesis of this kind Daumier was obliged to work from memory, without a model. "He has a marvellous and almost divine memory which, for him, takes the place of a model" (Baudelaire). When Henri Monnier goes to Daumier to pose for a portrait, he sees on the easel the portrait already finished and cries: "Superb! for Heaven's sake don't touch it!" When, in order to insert a few ducks into a composition, Daumier goes to Geoffroy Dechaume's, who owns a few, and the latter offers him a notebook and pencil, Daumier answers: "Thank you. You know very well, I cannot draw from the life." (Escholier).

Drawing from memory out of an innate certainty, synthesis

of character as revealed in gesture, subordination of reality to passion, resolution of the plastic form into light and shade, journalistic-caricatural origin of the new pictorial form, continual transition from the comic to the sublime, consequent discovery of new spiritual values, folk sanity and spontaneity of impulse, faith in the moral value of human dignity and liberty, these are the faces of the prism called Daumier.

Born in 1808, Honoré Daumier reached the full mastery of his lithographical technique, of his visual expression, of his pictorial form, in 1832, and, to be more exact, in that "Portrait of Charles de Lameth" (Delteil 43: Fig. 112) which initiates the series of portraits of celebrities for Philipon's journal, *Caricature*. In contact with reality, free of all ideology or prejudice, Daumier realises an absolute work of art, the character of which is that created grotesque of which we have already spoken. The portraits from now on follow one upon the other, all of them admirable for their unexpected qualities and expressive power, but perhaps none of them ever attaining to the disinterested detachment, the creative liberty of the grotesque Lameth. On coming out of prison, Daumier intensifies, accentuates, envenoms his political invective against Louis-Philippe and the men of his government, and, hugely multiplying his popular success, he publishes in 1834 four big lithographs, still considered to-day his masterpieces. They are: 1. "The Legislative Belly" (Delteil, 131); 2. "Ne Vous y Frottez pas, ou Liberté de la Presse," Have Nothing to do With It, or Liberty of the Press (Delteil, 133); 3. "Enfoncé, Lafayette! . . . Attrape, Mon Vieux!" Lafayette Gone! Tough Luck, Old Fellow! (Delteil, 134; Fig. 113); 4. "Rue

Transnonain, April 15, 1834" (Delteil, 135: Fig. 114). Of these, I reproduce two (Figs. 113–114). They certainly are masterpieces: what kind of masterpiece?

On July 31, 1830, Lafayette had thrown his arms around the neck of Louis-Philippe, and with this gesture he had obliged the victors of the "Three Glorious Days" to accept the monarchy, which promised to become the best of republics. But when this hope was followed by the gravest disappointment, Lafayette was considered a living reproach to the king, and his death—which took place on May 20, 1834— was an occasion for national mourning, all the greater in that it benefited the monarchy. Against the background, in which can be seen Lafayette's funeral procession, Daumier represented Louis-Philippe as fat, dark, awkward: it would seem as though he were weeping and praying; but a sneer appears —it is the King's satanic smile, expressing his pleasure at the death of an embarrassing friend. The plastic effectiveness of the King's jesuitism, the pitiless incisiveness of the caricature could not be greater; and they are admirable, those nuances of black and grey on the heavy body of Louis-Philippe, while the lightness of appearance in the little figures in the background is noteworthy. But there is no relation, visually, between image and background, and the figure of the King is so overemphasised as to overshadow everything else. The greater the projection obtained by the lithographer and the intenser its effect, the more do we sense the defect in the visual impression of the whole, caused by this overemphasis. The more a caricature is pure caricature, the less is its art art. As legal pleading, Daumier's lithography is a miracle, but not as a work of art.

The interpretation of character is carried to its extremes in

the "Rue Transnonain", because, all residue of the comic spirit having disappeared, political invective dominates. On April 15, 1834, during the repression of a republican revolt in Lyon, the soldiers, exasperated by gun-fire directed at them, penetrated into no. 12 rue Transnonain and massacred all the occupants, men, women and children. Daumier's indignation has reached its peak and the representation of the tragedy becomes a condemnation the more inexorable for being objective. In the background, the shadow in which the corpse of the woman is wrapped suggests the modesty of death, human regret, a detachment truly artistic, and the expression fulfills itself through light and shade rather than by means of the body itself. But the corpse of the man is daubed down without pity, in order to arouse horror, indignation and revolt; the naked legs, in their closed outlines, are thrust upon our sight, they seem the very accents of anger, the whiteness of the sheet an accent of horror. We admire the effectiveness of the condemnation, the nobility of the indignation, the assurance and definition of the representation. The crowd thronged to the places where the lithograph was exhibited, Daumier's name at once became popular, his was a battle won for civilisation. Much more, and something less, than a work of art!

The following year, because of the law against freedom of the press, *Caricature* was suppressed. The heroic period of political invective was ended, and between 1836 and 1848 Daumier establishes himself as a caricaturist of manners; and such, save for a few brief intervals, he remains throughout his life. The vehemence of his passion is attenuated, his satire castigates thieves rather than assassins by creating the type of Robert Macaire; he strikes at the men of law, judges and

lawyers, indeed he demolishes them when he persuades you that they cannot look at one another without starting to laugh and, above all, he attacks the pettiness, the obtusity, the little vulgarities of the bourgeoisie of those days. And when Daumier approaches the society at which he pokes his irony, this irony is tinged with benevolence and becomes human participation: his comedy becomes humour. Because of their political and social importance, "Lafayette Gone!" and "Rue Transnonain" at once became famous, and have remained so. "The Cancans" of 1848 (Delteil, 1719) and the "Regrets" of 1853 (Delteil, 2395: Figs. 115 and 116) were, on the other hand, so little appreciated, perhaps because of their tenuity of subject, that they remained unpublished and little known, and are extremely rare. Yet they are two works of absolute art, among the most beautiful that Daumier ever executed. Compare "Lafayette Gone!" and "The Cancans". The disequilibrium in the relation of light and shade in the first becomes a perfect equilibrium in the second. In this, the figures take part in their surroundings, rather than isolating themselves, and lay no claim to the three-dimensional, because the light and shade exclude it. The form is interrupted and resumed in a continuous rhythm, which is the rhythm of light and shade. The action is not cramped to convey a hidden snare, but is manifested with a certainty of expression that is in inverse proportion to the pretension to be noted in the exhibition. The vulgarity of the subject is transformed by human tolerance for the moral miseries of the people. In "Regrets", too, the effect of light and shade is balanced, and the contrast between the blacks in the man and the melting greys of the woman is pervaded by a subtle and melancholy humour, so that the naïve

178

surprise of the stodgy bourgeois awakens not so much laughter as pity. The delicate phantom of the woman as she goes away has an exquisite grace.

Until 1872 Daumier continued to make lithographs, and as late as 1870 and 1871, shaken by political events, he made a few masterpieces. I recall "The Republic Is Calling Us", made, to be exact, in 1870 (Delteil, 3810), in which the lines vanish in the pictorial thicket, without losing any of their expressive force; indeed, they may almost be likened to a choir of infinite voices. But in the meantime, from 1848 on, his activity as a painter had got the upper hand with Daumier, and lithography had taken second place. It now served chiefly to find subjects for him, and as a means of livelihood.

To the competition, opened in 1848, to represent the Republic, Daumier, encouraged by Courbet, submitted a sketch which to-day is in the Louvre; but he could not make up his mind to submit the finished picture. In spite of the qualities of the sketch, you feel it was a blunder, because the theme was allegorical and Daumier detested allegory (Banville). In the same way, "The Miller, His Son and Their Donkey" of 1849 (Klossowski, 5–6), "Oedipus and the Shepherd" (Klossowski, 3) or "The Drinkers" (Klossowski, 264), which belong to about the same period, do not show the painter's style in its final aspect. "The Miller, His Son and Their Donkey" (Tate Gallery: Fig. 117) gives us a very good idea of Daumier's taste when he began to paint. The subject is a typical genre-scene, but the anecdote is scarcely hinted at in the background. The motive, as opposed to the subject, is the great size, the heavy bodies and the vulgarity of the three derisive peasant-

women. But this representation of vulgar objects is itself the very opposite of vulgar. The lightness of tone, the vivacity of the contrasts of light and shade, the decisiveness of the movements, the disjunction of the form, which conforms to the necessities of light and shade rather than to the reality of the body and, at the same time, the expressivity of the lines which never become cursive, because they define volume, all this is the transposition of a vulgar subject onto a plane of pure and therefore perfectly noble art. The mastery of oil-technique is already to be found in this picture, which, as early as 1849, is complete and perfect. Daumier's art, on the other hand, is here neither complete nor perfect. Compared to his later works, this one is superficial. Just because he insists on his realistic volumes, the mobility of the lights is neither free nor absolute, and the nuances of light are lost in the contrasts. For the very reason that he is preoccupied with the physical presentation of his figures, the spiritual nuance is meagre.

In comparison with his predecessors or his contemporaries, Daumier already shows in this early work his greatness as a painter. Doubtless his technique is inspired by that of Decamps, who was the first true *tachiste*. The pictorial value of a dark "spot" against the light, of a clear juxtaposition of light and shade, is in fact Decamps' contribution to French romantic painting. And by means of spots he painted certain interiors which are authentic works of art. But in order to understand Daumier's position with regard to Decamps it is well to observe a work of the latter, "The Bell-Ringers" (Louvre: Fig. 118), painted in 1841. Here we see that the vivacity of the "spot" is superimposed on drawing which remains academic. In fact, Decamps felt, save for rare exceptions, the spot as an

element of the picturesque within the tradition of draughts-manship, rather than as a pictorial principle assimilating tra-ditional form to itself. Decamps' formal interest is, in fact, very superficial and distracted: the subject concerns him much more. What, on the contrary, counts for Daumier is the ex-pression of his sensibility in the most coherent artistic form possible, and thus he was obliged to give up the traditional plastic form.

The same observations, with necessary modifications, may be made concerning Millet. "The Sower" of 1850 (Boston Museum: Fig. 119) is in fact the work of a convinced realist who adopts the technic of oils in a way not very different from that of Daumier. Well, we easily notice that Millet has a thesis, sincerely professed, to be sure, but, after all, a thesis, because of which he is more interested in the *silhouette* than he is in the light and shade, in the elucidation of the prole-tarian "type" than in the creation of a pure vision. The artistic form is, for Millet, a means rather than the end of his paint-ing, and it is natural that to him, as to an orator, it seems opportune to maintain intact the traditional rhythms, easily grasped by the crowd: these rhythms, in painting, are the contours of academic draughtsmanship. In fact, we can trace in Daumier a course inverse to that of Millet. The first sets out from politics and attains to art, the second sets out from the academy and reaches a social and religious rhetoric—incident-ally, a far from contemptible one.

Thus, to understand the origins of Daumier's pictorial style, it will be well to by-pass Millet, severely limit the eventual influence of Decamps' "spot", and return, rather, to the litho-graphs of Daumier himself.

In 1864, Daumier made a lithograph of a scene from the theatre (Delteil 3280: Fig. 120) and, at about the same time, he treated the same subject, "Drama" (Munich Gallery: Fig. 121), in painting. The comparison, in my opinion, shows clearly how in painting Daumier discovered his perfect technique. In the lithograph, detail prevails; a few grotesque profiles distract you, the contrast of light and shade is interrupted by the need for stressing the heads, the figure of the actor is trivial and that of the actress is constrained. In the picture, on the other hand, the actress, who is a zone of pure white, takes on a tragic naturalness; the actor, a black zone, is exactly right in relation to the background; and the spectators become a mass, fused in the half-shadow, their gestures no longer the gestures of individuals but of a crowd. This enhances the unity of impression, while the intense light on the stage to the left attracts the eye according to the movement of the drama. It is a kind of monochrome, all gradations of precious greys, warmed by browns, especially in the faces of the spectators. The extreme simplification of the contrasting light and shade, the compact mass of the crowd, intensifies the dramatic movement; the flash of light, bursting forth amid the general shadow, heightens the pace, the surprise of that dramatic movement; from the space to which the transversal composition gives depth, but which is broken and interrupted so as to prolong it in the imagination, flows a sense of the overwhelming power of the crowd. According to the subject, the crowd is applauding; but according to the passion and style of Daumier, it is rather a crowd in revolt.

Some of the most perfect expressions of Daumier's art are found in his drawings.

182

"The Riders" (private collection, Paris: Fig. 122) is a masterpiece of the art of all time. Let us compare it with the frieze of the Parthenon representing the Panathenæan procession, and we shall perceive that Daumier is not only comparable to Phidias for the beauty of his forms, but that there is in him a wealth of feeling, a spiritual complexity, a heroic and monumental value, capable of assuring us that Christianity has not existed in vain. We must add that in this drawing there is a plastic strength, indeed a plastic intention, exceptional in Daumier. Daumier executed a few works of sculpture; it is possible that this drawing was made for a piece of sculpture which remained unrealised. Be that it as it may, this preoccupation with a plastic vision permitted him to convey a calm which is solemnity.

The drawing, "The Thieves and the Ass" (private collection, Paris: Fig. 123) reveals a completely different aspect of Daumier's talent as a draughtsman. Plastic vision has been replaced by pictorial vision; monumental calm by dramatic movement. The same composition was used by him in a lithograph of 1862 (Delteil, 3253) and in a picture in the Louvre. The superiority of the drawing over the lithograph and the picture is obvious. The lithograph relegates the ass to the remote background, which enhances the illustrative effect, but destroys the plastic unity of the scene. In the painting, unity is preserved, because the ass is an element of the background, without being too distinct from the soil and the trees, and in this way constitutes a dark spot against which the light tones of the fighting thieves stand out. That is, the contrast of light and shade is well realised in the painting. There remains, however, a residuum of typically caricatural drawing in the gri-

mace of the losing fighter. On the other hand, in the drawing, all illustrative or caricatural character vanishes. Energy, strength, movement, are the theme which Daumier purposes to represent, and which he represents with a success in inverse proportion to his insistence on the faces of the wrestling men and on the ass, a success overwhelmingly due to the way in which he loads a few thick black lines with feeling. It is a typical case of perfect identity between a purely imaginative form and the expression of a concrete reality. In the painting the imaginative form is less pure, and, because of a greater preoccupation with reality, it loses its expressive value.

No literary inspiration has been more fertile in results for Daumier's art than that of Don Quixote. Various elements link Cervantes and Daumier: the weapon of comedy, the enthusiasm for the heroic ideal, familiarity with popular themes. And yet Daumier's "Don Quixote" has very little indeed of Cervantes'. Daumier's "Don Quixote" is the perfect expression of that new Don Quixote that romanticism had invented. There is in Daumier the faith in his hero's ideal; he feels the grotesque as though it were the sublime, he sees in the adventurer above all the martyr to an ideal. Whence an amazing zeal and earnestness. Here we realize all that Daumier owes to Goya, both as a creator of the popular-sublime, and as an initiator, in painting, of the romantic style as regards Don Quixote. But at the same time we perceive how the romantic conception of Don Quixote was realised by Daumier not only in a perfect and personal way, but also with such energy of imagination that it is just as living and present to our spirit as is that of Cervantes. And we also observe that, in treating the popular-sublime, Daumier detached himself from natural

reality even more than did Goya, elevated it towards a purer and more coherent pictorial style.

Among the many representations that Daumier has given of "Don Quixote" I select four. The one in the Tate Gallery (Fig. 124) offers particular interest for a knowledge of Daumier's finished work, because it is considered the sketch of the picture formerly owned by Georges Petit (Fuchs, 155). In the latter (Fig. 125), the comic despair of Sancho Panza is concentrated in his face; the face in the "sketch" is in shadow. In the "picture", the plasticity of the arms and legs is well defined; in the "sketch", there is only the contrast of light and shade. But neither the expression of the face nor the plastic definition is in accord with the artist's vision; they lack cohesion with the rest of the work, and so distract from its expressiveness, which is the product of the whole as a unity. A few pictures of Daumier's, for instance the "Print-collectors", are perfectly finished. But the scenes from "Don Quixote" were conceived not in their finish, but in their simple effect of light and shade. In painting them, Daumier is stirred by a need for dramatic fantasy which only partially implicates the real. He feels what there is of unreality in Don Quixote's romantic dream, and he needs to find for it an adequate expression which shall be equally "unreal". They are spots that speak: torn, improvised, convulsed: they would be tragic, but they body forth their madness.

A quieter composition from "Don Quixote" with a moral background of an even deeper tragic quality (because all nature, with its rocky desolation and its torments, takes part in it), is that in the Metropolitan Museum of New York. The volcanic aspect of the landscape is stressed by the

dark spot of the dead mule, and the two distant spots of Don Quixote and Sancho further reveal its significance. It is all a gradation of browns, with a few greenish overlays. Phantoms, solitude, silence, death: the unreal could not take on a greater reality than this, which is the reality of art.

To decorate Daubigny's studio at Auvers, Daumier painted in 1868 a big water-colour, with the scene of "Don Quixote and the Dead Mule", now the property of Baron Gourgaud in Paris (Fig. 127). The rapidity of his drawing permitted Daumier to concentrate the expression of the theme. Towards the top, behind the bony carcass of the mule, beside the rotund Sancho, who is elongated by the form of his own mule, rises Don Quixote, with his lance pointed towards the sky. A few broken lines, a few suggestions of winy lilacs, of blue-greys and browns, suffice to suggest the hero's lofty solitude. The human form seems to disintegrate in the realm of abstract symbols, but these possess such intensity, such an eagerness of life, as to express, almost outside all association with known forms, a world of imagination, freedom, ideal aspiration and heroic dignity, which is certainly the finest dream that Don Quixote can ever have dreamed, the apotheosis of the hero elevated from the comic to the sublime.

Daumier assigned a romantic and a dramatic character to two other themes: "The Emigrants" and "The Pardon".

In "The Emigrants", of the Van Horne collection in Montreal (Fig. 128), the tragic expression, because of its rigorous unity, takes on a sublime power, more perhaps than in any other scene of the kind. In uncertain file, men and horses, bent and fatigued, move on through the storm: the clouds follow them; it would seem as though the earth itself followed. The

certainty, the unity, the inevitability of movement give the impression that this march will go on forever. There is not even a horizon to close it in. Beyond that desperate march lies nothing but the void of the heavens.

Countless times, in lithography and water-colour, did Daumier represent "the men of the law". The hypocrisy, self-sufficiency, venality, cynicism of these "men of the law" have remained in our cultural treasury as unforgettable indictments. With the same motive, he painted also a number of oil-paintings. But his pictorial vision was often influenced by this habit of accusation, as though his repulsion for those who had made him suffer in his youth prevented the detachment from reality which art requires. Sometimes this detachment was achieved, and the masterpiece makes its appearance, especially in "The Pardon" of the Jacob Goldschmidt collection (Fig. 129). Daumier's creative freedom is here at its zenith. The lack of detail has reached a point where he neglects to indicate the features of faces. The faces are light spots and yet perfectly capable of expression, through their direct relation to the dark tones. In fact, the eloquence of the face and hands of the lawyer appealing to the Crucifix for mercy is exceptionally moving. In these spots you see how suggestion can be more effective than representation. The Christ is in half-shade, remote, detached from the fierce reality that the white spots reveal. There is only the relation between the varying intensities of light, and yet it is sufficient to evoke a whole world of remote divine justice and near-by human reality. That world is not evoked by direct association with reality, but by hints through gradations of light, in the way peculiar to art. The emotion that springs from it is therefore not rhetorical, but free, purely human, be-

187

longing to pure art. In spite of the contrasts of light the whole picture is kept in half-shadow, the relations of colour are not only harmonised with extreme sensibility, but have also a certain preciosity seen through the atmospheric shroud. The background is a steel-grey, the benches are brown, the lawyers' table is green, their robes are black, the papers and the stoles are a white-rose colour, the flesh of the lawyers is pinkish, that of the judges grey, of the gendarme brown. The Crucifix is of a purplish brown. And certainly this is one of the masterpieces of Daumier and of painting in general.

The gradual transition from the linear accent of the "charge" to the effect of light and shade is slowly unfolded, and is parallel both to the relinquishment of the traditional graphic form in order to obtain the new pictorial one, and to the detachment from every romantic dream in order to permeate with poetry the reality of everyday.

The "Third-class Carriage", which I reproduce here (Fig. 130), is the one from the Murray collection in Aberdeen. It is more pictorial, less charged with popular-grotesque, more synthetic, than the other one, which, from the Havemeyer collection, passed to the Metropolitan Museum of New York. Doubtless in the work of greater pictorial maturity, here reproduced, certain refinements, psychological suggestions and even a few graces have disappeared. But the volume of the figures and the synthesis of light and shade gain thereby. And especially in the Murray exemplar do we find a certain detachment from reality and from the contingencies of types and classes, an absence of any thesis whatsoever, a greater natural ease, and therefore more poetry.

In the "Two Washerwomen" of the Gerstenberg collection

in Berlin, the composition is particularly felicitous. The stars, the distant bridge, the sky realise perfectly a sense of space and express the solitude in which appear the curved and silent figures of the washerwomen. Strong contrasts are lacking; it is all a nuance of colour. There is the delicate atmosphere of dawn. The relation between light blue and violet dominates, grows darker in the solid bodies and lighter in the atmosphere. An infinite disquiet of ecstasy is the result.

The "Washerwoman With Child" (The Louvre: Fig. 133) is a humble, shrinking shadow, bent under the weight of her work; she approaches us slowly and moves away from the great light that floods the parapet and the houses on the other side of the river. The colours nearby are dark, neutral and cold: the woman's dress is brown with a few greyish green half-lights, the child's garment is blue and her cap black, the neighbouring parapet is a greenish brown; but, on the other side of the bluish green river, the luminosity is a light yellow with a reddish glaze, the shadow of the roofs is a brownish red, and the sky has sanguine tints. Since she is monumental, in her misery, the figure of the woman assumes a heroic dignity, not labored as a social thesis—after the manner of Millet —but expressed with meditation, humility, human sympathy, and shot through with a vein of drama, due to the far-away sunlight so warm and vibrant.

Fig. 132 shows us a detail from "Old Comedy Types", in an American collection. It is a picture painted in order to present, in the form of a few heads, certain pictorial effects. The detail clearly shows what is volume, light and shade, touch, construction and nuance in Daumier's art. The absolute freedom of pictorial effect reveals itself with the assurance that

belongs to Daumier alone, and which is the intimate vitality of the picture.

The "Orchestra Stalls", from the Chester Dale collection in New York (Fig. 131), is almost a monochrome. The background is dark and the figures are lighter, in the flesh and the ornaments of the women; but the light is absorbed by the atmospheric darkness, as in Rembrandt; it appears and disappears in gleams. Of this half-light there is born an incredible grace, revealed not only in the faces of the women, but also in that of the old man above, to the left. It is a moral grace or beauty, explained by their attention, their spiritual participation. This attention suffices to purify this humanity from all vulgarity, revealing it in an instant of spiritual activity. For this reason, this scene is not a bit of "reporting", but a human moment; not a genre-scene, but a lyric song. Modulating his greys, Daumier has made peace with the middle-class and feels its charm.

"Shoppers at the Stalls", of the Staub-Terlinden collection in Maennedorf, Switzerland (Fig. 134), shows us a group in a moment of artistic curiosity interrupting the daily life of the street; a hurried pause to enjoy a print, and then back to one's work. The black of the man with the top-hat, the garnet-red of the little girl, the green and blue shadows of the portfolios, stand out against a light that caresses the brown of the wall, the bluish grey of the little old woman, the rosy white of the pretty girl moving away. Now by contrast, now by fusion, this light is truly a spiritual light, is an instant of genuine joy in our poor life of everyday.

"The Reader", from a private collection in London (Fig. 135), carries us into a subtler, more cultivated world, but one

190

none the less expressive, sincere, spontaneous, simple and human. Every model of Daumier's takes on, by virtue of his style, a sort of simplicity generically human, which partakes at the same time of the directness of the people and the refinement of the aristocracy.

The "Chess-players," in the Petit-Palais (Fig. 136), is another masterly study in attention. The expressive conception of the figures reveals Daumier's moral earnestness: every light, every nuance of shadow vibrates with the mood of concentration. The tones are, as always, shaded: the background is in brown and black; the player facing you is dressed in black and has brown hair; the player turning his back is dressed in grey and has grey hair; his flesh is light brown; the table is green, with brown and black chessmen.

"The Painter Before His Picture", formerly in the Jules Strauss collection in Paris (Fig. 137), is even freer in its luminous touch, without thereby attenuating the energy with which the figure is solidly planted on the ground, nor the concentration of the painter on his work—which lies at the root of the "certainty" of Daumier. Precisely this certainty, this moral seriousness, this concentration, are varying aspects of his capacity to invent his motive at the very instant in which he creates his image.

Every artist creates his motive together with his form, but often the motive is created by merely varying a traditional theme. Few are the geniuses who transport the creation of motives into a world entirely new in relation to immediate tradition in such a way as to create the supposition that the matter of their art is a product of form, rather than vice-versa. Giorgione is one of these, and another is Daumier. Compared

with the romantic painters who had preferred medieval history
or legend to classical themes, Daumier seems to have no mo-
tives for painting: washerwomen, people looking at prints,
chess-players, emigrants, theatre-goers. And yet, if we look
closely, it is he alone who has a motive for painting; the others
remained in a cultural zone, transitory as are all things cul-
tural. Daumier, the man of the people, by his sincerity and
sanity, by the force of his passion, attains at one bound to the
human universal, to that which is at once of the moment and
eternal, the life of everyday and the world of poetry.

To Manet, a youthful pupil in Couture's studio, his teacher
said contemptuously: "You will never be more than the Dau-
mier of your day"—without realising that he was opening
before him the gates of glory. Cézanne and Van Gogh, too,
repeatedly took their inspiration from Daumier. But, beyond
his personal influence, all modern painting is indebted to Dau-
mier for taking the most difficult and decisive step in the con-
quest of pictorial liberty: the choice of themes at once of the
moment and eternal, and the adjustment to the human figure,
with a greater resoluteness than we noted in Corot, of pictorial
form, which until then had been a specialty of landscape.

On a day of discouragement over the fact that he was always
doing caricatures, Daumier said: "It will now soon be thirty
years and each time I think I am doing the last one" (Escho-
lier). In order to paint he gave up caricature, which the pub-
lic, besides, no longer had a taste for; so that from 1860 to
1863 he was excluded from *Charivari*. It meant want and at
the same time freedom to paint; but even when he was again
taken on by *Charivari,* Daumier withdrew more and more,
leaving Paris for Valmondois to await blindness and death

(1879). In the solitude that the years and the change in public taste brought him, he painted for himself and for posterity. If in youth he had flung himself into life as no other painter of his day had done, in his old age he withdrew his work as an artist from the exigencies of life, to the point of incurring universal incomprehension. There is a parallel rhythm in Daumier's passage from caricature to painting, from success to isolation, from struggle to peace, from life to art. Hard and painful had been the man's sacrifice: so much the greater today shines his glory as an artist.

Chapter Eight

COURBET

ERHAPS no French painter of the nineteenth century has been hated as much as Courbet. Yet behind the most determined expressions of hatred, it is easy to detect a certain fear or respect, a recognition, as it were, of his great power. In fact no one, perhaps, in France and in regions far removed from France, has had a wider influence, especially in his way of conceiving pictorial art, and literary art into the bargain. On literary realism the influence of Courbet has, in fact, been very strong. The social value of painting as a return to the people, as the banner of the people's claims, received from Courbet an imprint that even to-day has not completely vanished.

Hatred of Courbet was, moreover, directed far more against the man than against his painting. And if his social character helped the diffusion of his painting, there is no doubt that his pose as a prophet and, above all, his share in the Commune, prevented for a good while any objective appreciation of his work.

It seemed natural therefore that, with the years, with the passing of partisan passions, Courbet's artistic importance should have come to be universally recognised. Without his realism, impressionism would have been unthinkable, and

194

Manet, Renoir, Cézanne, to cite only the greatest, owed, in fact, to Courbet more than one lesson. Indeed, after the first world war, the reaction against impressionism, towards post-impressionism, towards symbolism, was made in the name of plastic energy, of construction by volume: and Courbet was, against the tendencies of his time, a decided supporter of plasticity and volume. Even to-day, Picasso is a firm admirer of his. And yet Courbet strikes us as remote from our mode of feeling, much more so than some of his contemporaries, much more so than a Corot or a Daumier, who were born before he was. And when, in 1929, a great exhibition of Courbet's work was held at the Petit-Palais, the general impression was one of boredom—the worst, that is, of all possible impressions. Thus Courbet was buried for the second time.

The contradiction which has been noted in Courbet's fortune is repeated and complicated in him, as man and as artist, and in the critique of his works.

"A great stupid painter" who "put his wooden shoe through the plate-glass window" (Lemonnier) is the commonest appreciation of his contribution to art. Baudelaire called him "spirit of a sectarian" and "butcher of his faculties"; Mérimée says that his nudes are good for the cannibals of New Zealand. Castagnary, who later became his most faithful defender, wrote in 1857 that Courbet "makes fun of himself, of others, and of his art. As a landscape-painter, he has scarcely seen nature except through the window of a tavern," a shot directed at Courbet's too-great love of beer. Even his friends admitted that "his realism was nothing but ignorance". Silvestre spoke of the "triviality of his tastes", of his "flaccid nature". "His incredulity," he said, "shelters him from the torments of im-

agination. There is nothing violent in him but his vanity; the soul of Narcissus sojourned in him on its last migration. He always paints himself with delight, and languishes with admiration of his own work." Others stress the contradictions in his character: Courbet claimed to be a philosopher and had eyes for nothing but surfaces; whatever his subject was, he painted only still-lifes; he thought he was representing reality, and saw nothing but its physical aspect; he played the simpleton, and had the diplomatic slyness of a peasant; he seemed to be a rock, and his temperament was soft; he affected the strength of a giant, and was as impressionable as a woman.

On one point only was there an agreement between him, his friends and his enemies. He used to call himself a "master-painter", the better to stress the artisan character of his painting. And all admitted in chorus that he was a "puissant work-man". "Courbet was perhaps one of the ablest artisans of painting that this art has ever produced" (Silvestre). Obviously, in this praise there was some reserve concerning the difference between an artisan and an artist.

The climax, or the caricature, of all these contradictions is reached in the ingenuous impression of certain Munich painters as reported by Muentz: Courbet's characteristic was "to see nature like a peasant and to paint it like a teacher". However, neither the animal man joined to the perfect artisan, nor the peasant to the teacher, produces an artist. And since no one to-day doubts that Courbet was an artist, we must seek for another way of understanding him.

This way can lie only through determining what was Courbet's ideal, for, of course, Courbet too had his ideal. He called it realism, and he invented it as an antithesis to the ideal.

196

Critical doubt was not his forte, and so he did not perceive that an ideal, historically determined, such as that against which he was fighting, could be combated only by a different ideal, and not by a mere absence of ideals. Nor were the critics more aware of this fact, with the exception of Proudhon, who understood that "art is . . . at the same time realistic and idealistic, that Courbet and his imitators are in no wise exceptions to this rule" and that if any painters tried to eliminate either the real or the ideal, "they would by that very fact cease to be artists". Unfortunately, Proudhon confused the ideal of the artist with the moralist's ideal, and inspired in Courbet a humanitarian ideal, which the artist in his latter days thought well to adopt, but which did not answer either to his original impulses, or in any way to what was truly artistic in him.

First of all, we should recall that "realism", as Courbet saw it, is an element of romanticism and antedated him. In 1833, Laviron and Galbaccio had written: "Actuality and the social tendency of art are the things that most concern us; only secondarily do we demand truth of representation and the greater or lesser skill of material execution. Above all things we ask the artist for actuality, because we want him to act on society and push it towards progress; we ask him for truth, because he has to be living in order to be understood. All the rest, let us say it once more, belongs to the domain of Utopias and of abstractions." Without counting the landscape-painters, there was Decamps, for instance, who had attempted to realise this ideal programme. And yet Courbet, by reason of his exclusive devotion to his ideal, and by the power of his personality, was the only one to give the impression of having realised

it. This took place about fifteen years after Laviron and Gal-
baccio had formulated the programme of realism, in a moment
in which the revolution of 1848 accentuated the social charac-
ter of thought and gave it a polemical value as over against
other romantic ideals: Christian medievalism, free love, art for
art's sake, dandyism and so forth.

Other contemporaries, Chesneau for instance, understood
moreover that the polemic against the "ideal" meant in fact,
for Courbet, the polemic against tradition. Proudhon discov-
ered the enemy in the neo-classics as much as in the romantics,
between whom he refused to distinguish. Indeed, Ingres and
his followers were the fashion, and found defenders on the
theory of art for art's sake, that is, the theory of ideal beauty.
Delacroix, then, in search of his freedom of imagination,
cursed the realist painter and identified realism and illusion-
ism. Corot and Daumier too had freed themselves from neo-
classicism of the Ingres type and from romanticism of the
Delacroix type, but had done so instinctively, without po-
lemics, the first by remaining apart and by showing only
landscapes, the second by limiting himself to publishing only
his so-called caricatures. The polemical work fell to the lot of
Courbet. And Courbet was well equipped for polemics, as
much by his great qualities as by his defects.

He had no inventive imagination, even if he had a strong
creative one. And so he felt no interest in imagining, by means
of memory and a sense of the appropriate, a composition sug-
gestive of reality. He needed a model for painting either a
human figure, a landscape or a still-life. The function of his
creative imagination consisted only of the way he presented
what he saw. Courbet's great merit consists in limiting himself

198

to what he is capable of: namely, a portrait of what he sees around him. And since he sees neither angels nor the heroes of antiquity and of the Middle Ages, he makes only a portrait of his own environment. It has been said that he painted the portrait of his period, but that must be qualified. It is his period, but limited, as regards locale and milieu, to that with which he was really familiar: the peasant and the small towns-man of Ornans and of the villages of the Franche Comté, Montpellier, and a few other provincial places. Paris, where he lived a good part of his life, did not interest him. So, Courbet's world is very restricted, but it is what he cared for. And, given his innate vanity, he asserts that there is no other. The limitations of his field of vision and his seclusiveness encourage him to attribute an excessive importance to his own world. Before his time it was curiosity about the life of the humble which inspired a peasant scene and this, therefore, belonged to what used to be called the genre-picture. To Courbet, there fell the task of attributing to everyday life, with its poverty and its provincialism, an heroic quality, treating a genre-scene in the same spirit in which others treated an historical one. And this, both materially, inasmuch as he painted peasants on a scale usually reserved to the heroes of history, and morally, because he portrayed the life of the peasants with epic grandeur. Later, we shall see to what degree he succeeded; in any case this was his ideal.

The limitation of his world and the insistence, not to say stubbornness, with which Courbet projected it as the sole world of art, gave to his pictorial production a certain controversial character. The more the sophisticated Parisians were shocked by what that stubborn mountaineer offered them, the more he

gloried in the scandal he created and confused his vanity with his pride of conscience as an artist. Regarding this, even his friend and admirer Proudhon had his reservations: "He still sets himself up as the apologist for pride; in doing so, he shows himself altogether an artist, but a second-rate artist; for, if he had a higher sensibility, he would feel aesthetically that modesty has a value of its own." The combatant, vulgar but full of courage, revealed himself thus by challenging all that artists, critics and the public considered to be the social, moral and intellectual values of tradition. And if Courbet's art suffered from this excessive egotism in his production, controversy profited thereby.

Courbet's ignorance was based on his *incapacity* to learn: he had finished his studies in a provincial college, and later read only, or almost only, what was written about himself. From the revolution of '48, towards which he had taken almost a cold attitude, he had yet derived certain social and humanitarian aspirations which, though somewhat vague and incapable of serving as the basis for any political viewpoint whatsoever, were still such as caused him to put at its service the only thing he was capable of: painting. And with the strong faith not susceptible to doubt which was characteristic of Courbet, he took upon himself "the rôle of saviour of the world through painting". Worse still, in the face of such tremendous events as the war of 1870, the fall of the Empire, and the Commune, he thought he could save France by addressing two letters: one "to the Germans" and one "to German artists", and by taking part in the Commune. The results, for him, were prison, exile and premature death, those "fatal consequences" which Champfleury had foreseen as

200

early as 1863, the fruit of his measureless vanity, of the prevalence of the man over the artist. Courbet the man was a visionary as ingenuous as a child but as sly as a peasant, and altogether devoid of any sense of political or social reality. And although in the recognised representative of "realism" this may appear strange, it suggests that we ought to try to see what there may be of a visionary character in his pictorial realism.

It is in his hankering after caricature that his ingenuousness reaches such a pitch as to destroy all intelligence and all traces of art. The "Return from the Conference" (Fig. 138) aims at being a caricature of drunken priests. The contrast between their clerical dress and the deportment of the drunkards is supposed to arouse laughter. And Courbet in fact painted, in the background, a peasant who is laughing at the procession of drunken priests. But the art of caricature is more complicated than Courbet perhaps realised. The vulgarity of the attitudes and types depicted is such as to place them beyond the pale of laughter. The satirical intention is evident enough, but does not achieve its effect. Instead of a satire, we have a display of brute anger. The laughter and the ridicule which the painter intended to direct against the priests falls back upon himself. Instead of being the caricaturist, he becomes the caricatured. And this is the kind of ridicule that is evoked by several of Courbet's pictures, painted with the most serious intentions; for instance, "The Meeting", which, because of the vanity with which the picture is impregnated and the pointed beard the painter is sporting, has been called: "Bonjour, Monsieur Courbet!"

Courbet's lack of inventive imagination and his congenital

ignorance contributed to the effectiveness of his realistic po-
lemics against neo-classicists and romantics. They did this at
least just as much as did his more solid qualities: his näive
love of nature, whether a woman in the nude or a brook amid
trees, and his faith in the artistic, moral and social value of his
world, so limited and provincial, but close to him, possessed
by him, worthy of poetry simply because it was beloved by
him. Courbet's ideal lives, even if it be limited and exclusive,
even if at times it be confused; it lives because it is sincere,
because Courbet has put his whole heart into it, has enjoyed
and suffered intensely for it. That ideal took on a great im-
portance in the history of taste precisely because of the excep-
tional power with which it was realised.

By an apparent contradiction, Courbet's form, above all, the
form with which he represents the human figure, is much
more traditional, much less revolutionary than is his content.
Think of Delacroix's chromatic masses, of the landscape-style
interpretation of the human figure conceived by Corot, of the
flashing lights of Daumier. Courbet defines his forms much
more than do Delacroix, Corot or Daumier and, in spite of
his undeniable qualities as a colourist, he continues after a
certain fashion the tradition of Gros and Géricault, from
whom, he openly admitted, he derived his origin. That tradi-
tion consisted of a mannerist schooling and a realist intention.
After basing your draughtsmanship on the neo-classical tradi-
tion, you modified and vivified it in order to represent reality.
Ingres proceeded in the same way when he painted his por-
traits. With a revolutionary ardour, which has a certain af-
finity with that of Courbet, Caravaggio too had started from
mannerism to arrive at realism. And in spite of the effective-

ness of their realistic realisations, both of them, Caravaggio as well as Courbet, often reveal their mannerist schooling, and owe to it a taste for plastic precision not always in harmony with the essence of their style.

Before coming to Paris, Courbet had been initiated in the art of painting by a certain Flajoulot, who declared his allegiance to the principles of David. In Paris, he studies neither the Seine nor the sky, but the paintings in the Louvre. In this respect, a comparison with Corot is unavoidable. On his first trip to Rome, Corot, in spite of his neo-classical principles, finds himself in the Forum or before the broken bridge at Narni or on the banks of the Tiber, but forgets to pay a visit to the Sistine Chapel. Courbet, on the contrary, not only works in the Louvre, but creates "pastiches" of the old masters. In his one-man exhibition of 1855, he himself defines his pictures as "studies after the Venetians, Florentine pastiche, pastiche of the Flemings". And note that the pictures he called "pastiches" were actually extremely personal works: that is, his avowed intention to return to tradition was less strong than the impulse of his personality when confronted with nature. In fine, he was a realist in fact more than in intention. In the programme annexed to the catalogue of that exhibition he wrote: "I have simply wished to base upon a thorough knowledge of tradition the reasoned and independent feeling of my own individuality. To know, so as to be able to do, *savoir pour pouvoir,* such was my idea." His "knowledge" of tradition was anything but thorough, but here we are discussing his intentions only. We shall see, later, how far he realised them. It is necessary, rather, to note that *savoir pour pouvoir* is a programme for the physician and for the engineer, or, if

you will, for the wizard, but not for the artist. His *savoir* reeks too much of intellectualism to serve the purposes of imaginative creation, and that *pouvoir* reeks too much of the practical task, of the thirst for power, to be identified with imaginative realisation. Courbet studied Franz Hals and Rembrandt and, in his later years, even made copies of their pictures. But he never attained their creative freedom because he remained too strongly attached to his *savoir* and had too great a thirst for *pouvoir*.

But contemporary critics did not go in for these subleties. "One admits at once, and without reserve, the robustness and the expert skill of his draughtsmanship and of his colour" (Gustave Kahn). In short, what the public will not forgive is, precisely, the originality of the artist, while it appreciates at once that which is least creative in him. The importance of Courbet's personality consists, therefore, in his sectarian ideal, an ideal which annoyed everyone, rather than in his form and colour, most expert, to be sure, and even sensitive but, after all, less original and less spontaneously created. Manet and the impressionists were more indebted to Courbet for his ideal than for his form. Traditionalism of form and ideal revolt remained in Courbet's art as two elements not easily reconcilable, or only in his happier moments of genuine inspiration. At other moments we feel that he degrades a certain type of form invented for heroes, by applying it, pedantically, in the depiction of humble subjects which demand an entirely different form of their own. Compare a peasant of Courbet's with one of Cezanne's and you will understand what is meant by harmony or disagreement between form and content. This comparison will reveal the reason for the indelible impression

made on his contemporaries, as on posterity, of Courbet's "bad taste".

Courbet's abstract or traditional formalism is the result of his plastic imagination. As is well known, the plastic imagination, far from identifying itself with the artistic imagination in general, may lead away from art. It is, more than anything else, the imagination that evokes in the sense of sight the sensations of feeling; which materialises, specifies, renders evident. And therefore, in a certain fashion, it abstracts form from life, renders it typical rather than individual, transforms imagination into myth, and, in fine, in its most complete manifestation, becomes mechanical invention. Then the greatest clarity may be achieved, the most flawless logic: but the creative imagination, the impulse of art, will have disappeared. Therefore, all the greatest artists, while remaining faithful to their plastic ideal, have felt the need for correcting their plastic imagination. Raphael profited from the colouring of the Venetians; Michelangelo found in movement the symbol of life. Courbet found it in his experience of landscape, in his lights, in his transparencies. In his best works the density, the weight, the materiality of the objects represented receive an inner life from the outer vibration. Plasticity becomes what is called "volume". Courbet "studied, above all, the volume of things, the thickness rather than the fineness of silhouettes on layers of transparent air, the density rather than the lightness of the effect" (Lemonnier). This matter of volume is the bridge between the past and the future, by which he leaves behind him the taste of David and Géricault in order to reach the threshold of Cézanne's taste.

Volume is one of the essential elements in Courbet's art. In

205

it his technical learning and his devotion to the physical aspect of reality coincide. Out of a desire for emergence, he rarely constructs his pictures in depth. He needs to have his figures stand out from the surface of the picture, to have his forms extend themselves on the surface, even when they have been given density in order to make them more evident; in fact, he wants every one of his forms to impose itself on the spectator's vision. Generally the item, even if it be strongly individualised, harmonises with the whole, is included in the whole; but, at worst, it dominates and unbalances the composition. In any case, the surface disposition of these items, and the insistence on their emergence, give to Courbet's compositions that character of "marquetry" with which Delacroix reproached him.

On the other hand, as regards execution, Courbet's volume takes on a value all its own. With great subtlety, Zacharie Astruc perceived, as early as 1859, that Courbet's form was opposed to the so-called ideal form, not because it was vulgar rather than noble, but because of the particular character of its execution. He loved to watch Courbet paint: "The ease, the assurance, the firmness of his brush as it races across the canvas, emphasising at the same moment, in order to get a more correct and sustained intonation, every stroke with a marvellous precision of touch, is a spectacle indeed interesting and one that initiates you into the character of the man himself."

To explain what this form is which does not find its justification in any ideal of geometry or of perspective, but solely in a particular quality of execution, we must transform the myth of number into the myth of energy. It is precisely this

energy or vitality of touch that imparts its poetic vibration to everything that Courbet does.

Both the interpretation of plasticity as volume, and his mode of executing form, suggest to us that to Courbet, at least in his happiest moments, form was colouring. Yet he represented a reaction to colourism, to pleasure in varied and brilliant colouring, to the intensity of each separate colour, which romanticism had brought in its train. And this reaction found favour even with the most advanced critics. "M. Courbet by no means overdoes the sonority of tones. . . . The impression that his pictures make will not be the less enduring because of that. . . . M. Courbet's scale is tranquil, imposing and calm" (Champfleury). And this is another one of the surprises in Courbet's character. The aesthetic tradition would have it that colour is the most sensual side of painting. Well, this provincial, usually so sensual, this man otherwise so earthy, in his colouring is impeccably austere. He loves colour, he knows how to evoke a depth of life from the transparencies of half-shadows, and yet he respects colour, much more and much better than he does plastic form. He makes use of form for purposes of *pouvoir,* he uses colour because it inspires him with tenderness. His colouristic sensibility is very deep, yet at the same time limited. And therefore he does not by any means exploit the rich experience of a Delacroix, he does not grasp the possibilities of light in colour. When he wants to go in for *plein-air,* and heightens his palette, he blunders, as in the picture of the "Rencontre" ("The Meeting"). His process is from the dark to the light tones, like that of Corot, but he uses the dark tones a good deal, and the lower they are, the greater the wealth of tone he obtains. Colour is for Courbet

the motive of inner concentration. That is why Courbet's colour possesses a richness that he likes to veil, to give one only a glimpse of; he wishes it to impose itself by barely appearing. But it loses nothing of its material tangibility. He was greatly preoccupied with the "paste" of his colour, and sensed, before any other nineteenth-century painter, the value of effects derived from the splendour of colouring-matter. It is known that a tone is reflected with greater intensity by thick and solid colouring-matter than by a glaze of colour. And in order to accentuate the thickness Courbet substituted the palette-knife for the brush. The readiness and skill of his hand allowed him to manipulate the dense substance with a touch as light as though he were using the finest of brushes. And so he realises the transparencies of lights in half-shadow not by glazes but by the relation of the heavy touches to one another. Thus, he obtains, even if in muted form, a synthesis of the lights of each colour rather than a mixture of the colouring substances. And it is this synthesis which lends to the most material of his volumes the wings of poetry.

Courbet was born at Ornans in 1819, and died an exile in Switzerland in 1877. At the age of twenty-three he is already a master of the essential elements of his style. As early as 1842 he paints the "Courbet With the Black Dog", now in the Petit-Palais at Paris. Using the same elements, but in a loftier flight of genius, he paints, in 1846, another self-portrait, called "The Man With the Pipe" (Fig. 140), now in the Museum of Montpellier. The background is a dull red, the suit is grey, the shirt white, with greyish green shadows; the hair and the beard are black, and frame a reddened face within olive shadows. The flesh painting is worthy of Titian. The torso

has beautiful volumes, the planes of the face have an incredible charm. This grace, which extends throughout the lower tones, and caresses, almost anxiously, the form emerging from the dark shadows, imbues with a certain voluptuousness, "ecstatic and sophisticated, this figure which seems to dream and drowse amid the cloudy smoke from his well-seasoned pipe" (Silvestre). Here the plastic imagination offers a solid foundation for pictorial grace; voluptuousness, realistically portrayed, becomes an accent of the romantic dream; and Courbet's narcissism finds its perfect lyric realisation. Standing before this picture, we remember his great predecessors: Caravaggio for pictorial conception, Velasquez for energy, Giorgione for a dreamlike quality. This is perhaps the work in which Courbet's realism is at its most transcendental. Later on, he will paint more important works, pictorially richer, but none more beautiful. And he was only twenty-seven years old.

It is precisely because of his narcissism that Courbet's self-portraits are so often masterpieces. When he painted other persons, the painter's enthusiasm for his model was much less keen. The portrait of Baudelaire (Montpellier Museum) is only a pretext for devising contrasts of light and shade and transparencies of light, for composing an image in the atmosphere, and amid the objects, of a room. The painter's feeling for the subject does not go beyond his interest in a genre-scene.

It is more traditional, because of the arrangement in space and the gradations of light and shade on the face, than is the "Portrait of Hector Berlioz", of 1850 (Louvre: Fig. 139). But when he is not distracted by problems of light and shade,

Courbet takes a greater interest in the life of his image, and the lovely half-shadows of the eyes, as well as of the image as a whole, express beautifully the severity of meditation.

On November 20, 1849, Courbet writes to a friend: "I had taken our carriage; I was going to the château of Saint-Denis, near Mazières. I stop to watch two men breaking stone along the road. It is seldom that one comes across a more complete picture of misery." He invites the two poor devils to his studio and composes the painting "Stone-Breakers" (Fig. 141), now in the Dresden Museum. "All this takes place in broad daylight, beside the embankment of a roadway. The men stand out against the green slope of a great mountain which fills the canvas and over which cloud-shadows pass; only in the right-hand corner does the slope of the mountain allow a little blue sky to be seen. I invented nothing, dear friend; every day, going out for a drive, I saw these men. Well, in this country that is how you end up."

The revolution of 1848 certainly did increase Courbet's interest in depicting human misery. And yet, in the painter's intention there is no desire to protest, there is no political accent. There is feeling for the disinherited, there is human sympathy. But by his precise and insistent execution, misery, fatigue, old age bowed under its lot, youth void of hope, are made manifest. And that is how people came to realise that Courbet "without wanting to, merely by pointing out injustice, had raised the social question" (D'Ideville).

The problem consists in determining whether human sympathy is implicit in the picture, or whether the exhibition of misery is not rather a mere demonstration, a statement, or even something designed to satisfy curiosity. The genre-scene,

210

which satisfies curiosity rather than artistic needs, is surpassed, but not totally. The attitude of the younger man, the tatters of his shirt, the rustic cooking pot are worthy of a genre-scene. But the figure of the old man has a monumental quality not at all characteristic of genre-scenes. And it is this monumental quality which saves the figure of the old man, and it alone, from a mere rhetorical exhibition of misery. Mantz objected to this figure for simply being, rather than doing. And it is true that the movement of the younger man is more natural. But the movement of the old man is more artistic, for the very reason that natural representation has been replaced by ideal presentation. Every element of the old man's body must be referred to a surface, and is therefore perceived in its plastic value. His action is static precisely in order to stress his plastic reality, even though he gets his vividness from the effect of light and shade. His monumental quality derives from the rigour of the plastic synthesis. The old man is in relation with the shadows of the mountain, but completely isolated from the stones, the pot, the boy. And it is from just these residua of the genre-scene, with its social message, that the authentic theme of art, personified by the image of the old man, is lacking.

"The Burial at Ornans" (Louvre: Fig. 142), which was also begun towards the end of 1849, did not take its rise from a humanitarian impression as did the "Stone-Breakers" and owes its value to a prodigious ability of execution. Magnificent transparencies in the landscape, red, white and light-blue tones enrich the scene. We shall better understand the composition if we remember the small dimensions of Courbet's studio, because of which he lacked sufficient perspective and had therefore, as he said, to work his way blindly. Whence the

over-crowding, in the foreground, of bizarre portraits, has extraneous rather than artistic importance, an interest deriving from the forceful characterisation of strong, tough-fibred— even morally tough-fibred—mountaineers. The expression of sorrow in the women, though it has been admired, is rather mannerist. We are more inclined to admire in them a few pictorial felicities.

The scandal produced by the "Stone-Breakers" and "The Burial" induced Courbet in 1851 to moderate his challenge to popular taste, and to paint his sisters in the landscape of meadows and rocks so dear to him. The result was the picture entitled "Demoiselles de Village" (Metropolitan Museum of New York: Fig. 143), one of the happiest of his works. The prevailing tone in the landscape is yellowish green with yellowish grey rocks. The sky is a bluish green. The little girl is dressed in bluish grey, with a red apron. The three young girls are dressed in pink, white and yellow. The dog is white and black. The chromatic substance is marvellous, soft, exquisite, worthy of Ver Meer. The cattle are a blunder. But the rest of the composition is excellent. The images are isolated against the background, but the elegance of the colouring is sufficient to establish a relation. The contour of the figures recalls popular prints, but the subtlety of the execution dissipates any suggestion of the popular. The masses in the landscape are extremely plastic, and yet their disposition creates a sense of space. The whole is closed and static, whence the clarity of the effect. There is no over-emphasis on a realist programme; reality is here only a pretext for determining the accidental forms.

"The Studio" (Louvre: Fig. 144), of 1855, is the most

complex of Courbet's paintings and, pictorially, the most successful. It is meant to be an evocation of his life after 1848, with himself in the centre painting a landscape, flanked by his nude model; while to the left there is a glimpse of Bohemian life, and to the right are portraits of his friends. Lyric pride, sentimental memories, beatific satisfaction with himself, give to the scene a warmth of life so candid, of such good faith, as to save it from becoming ridiculous. Here also the supreme execution redeems the conception from bathos. Contrary to what has been said about it, this picture has a pictorial unity of composition, atmosphere, colour. The composition describes a semi-circle about the image of Courbet. The unity of atmosphere, heavy and sultry, is interrupted only by the somewhat too crude tones of the picture he is painting. The unity of colour is based on brown, upon which the most varied colours have been grafted. The rear wall is in itself a masterpiece, in which the pinks, light blues and browns are of an infinite delicacy. The nude is one of Courbet's happiest: yet it was painted from a photograph. It is realised entirely through volumes of light and shade. And the pink garments on the floor constitute a perfect still-life. The portraits are taken from previous works of Courbet's. We are dealing, therefore, with a picture based on memories, with a true vision, in which the desire for realism does not count. Indeed, compared with "The Burial" it is obvious what an advantage Courbet has derived from his indifference here to reality, from the warmth with which he has glorified himself. The images represented often remain isolated through over-emphasis, while the dense atmosphere serves as an independent element to bind the whole thing together. Whence a contrast between

unity of effect and the isolation of images which is not without a certain grace.

Other pictures, and other compositions, of equal artistic merit were created by Courbet both before and after 1855. For instance, "The Sleeping Blonde" (Matisse Collection, Nice: Fig. 145), in which the development of the planes of the flesh has an extraordinary plastic effectiveness, and in which can be noted a certain concentration of the artist's attention on form freed from too many associations with real objects.

Courbet was naturally and healthily sensual, nevertheless he inclined to dream of ineffable purity. "A Young Girl's Dream" of 1844 (Collection Oskar Reinhart, Winterthur: Fig. 146) has the mood of a fairy-tale. The woods, the sleeper, the hammock, suggest a fantastic vision. But the attention given by the painter to the firm and blooming contours of the young girl holds us to reality and plants the roots of the fairy-tale solidly in earth. Yet the outlines are still a trifle mannered.

No mannerism, on the other hand, is observable in the exceptional grace of "The Lady of Francfort" of 1858 (Zurich Museum: Fig. 147). The whiteness of the flesh and of the garments appears wraith-like against the green-blue-grey of the landscape, which reflects the orange of the sunset sky. The charm exerted over Courbet by such bourgeois prosperity, by such simple and distinguished tranquillity, inspired him to a masterpiece. Courbet the dreamer took hold of Courbet the realist, and made of his realism a sort of bridle, which, while it checked, intensified the dream. Other works of Courbet's, although more famous, such as "The Burial", are less felicitous.

Even the fat "Mother Grégoire" (Art Institute of Chicago:

214

Fig. 148) of 1860 inspired Courbet. The vulgarity of the image is redeemed by sheer delight in its vulgarity, by the lower-class good-nature with which it has been observed, and by the discreet vivacity, full of nuances, with which it is painted.

Yet the figure-pictures by Courbet that are real works of art grow continually rarer after 1855. Between 1859 and 1861 Courbet's concessions to public taste grow ever more frequent. Castagnary is glad that Courbet has given up his powerful nudes of women of the people and is paying homage to the elegance of Parisian models. In 1865, at Trouville, Courbet wins even social successes, which are followed by financial ones. Courbet loses his head. The apostle of realism and democracy takes over the painter. In 1861, at the Congress of Antwerp, he affirms that "By resolving on the negation of the ideal and all that follows from it, I arrive at the total emancipation of the individual, and finally at democracy". In the same year, he opens a school in Paris, choosing as his first model an ox. And forty young men leave the Académie des Beaux-Arts to follow him. At the same time, the pleasure he takes in the finish of his works, in his skill and virtuosity, render Courbet insensible to reality. In vain Mantz invites him to resume contact with nature. Champfleury senses that Courbet "realising in his heart the decline of his power of execution, seeks to stimulate himself by the selection of rowdy themes". And, with melancholy, he adds, in a note published posthumously: nature "armed him for twenty years of struggle, but not for more".

In 1866, the public looked upon Courbet's works with benevolence but, alas! with indifference. Zola accused him of

having "gone over to the enemy". He is a "powerful spirit, admired at the very moment when he has lost some of his power". In the selfsame year, Courbet exhibited "The Woman with the Parrot" (Metropolitan Museum of Art of New York: Fig. 149), one of the most staggering blunders he ever committed. The face and the sheet are splendid bits of painting. But plastic imagination here reaches a pitch of exhibitionism so precise and deliberate that the result, far from being art, is an essay in cold-blooded eroticism. His anti-clerical propaganda didn't fare any better, as we have already seen in connection with the "Return from the Conference", painted in 1863 (Fig. 138).

In order to recapture his detachment, the emotion, the freedom necessary for artistic creation, Courbet had to turn to the sky and the sea, to landscape and to still-life. Friends and enemies were all agreed that Courbet was a great landscape-painter. There were always some who complained that he did not embellish nature. But after the success of Constable, after Huet, Rousseau and the other landscape-painters of 1830, the "idealist" eye had lost its keenness in gauging landscape. Everybody had confidence in Courbet and his realism: a tree or a rock did not arouse social resentment as did a stone-breaker or a too obese nude. And everybody recognised the obvious fact that his colouring was admirable and his light and shade marvelously executed. Nobody, however, so far as I know, has shown how keenly Courbet felt landscape, what it was that he selected from the totality we call nature. To say that he did not select, because he did not select the *beau idéal,* is a mistake, for every landscape of his reveals a style that is extremely homogeneous. Courbet himself boasted that he did

not select—but that meant only that his selection was based on impulse and not on conscious choice.

Francis Wey heard Courbet say to him: "Look at what I've just been painting", and Wey observed that it was "firewood". "I felt no need to know that," said Courbet; "I painted what I saw, without realising what it was." He got up, walked back, then: "Why! it's true, it is firewood." And Wey adds: "Being by nature, just as much of a mountaineer as he, I can certify that he was sincere." There you have what Courbet first noticed, the appearance of things, rather than the fact that these natural objects were "firewood".

Having concentrated on appearance, he had to select from among the details of appearance. And here, density, volume and the other methods of visualisation to be found in his figures are once more evident in his landscapes. We must observe, however, that transparencies of light and shade are much more essential in the picture of a glade or an "under-wood" than they are in that of a stone-breaker, and that in consequence the subject itself obliges Courbet to make greater use of his plastic imagination in a landscape than in a figure. Last of all, we have indicated Courbet's narcissism, which prevented his taking sufficient interest in other individuals to portray them lyrically. Nature, on the contrary, its rocks and woods and brooks in the Franche Comté, or the sea at Palavas and Trouville, were things after his own heart, mirrors of his lordly soul, and aroused in him unlimited enthusiasm. This is the secret of his landscape masterpieces.

"The Shaded Stream", also called "The Stream of the Black Spring" (Louvre: Fig. 150), exhibited in 1867, and "Solitude" (Montpellier Museum) of 1866, represent the happiest ex-

amples of the treatment of similar themes. The scale is limited. In "The Shaded Stream" the trees are painted a green which, in the shadow, turns to grey, and the waters a grey which receives green reflections. The rocks are grey with brown shadows. The sky is a light grey, with a few pale-blue zones. The whole life of the picture depends therefore on a few gradations, reflections, transparencies. There is a magic pulverisation of the atmosphere that evokes ecstasy, and in every rock there is a feeling of grandeur, of certainty, of eternity, through which the majesty of nature, the majesty of silence, are represented in monumental fashion. Concerning the "Solitude", the same observations might be made.

It is well to compare these two rather obscure masterpieces with a famous but very superficial picture: "Covert of the Roe-deer" (Louvre: Fig. 151). It also dates from 1866, and is therefore contemporary with the two pictures just mentioned. And the care that Courbet took with it was, without doubt, far greater. But this care results not in ecstasy but, rather, in a victory for technique. Therefore, the colour is lightened, and loses its tonal value, and the finish is excessive; things lose their atmospheric life, their reserve, their intimacy. The expertness of touch and the energy of the light are marvellous. But in the roe-deer the plastic imagination prevails: they lack fusion, and in the rocks and trees the zones are a little too independent of the total effect. In fine, this constitutes a lesser blunder of the same type as that found in "The Woman with the Parrot".

In the picture called "In the Forest" (Tate Gallery: Fig. 152), the beauty and monumental dignity of the vision are truly remarkable. There is, however, an illusionist prin-

218

ciple that makes the picture prosaic: it seems as though Courbet were inviting us to enter the woods, to enjoy the shade and the humid coolness; one's contemplation of the picture is, in consequence, not sufficiently detached.

The need for weight and volume innate in Courbet's imagination suggested to him the value of the rocks of his countryside. At the Salon of 1849 he exhibited "The Valley of the Loue Viewed from La Roche du Mont" (Homberg collection). The colour effect is based on the yellowish green of the meadow and on the brownish green of the tree in relation to the black grey of the rocks, the blue grey of the brook, the pale-blue white of the sky. And the transversal composition, which suggests space, permits the rock to take on a particularly monumental aspect.

Courbet also counterposed the solidity of a rock to the spatial extension of the sea, for instance at Étretat, in a theme which was to become a commonplace of impressionism. Among the various examples of the Étretat theme, that in the Cleveland Museum is particularly felicitous (Fig. 153).

The sea suggested to Courbet the possibility of heightening his palette without letting the light values lose their tonal support, but by intensifying the single colours. The less he has been faithful to the theme and the more he has concentrated his attention on the light of the sea and sky, the better he has succeeded. The "Calm Sea" of 1869 (Metropolitan Museum: Fig. 155) is a great masterpiece. The beach in the foreground is a violet grey, the two boats are brown, the water is a rosy yellow, the sea is green, the sky is a grey, now light and now dark, with scarcely a trace of blue. Yet these few touches of colour suffice to give vitality to the vision. The horizon is

enormous. The sea and the sky are gigantic. But Courbet feels himself a giant, too. The boats may well be miserable specks. But a man who can see such visions is a giant. Nobody in the nineteenth century, not even Delacroix, had sensed in the presence of the sea such majestic power, such a heroic force. The sea when calm was a source of happy inspiration to Courbet on other occasions (Fig. 154).

"The Wave", and Courbet's other dramatic marine paintings are mere side-shows compared with the epic character of his "Calm Sea".

His pictures of flowers and fruits (Fig. 156) reveal another aspect of Courbet's lyricism, an aspect less imposing, more sensual, and yet authentic. For this sensuality exalts itself and renders monumental the petal of a flower, or the rondure of an apple. It is a monumentality that does not lose its vigour, but rather takes on substance through the corporeality of the colour.

The "Flowers at the Foot of a Tree", now in the Paul Rosenberg Gallery (Fig. 157), was painted in 1871, in the year in which Courbet was imprisoned. His serene submission to the plastic and pictorial values of the theme is obvious proof of the moral sanity, of the unshakable vitality of the artist, even at those moments when Courbet the man was at his most unfortunate.

The "Cherry-branch in Blossom" of 1863 (Collection Ludwig Wolde, Berlin) is one of the clearest examples of Courbet's ability to transform his vision of nature into a fairy dream, to set out with the intentions of a realist and end up with the joys of the imagination.

So the impression that Courbet leaves on anyone who tries

to understand him is that of an artist, all the more perfectly ideal the more he is in touch with the earth and, especially, with his own earth, with what he feels and loves. He idealises Mère Grégoire and materialises the woman with the parrot. He idealises a few round apples or the walls of his studio, and even his own face, but he materialises the figures of priests or even that of his friend and Maecenas, Bruyas. A sensual attachment is necessary for him in order to be able to detach himself from his theme with an imagination at once ingenuous and sentimental. If the sensual attachment is lacking, he then abandons himself to his skill, with a veritable spiritual frigidity. And his art ceases to function.

This is the limitation and this is the strength of Courbet. The narrower his limitation, the more indomitable his power.

Bibliography [1]

Among works of a general nature may be mentioned: André Michel and Alfred de Lostalot, *L'art au 19me siècle;—L'école française;* André Fontainas, *Histoire de la peinture française au 19me siècle,* 1906; et L. Vauxelles, *Histoire de l'art français de la révolution à nos jours,* n.d.; Léon Rosenthal, *Du romantisme au réalisme,* 1914; Henri Focillon, *La peinture au 19me siècle,* 1927–28, 2 vols.; Julius Meier-Graefe, *Entwickelungs-geschichte der modernen Kunst,* 1920, 3 vols.; Karl Scheffler, *Geschichte der Europaeischen Malerei,* n.d.; Max Deri, *Die Malerei im 19. Jahrhundert,* 1923.

I. GOYA.

Main sources: Charles Baudelaire, *Curiosités esthétiques,* 1857; Fr. Zapater y Gomez, *Noticias biográficas,* 1868; Pierre D'Achiardi, *Les dessins de Goya,* 1908; A. De Beruete y Moret, *Goya,* 1917–1919, 3 vols., Albert F. Calvert, *Goya,* 1908; A. L. Mayer, *Goya,* 1923; F. J. Sanchez Canton, *Goya,* 1930.

Other sources: Louis Viardot, *Les musées d'Espagne,* 1843; Théophile Gautier, *Voyage en Espagne,* 1845; Laurent Matheron, 1858; Gustave Brunet, *Études sur F. G.,* 1865; Charles Yriarte, 1867; Paul Lefort, 1877; Conte de la Vinaza, 1887; Sir W. Rothenstein, 1900; Paul Lafond, 1902; W. von Loga, 1903; Richard Muther, 1904; Loth. Brieger, 1912; W. E. B. Starkweather, 1916; Jean Tild, 1921;

[1] This is by no means a complete bibliography, but simply an indication of the most important works that have been consulted. Abbreviations used are: *G.B.A.,* for *Gazette des beaux-arts; B.M.,* for *Burlington Magazine; Am.A.,* for *Amour de l'art; A.A.,* for *L'Art et les artistes.*

Jean Cassou, 1926; H. Guerlin, 1927; P. Frédérix, 1928; Eugenio d'Ors, *L'art de G.,* 1928; François Fosca, 1931; Jean d'Elbée, *Le sourd et le muet,* 1931; Charles Terrasse, 1931. Compare also: Menendez y Pelayo, *Historia de las ideas esteticas en Espana,* T. VI, 3d. ed., 1923; J. J. Bertrand, *Cervantes et le romantisme allemand,* 1914.

II. CONSTABLE.

Main sources: C. R. Leslie, *Memoirs of the Life of John Constable,* 1st ed., 1845; 2d augmented edition, ed. A. Shirley, London 1937; French translation by Léon Bazalgette, with much information concerning Constable's relations with France, Paris, 1905.

Various Subjects of Landscape, Characteristic of English Scenery, from Pictures Painted by John Constable, London, 1830.

Other sources: Augustin Rischgitz, *Drawings by J. C.,* n.d.; Ch. Holmes, C., 1902; E. V. Lucas, 1924; A. Fontainas, 1926; J. Ruskin, *Modern Painters,* vol. I and III; W. Buerger, *L'école anglaise,* 1871; E. Chesneau, *Peinture anglaise,* n.d.; R. H. Wilenski, *English Painting,* 1933; Roger Fry, *British Painting,* n.d.; Chr. Hussey, *The Picturesque,* 1827; D. S. MacColl, in *B.M.,* 1912, XX, p. 267 and ff.; *Centenary Exhibition of Paintings and Water-colours by John Constable,* 1937. Illustr. catalogue. Tate Gallery.

For Bonington compare A. Dubuisson, *R.P.B.,* 1924.

III. DAVID.

E. -J. Delécluze, *L.D., Son école et son temps,* 1855; J. L. Jules, *David,* 1880–82, 2 vols.; Ch. Saunier, 1903; L. Rosenthal, 1905; R. Cantinelli, 1930; Fr. Benoit, *L'art français sous la révolution et l'empire,* 1897; Quatremère de Quincy, *Essai sur la nature . . . de*

l'imitation dans les beaux-arts, 1823; Émeric-David, *Recherches sur l'art statuaire,* 1805; F. P. G. Guizot, *Essai sur ... les beaux-arts,* 1816; Stendhal, *Salons de 1824 et 1827* (in: *Mélanges d'art,* 1923); "Concerning A. Thiers as an Art-critic," see: (*GBA*) 1873, I, p. 295 and ff.

L. Vitet, *Études sur les beaux-arts,* 1845; E. Delacroix, *Journal,* vol. I, p. 240; Henry Jouin, *David d'Angers,* 1878; T. Thoré, *Le salon de 1846,* 1846; Louis Conrajod, *Leçons,* III, 1903; P. Dorber, in: *GBA,* 1907, I, p. 306 ff; Ch. Saunier, in: *GBA,* 1913, I, p. 271 ff; *Exposition David et ses élèves.* Catalogue, 1913.

IV. INGRES.

Main sources: Charles Baudelaire, *L'art romantique: Ingres,* 1855; Th. Silvestre, *Les artistes français,* 1856; Ernest Chesneau, *Les chefs d'école,* 1852; Henri Delaborde, *Ingres,* 1870; Amaury-Duval, *L'atelier d'Ingres,* 1878; H. Lapauze, *Les dessins de J. A. D. Ingres du Musée de Montauban,* 1901, I, 1911.

Other sources: X. Doudan, Letter of Feb. 23, 1842, in: *Lettres,* I; Delécluze, *David,* 1855; Th. Gautier in: *Les beaux-arts en Europe,* I, 1855; Ch. Lenormant, *Beaux-arts et voyages,* 1861; Olivier Merson, 1867; Ch. Blanc, 1870; R. Balze, 1880; L. Jannot, *Opinions,* 1887; André Michel, *Notes sur l'art moderne,* 1896; T. de Wyzewa, 1907; Ch. Morice, 1911, in the: *Mercure de France;* G. Lecomte, in: *Correspondant,* April 25, 1911; R. de la Sizeranne, in: *Revue des deux-mondes,* May 15, 1911; J. E. Blanche, *De David à Degas,* 1919; J. Gasquet, in: *Am.A.,* 1920; Collins, Baker, in: *B.M.,* 1921, XXIX; Froehlich-Bum, 1924; Clive Bell in: *B.M.,* 1926, II; F. F. Bouisset in: *Renaissance,* Sept. 1927; J. G. Goulinet, in: *A.A.,* 1927–1928; L. Hourticq, 1928; J. Fouquet, 1930; A. L'Hote, *La peinture,* 1933; Grappe, in: *Art vivant,* May, 1934.

V. DELACROIX.

Main sources: Eugene Delacroix, *Journal et correspondance générale, publiés par André Joubin,* Plon, 8 vols.; *Oeuvres littéraires,* 1923, 2 vols.; Baudelaire, *Variétés critiques,* 1924; Th. Silvestre, *Les artistes français,* 1856; Ernest Chesneau, *Les chefs d'école,* 1862; Maurice Tourneux, *E.D. devant ses contemporains,* 1886; Adolphe Moreau, *E.D. et son oeuvre,* 1873; Moreau-Nélaton, *Delacroix raconté par lui-même,* 1916; Meier-Graefe, *D.,* 1922; Escholier, *D.,* 1926.

Other sources: Théophile Gautier, *Les beaux-arts en Europe,* 1855; ——, *Histoire du romantisme,* 1874; Zacharie Astruc, *Les 14 stations du salon,* 1859; Piron, *E.D. sa vie et ses oeuvres,* 1865; Pierre Petroz, *L'art et la critique en France,* 1875; Ch. Blanc, *Les artistes de mon temps,* 1876; E. Dargenty, *E.D. par lui-même,* 1855; Jean Gigoux, *Causeries sur les artistes de mon temps,* 1885; André Michel, *L'art du 19me siècle,* n.d.; E. Bernard, in: *Révolution esthétique,* 1908; Rosenthal, *Du romantisme au réalisme,* 1914; Mary Pittaluga, in: *L'Arte,* 1917–1918; Paul Signac, *De E.D. à néo-impressionisme,* 1921; Gillot, 1928; Courthion, 1928; Paul Jamot, in: *Le romantisme et l'art,* 1928; and in: *Catalogue de l'exposition Delacroix,* 1930; Louis de Planet, *Souvenirs de peinture avec M.E.D.,* 1929; Graber, 1929; Walter Pach, in: *Am.A.,* 1930; Camille Mauclair, in: *AA.,* 1929; Lionello Venturi, in: *L'Arte,* 1931; Louis Hourticq, 1930; André Joubin, in: *Voyage de Delacroix au Maroc,* Musée de l'Orangerie, 1933.

VI. COROT.

Main sources: Henri Dumesnil, *C., souvenirs intimes,* 1875; Jean Rousseau, *Camille Corot,* 1884; Alfred Robaut, *L'oeuvre de*

226

Corot, 1905, 4 vols.; Moreau-Nélaton, 1924, 2 vols.; C. Bernheim de Villers, *C., peintre de figures,* 1930; J. Meier-Graefe, 1930.

Other sources: Baudelaire, *op. cit.;* Thoré-Buerger, *Salons,* 1845–68; P. Mantz, *Salon de 1847;* Z. Astruc, *op. cit.,* 1859; A. Stevens, *Le salon de 1863;* Camille Lemonnier, *Salon,* 1870; Ph. Burty, E. Vernier, *Douze lithographies d'après Corot,* 1870; Ch. Blanc, *op. cit.,* 1876; J. Clarétie, *L'Art et les artistes français,* 1876; A. de Lostalot, *L'école française de Delacroix à Regnault,* 1880; H. Jouin, *Maitres contemporains,* 1887; Castagnary, *Salons,* 1892; George Moore, *Modern Painting,* 1893; André Michel, *op. cit.,* 1896; Geffroy, *La vie artistique,* VII, 1901; Roger Marx, *Études sur l'école française,* 1903; Werner Weisbach, *Impressionismus,* 1911; Gustave Charlier, *Le sentiment de la nature chez les romantiques français,* 1912; D. Croal Thompson, *Les paysages de C.,* 1913; A. Dubuisson, in: *The Studio,* 1913; André L'Hote, *C.,* 1923; Geffroy, *C.,* 1924; Prosper Dorber, *L'art du paysage en France,* 1925; Oppo, *Corot,* 1925; Marc Lafargue, *C.,* 1925; *Le paysage français de Poussin à Corot,* 1926; F. Fosca, in: *Am.A.,* 1928; Anonym., in: *Documents,* 1929; Blanche, *Les arts plastiques,* 1931; Bertello, in: *L'Arte,* 1931; René Jean, *C.,* 1931; Fr. Paulhan, *L'esthétique au paysage,* 1931; Roger Fry, in: *B.M.,* 1934; Camille Mauclair, in: *A.A.,* 1934.

VII. DAUMIER.

Main sources: Baudelaire, *op. cit.;* Champfleury, *Histoire de la caricature moderne,* 1864; Arsène Alexandre, 1888, repr. 1928; E. Klossowski, 1923; R. Escholier, 1923; L. Delteil, *Le peintre-graveur illustré,* vol. XX-XXIX-bis, 1925–30; *Honoré Daumier, Holzschnitte,* ed. E. Fuchs, n.d.; E. Fuchs, 1930.

Other sources: Stendhal, *Mélanges d'art et de littérature;*

Duranty, in: *GBA.*, 1878, vol. I; E. Montrosier, in: *L'Art*, 1878, vol. XIII; J. Clarétie, 1882; Th. de Banville, *Mes souvenirs*, 1883; J. Gigoux, *op. cit.*, 1885; Goncourt, *Journal*, 1888, vol. I, II, VI; Catagnary, *op. cit.*, 1892; Gustave Kahn, in: *GBA.*, 1901, vol. I; G. Geffroy, *La vie artistique*, 1901; E. Fuchs, *Die Karikatur*, 1901; Franz Jourdain, *De choses et d'autres*, 1902; E. L. Clary, 1907; J. J. A. Bertrand, *Cervantes et le romantisme allemand*, 1914; A. Blum, in: *GBA.*, 1920, vol. I; Ardengo Soffici, in: *Dedalo*, 1921; E. Waldmann, 1919; Gustave Geffroy, n.d.; L. Rosenthal, n.d.; A. Fontainas, 1923; H. Marcel, n.d.; R. Rey, 1923; Michael Sadleir, 1924; K. Scheffler, in: *Am.A.*, 1926; Zervos and Fuchs, in: *Cahiers d'art*, 1928; L. Rosenthal, *Le romantisme et l'art*, 1928; H. Facillon, in: *GBA.*, 1925, vol. II; Grass-Mick, 1931; L. Refort, *La caricature littéraire*, 1932; L. Venturi, in: *L'Arte*, 1934; *Catalogues de l'Exposition Daumier au Musée de l'Orangerie et à la Bibliothèque Nationale*, 1934; Cahen-Hayem in: *Formes*, 1934; Carlo Rim, 1935; Jean Adhémar, in: *Bulletin de la société d'histoire de l'art*, 1935; G. Scheiwiller, 1936; A. Mongan, in: *GBA.*, 1937, I; D. Rosen and H. Marceau, *Technical Notes on D.*, 1937; Lionello Venturi, in: *The Art Quarterly*, 1938.

VIII. COURBET.

Main sources: Baudelaire, *op. cit.;* Th. Silvestre, *op. cit.*, 1856; Champfleury, *Grandes figures d'hier et d'aujourd'hui*, 1861; M. Guichard, *Les doctrines de M.G.C.*, 1862; P. J. Proudhon, *Du principe de l'art et sa destination sociale*, 1865; Camille Lemonnier, 1878; H. d'Ideville, 1878; P. Mantz, in: *GBA.*, 1878, vol. I; Castagnary, *Fragments d'un livre sur C.*, in: *GBA.*, 1911–1912; Jules Troubat, *Une amitié à la D'Artez*, 1900; George Riat, 1906; Th. Duret, 1918; Pierre Borel, *Le roman de G.C.*, 1922; Charles Leger, 1929.

BIBLIOGRAPHY

Other sources: Delacroix, *Journal,* II; Th. Gautier, *op. cit.,* 1855; Buerger, *op. cit.;* E. Zola, *Mes haines,* 1866; Chesneau, *op. cit.;* Max Claudet, 1878; Gros-Kost, 1880; J. Gigoux, in: *La revue Franc-Comtoise,* 1884; Barbey d'Aurevilly, *Sensations d'art,* 1887; A. Estignard, 1897; G. Geffroy, in: *La vie artistique,* VI-VII, 1900–1901; G. Gazier, 1906; Béla Lázár, *C. et son influence à l'étranger,* 1911; Paul Audra in: *L'Olivier,* a periodical published at Nice, 1913; E. Lecomte, in: *Renaissance,* 1919; Clive Bell, in: *BM,* 1920; A. Fontainas, in: *Am.A.,* 1920; L. Bénédite, n.d.; A. Fontainas, 1921; Edith Valerio, in: *Art in America,* 1922; Meier-Graefe, 1924; Roger Fry, *Transformations,* 1926; Gustave Kahn, in: *AA.,* 1927; G. Grappe, in: *L'Art vivant,* 1928; Gronkowski in: *GBA.,* 1929, vol. II; J. E. Blanche, in: *L'Art vivant,* 1929; Marie Elbé, in: *Documents,* 1930; *Am.A.,* 1931, p. 383 ff; P. Courthion, 1931.

INDEX

INDEX

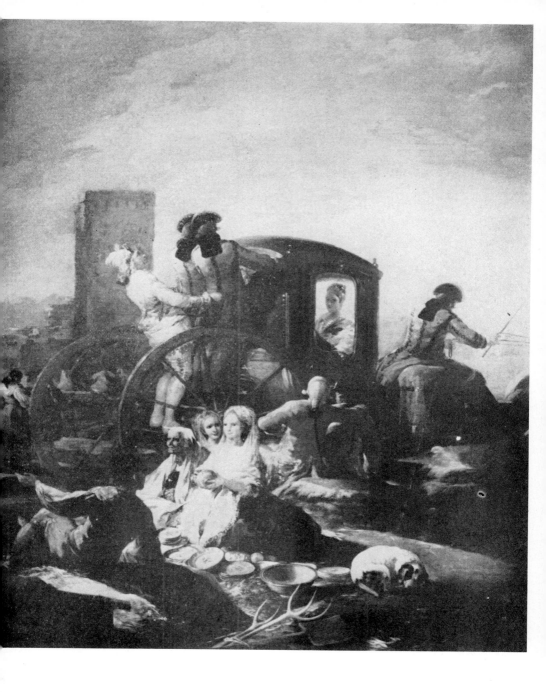

. I. GOYA: *Crockery Vendor,*

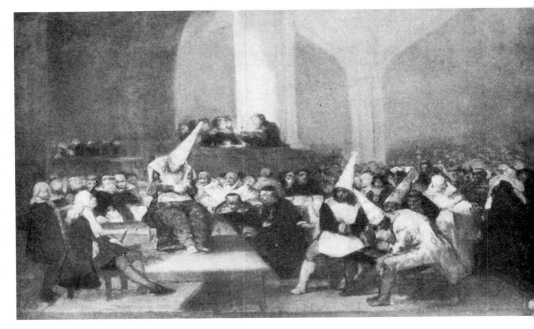

Fig. 2. GOYA: *Judgment of the Inquisition.*

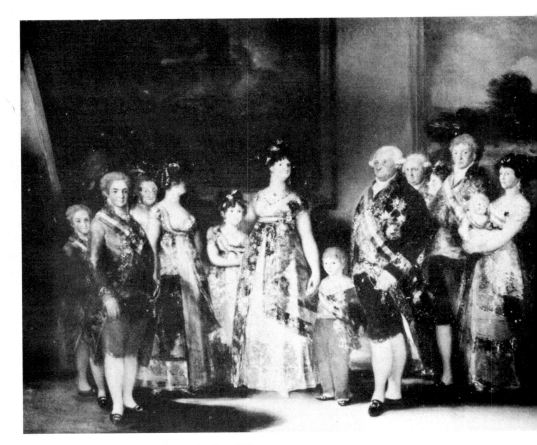

Fig. 3. GOYA: *The Family of Carlos IV.*

Fig. 4. GOYA: *Young Woman Pulling Up Her Stocking.*

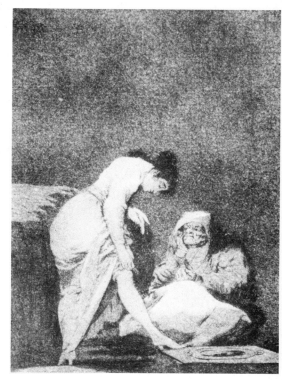

g. 5. GOYA: *The Sleep Which Enervates* (design for the print).
g. 6. GOYA: *The Sleep Which Enervates.*

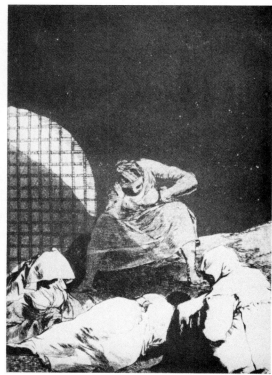

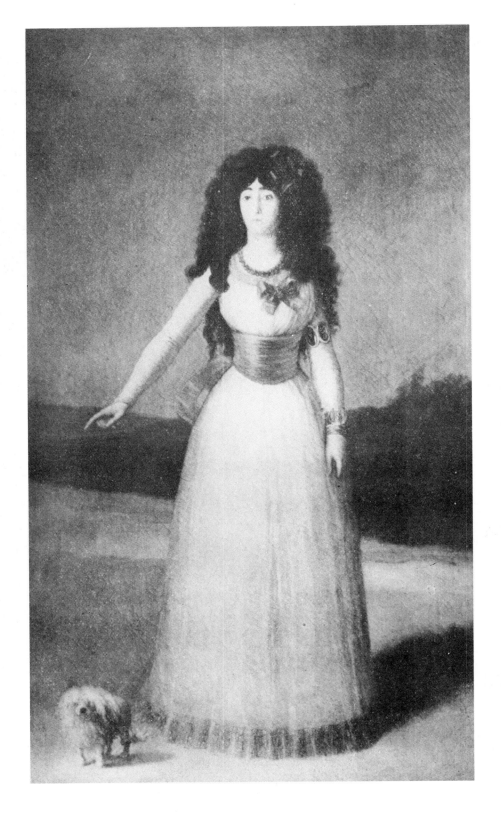

Fig. 7. GOYA: *Portrait of the Duchess of Alba.*

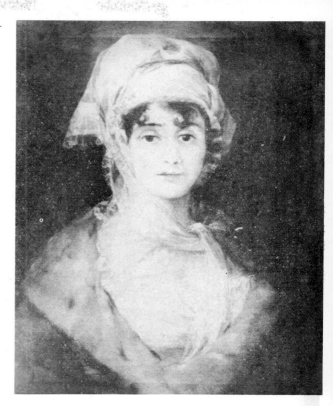

Fig. 8. GOYA: *Portrait of Doña Antonia Zarate.*

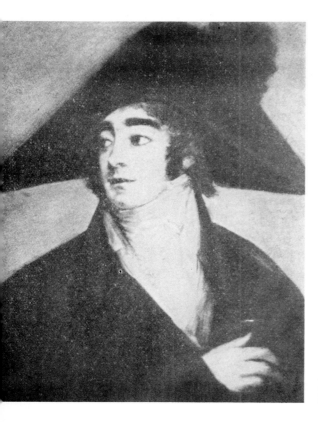

Fig. 9. GOYA: *Conde de Fernan-Nuñez* (detail).

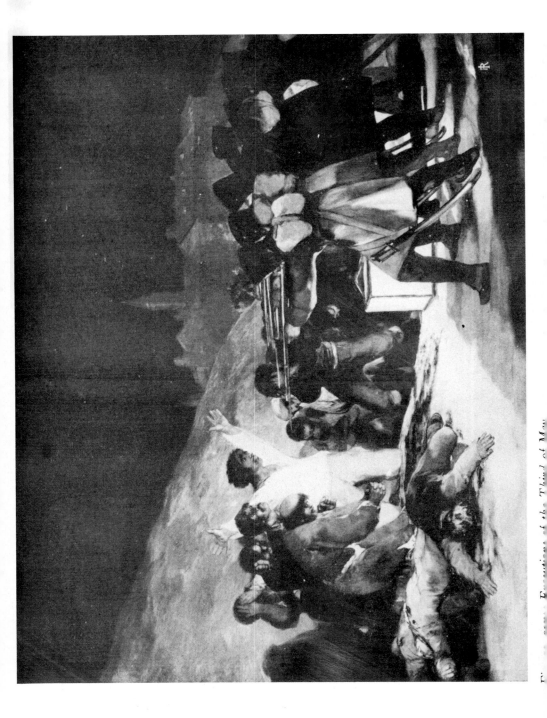

Figure 9999. Executions of the Third of May

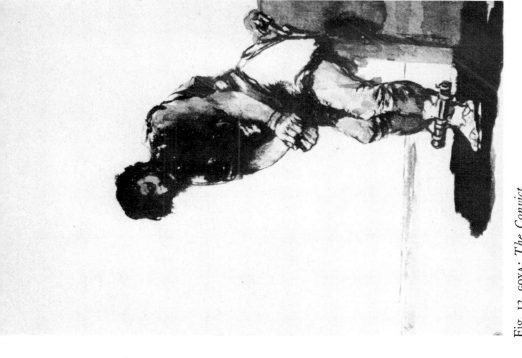

Fig. 12. GOYA: *The Convict.*

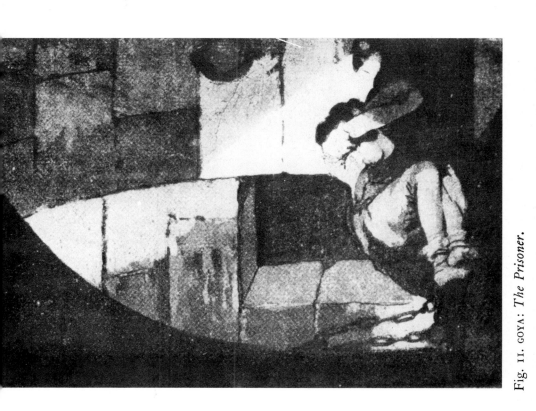

Fig. 11. GOYA: *The Prisoner.*

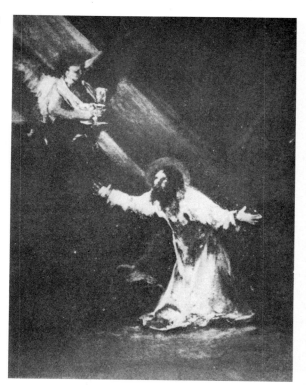

Fig. 13. GOYA: *Prayer on the Mount of Olives.*

Fig. 14. GOYA: *Detail of Vault in the Church of St. Antonio de la Florida, Madrid.*

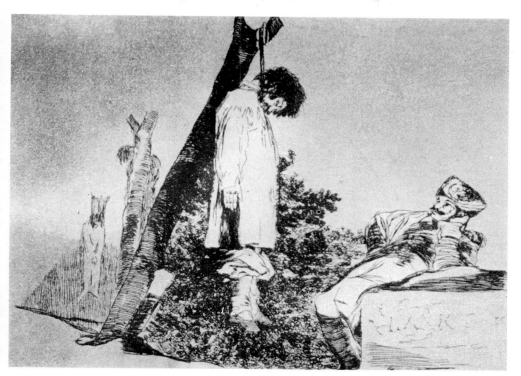

Fig. 15. GOYA: *The Disasters of War* (No. 36).

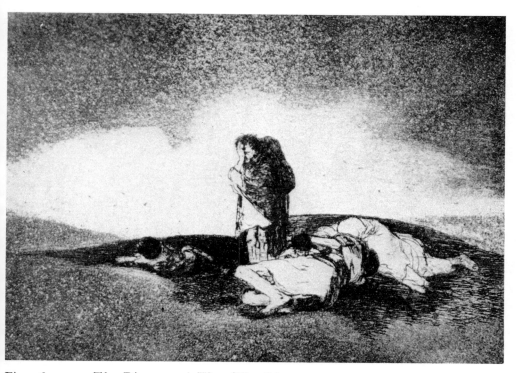

Fig. 16. GOYA: *The Disasters of War* (No. 60).

Fig. 17. GOYA: *Don José Pio de Molin*

Fig. 18. GOYA: *Don Juan-Antonio Lloren*
Fig. 19. GOYA: *Youth*.

Fig. 20. GOYA: *The Vision of St. Isidore* (detail).

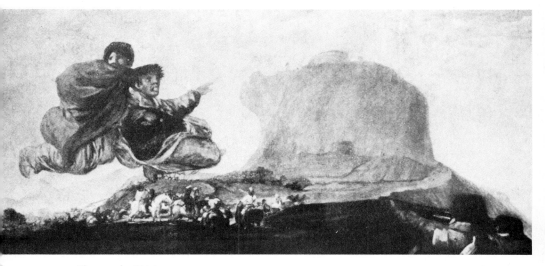

ig. 21. GOYA: *Fantastic Vision*.

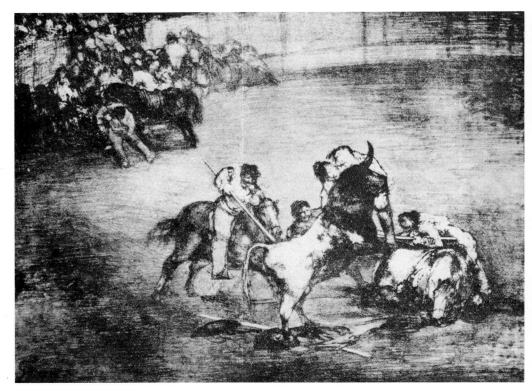

Fig. 22. GOYA: *Goring of a Picador.*

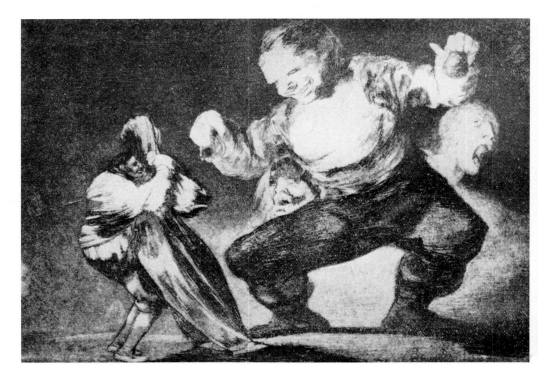

Fig. 23. GOYA: *Bobalicon.*

Constable

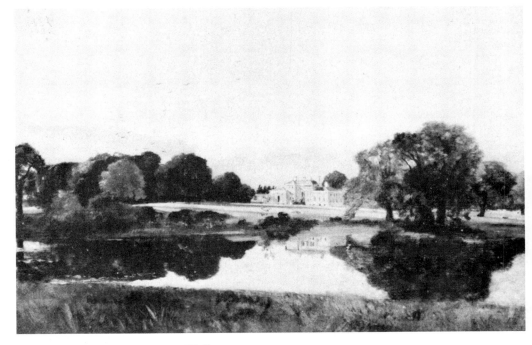

Fig. 24. CONSTABLE: *Malvern Hall*.

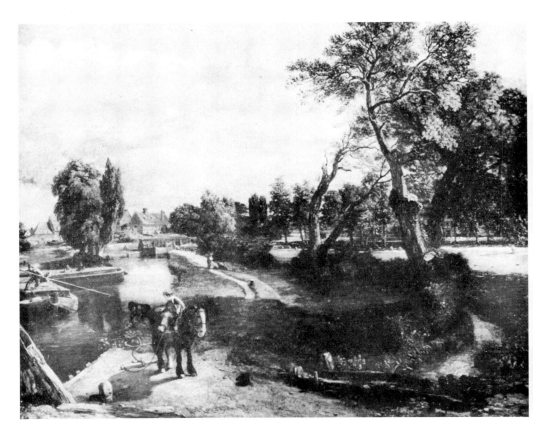

Fig. 25. CONSTABLE: *Flatford Mill*.

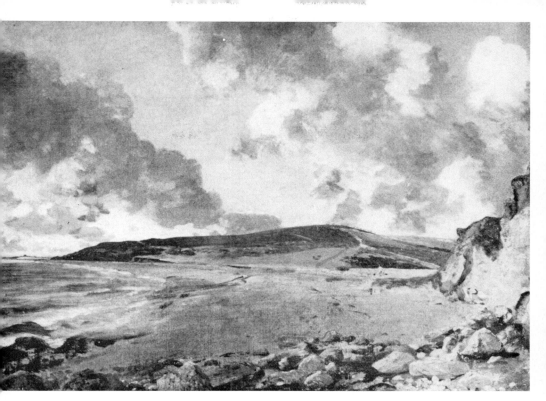

Fig. 26. CONSTABLE: *Weymouth Bay.*

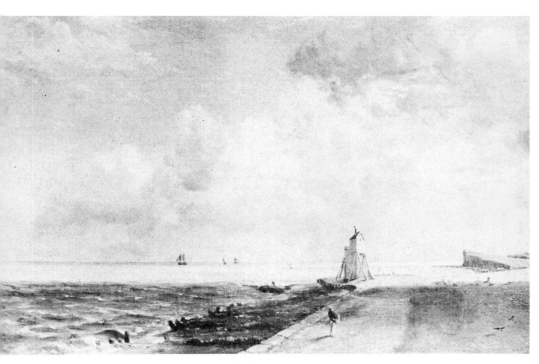

Fig. 27. CONSTABLE: *Harwich, Sea and Lighthouse.*

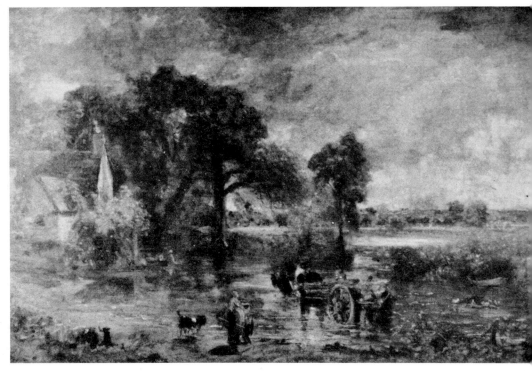

Fig. 28. CONSTABLE: *Hay Wain* (the sketch).

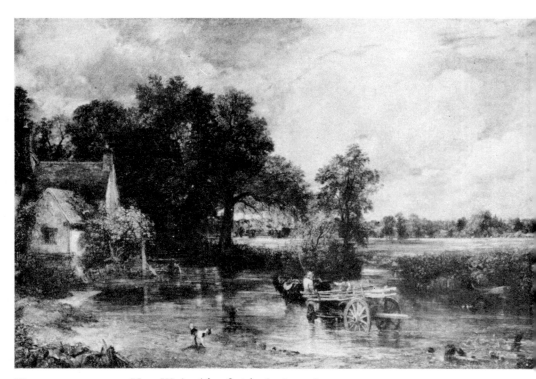

Fig. 29. CONSTABLE: *Hay Wain* (the finished picture).

Fig. 30. CONSTABLE: *The Jumping Horse* (the sketch).

Fig. 31. CONSTABLE: *The Jumping Horse* (the finished picture).

Fig. 32. CONSTABLE: *Salisbury Cathedral from the Bishop's Garden* (the sketch).

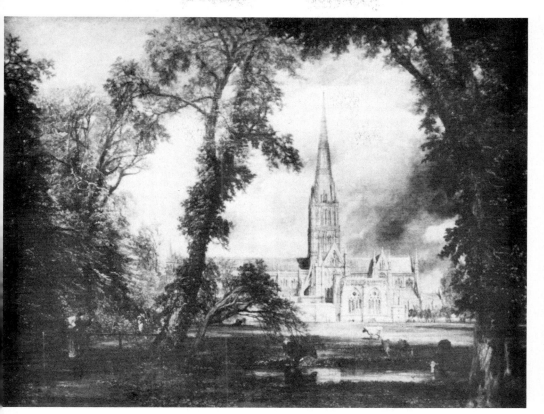

Fig. 33. CONSTABLE: *Salisbury Cathedral from the Bishop's Garden* (the finished picture).

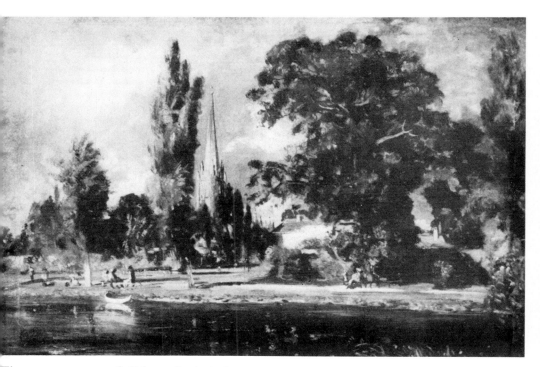

Fig. 34. CONSTABLE: *Salisbury Cathedral*.

Fig. 35. CONSTABLE: *A Dell in Helmingham Park*, 1823.

Fig. 36. CONSTABLE: *A Dell in Helmingham Park*, 1830.

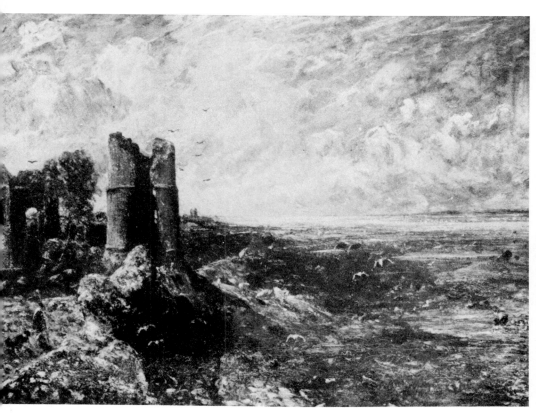

3. 37. CONSTABLE: *Hadleigh Castle*.

Fig. 38. BONINGTON: *Francis I and Margaret of Navarre*

Fig. 39. BONINGTON: *Marine*.

David

40. DAVID: *Portrait of Madame Pécoul.*

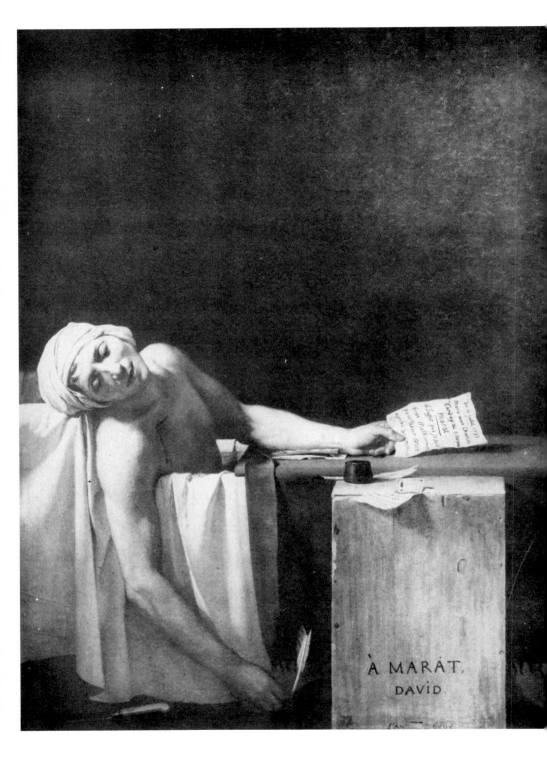

Fig. 41. DAVID: *Marat Assassinated*.

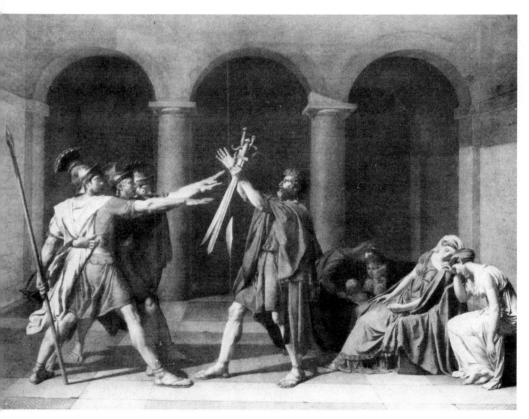

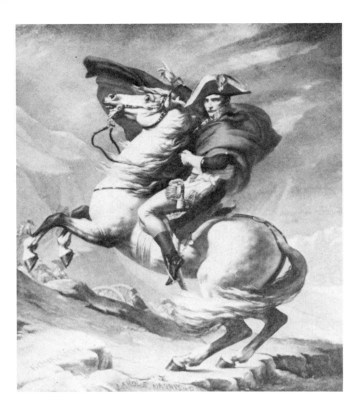

Fig. 44. DAVID: *Bonaparte Crossing the Saint-Bernard*.

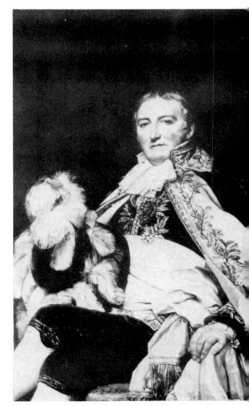

Fig. 45. DAVID: *Comte François de Nantes*.

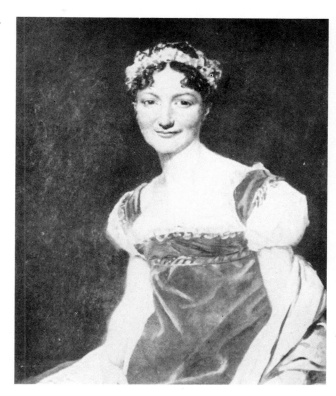

Fig. 46. DAVID: *Portrait of Baroness Pauline Jeannin*.

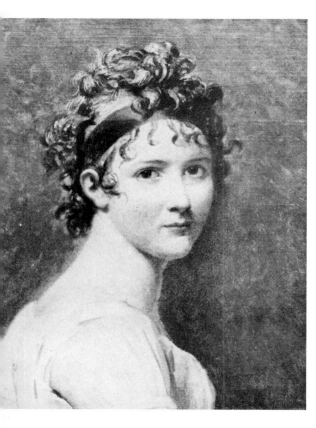

Fig. 47. DAVID: *Portrait of Madame Récamier* (detail).

Ingres

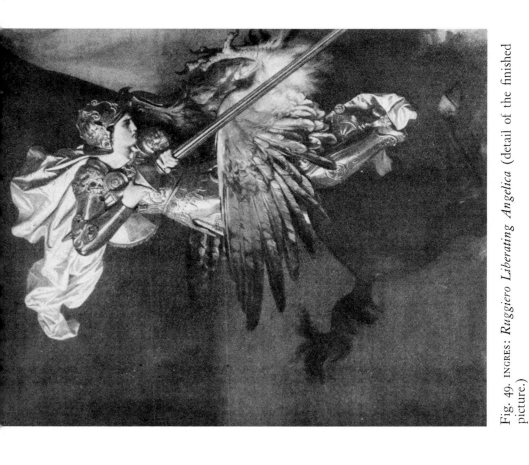

Fig. 49. INGRES: *Ruggiero Liberating Angelica* (detail of the finished picture.)

Fig. 48. INGRES: *Ruggiero Liberating Angelica* (study).

Fig. 50. INGRES: *Bain Turc* (study).

Fig. 51. INGRES: *Bain Turc* (detail of the finished picture).

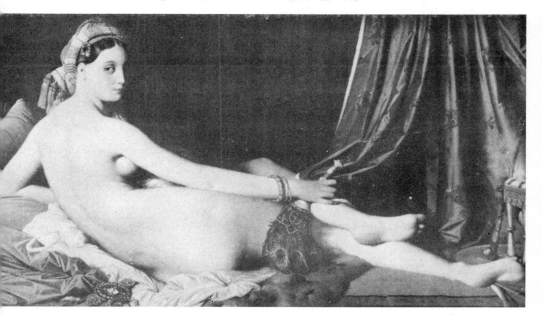

Fig. 52. INGRES: *Grande Odalisque.*

Fig. 53. INGRES: *Jupiter and Thetis* (detail).

Fig. 54. INGRES: *The Bather of Valpinçon.*

Fig. 55. INGRES: *The Sistine Ch*

Fig. 56. INGRES: *Stratonice,* 1866 version.

g. 57. INGRES: *The Montague Sisters*.

Fig. 58. INGRES: *Portrait of Granet.*

Fig. 59. INGRES: *Portrait of Madame Rivière.* Fig. 60. INGRES: *Portrait of Madame Devauç*

Fig. 61. INGRES: *Portrait of M. Bertin* (study).

Fig. 62. INGRES: *Portrait of M. Bertin.*

Fig. 63. INGRES: *Portrait of Madame d'Haussonville.*

Delacroix

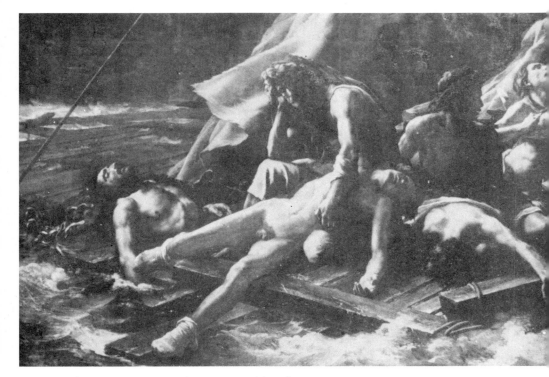

Fig. 64. GÉRICAULT: *Raft of the Medusa* (detail).

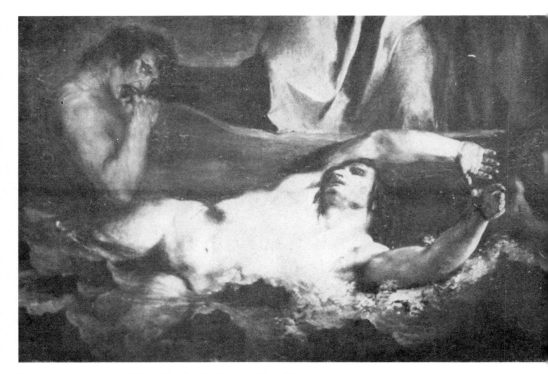

Fig. 65. DELACROIX: *The Bark of Dante* (detail).

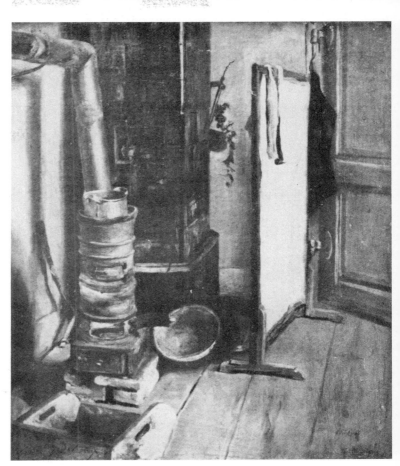

Fig. 66. DELACROIX: *The Stove*.

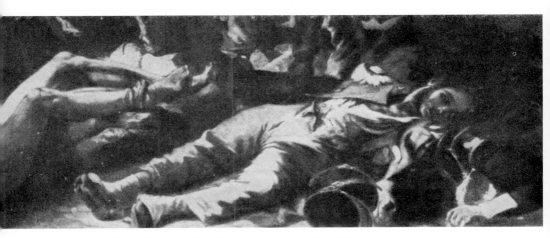

Fig. 67. DELACROIX: *The Twenty-eighth of July, 1830* (detail).

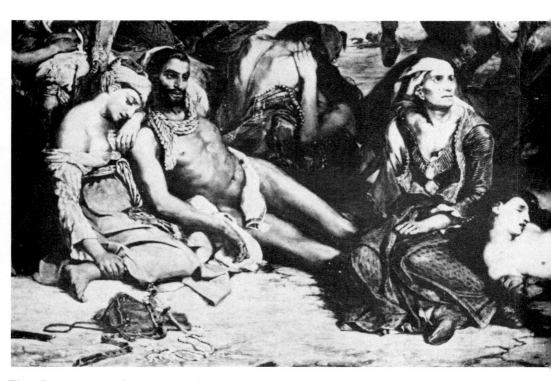

Fig. 68. DELACROIX: *Scenes from the Massacre of Chios* (detail).

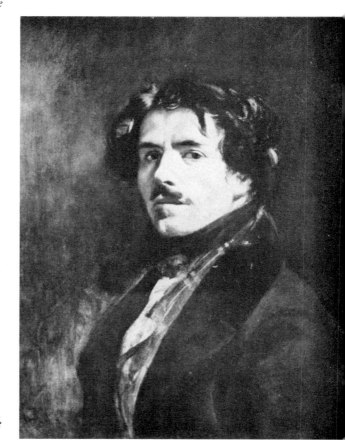

Fig. 69. DELACROIX: *Portrait of the Artist*.

Fig. 70. DELACROIX: *Mirabeau and the Marquis de Dreux-Brézé* (the sketch).

Fig. 71. DELACROIX: *Mirabeau and the Marquis de Dreux-Brézé* (the finished picture).

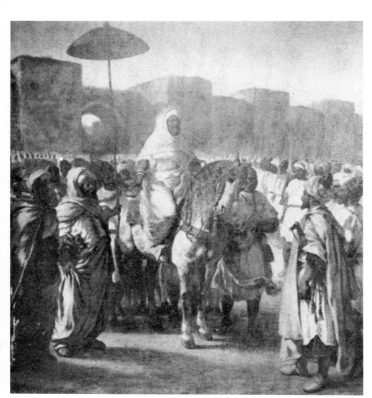

Fig. 72. DELACROIX: *Muley-Abd-er-Rahman, Sultan of Morocco, Leaving His Palace at Méquinez, Surrounded by His Guard and His Principal Officers*, 1845.

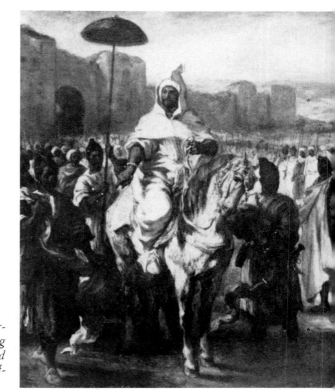

Fig. 73. DELACROIX: *Muley-Abd-er-Rahman, Sultan of Morocco, Leaving His Palace at Méquinez, Surrounded by His Guard and His Principal Officers*, 1862.

Fig. 74. DELACROIX: *Jewish Wedding in Morocco* (detail).

Fig. 75. DELACROIX: *Women of Algiers in Their Apartment* (detail).

Fig. 76. DELACROIX: *Medea*.

Fig. 77. DELACROIX: *The Taking of Constantinople by the Crusaders* (detail).

Fig. 78. DELACROIX: *A Landscape of Champrosay.*

Fig. 79. DELACROIX: *Ovid Among the Scythians.*

g. 80. DELACROIX: *Lion-hunt*.

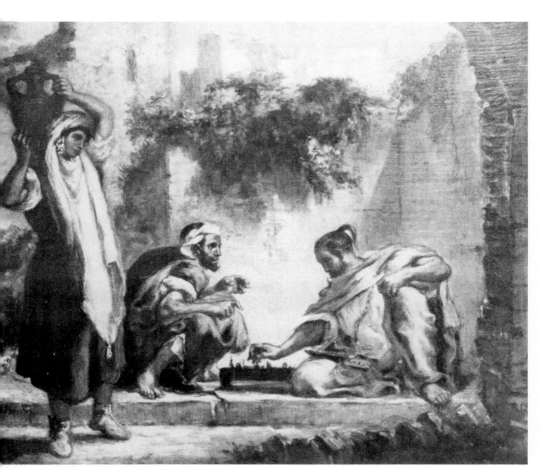

g. 81. DELACROIX: *Chess-players in Jerusalem*.

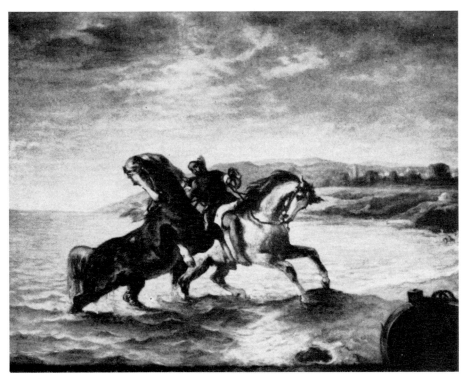

Fig. 82. DELACROIX: *Horses Emerging from the Sea.*

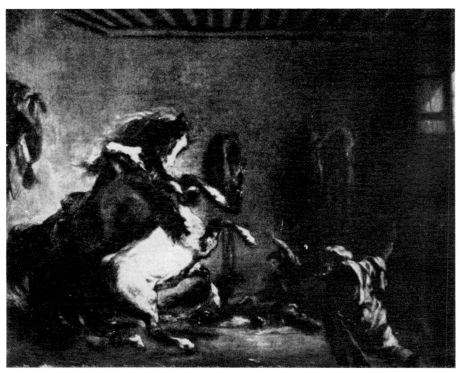

Fig. 83. DELACROIX: *Arab Horses Fighting in a Stable.*

Corot

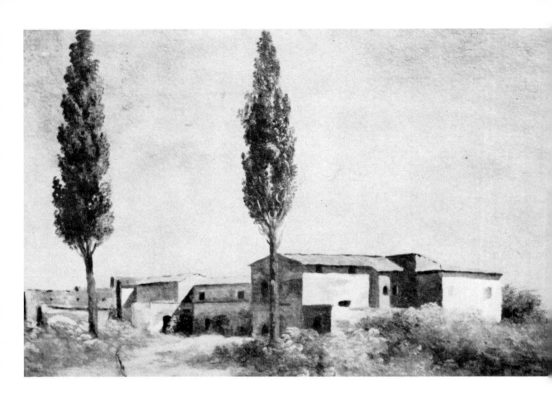

Fig. 84. VALENCIENNES: *Farm-house with Cypress Trees.*

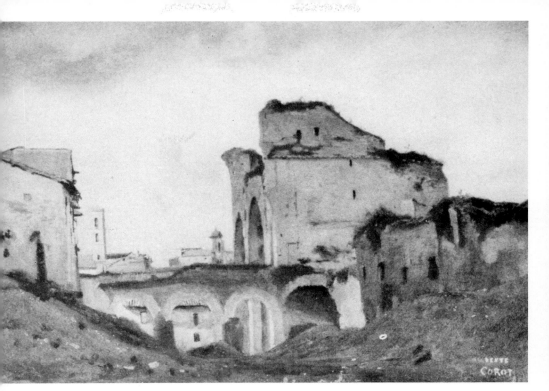

g. 85. COROT: *Basilica of Constantine.*

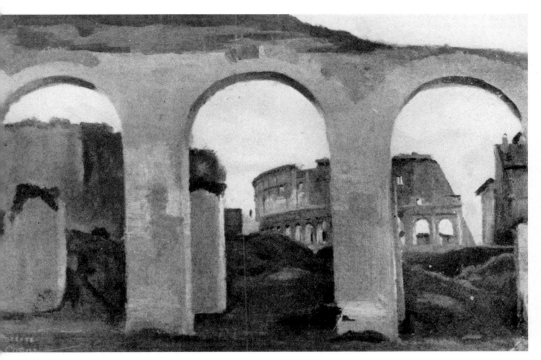

g. 86. COROT: *The Colosseum Seen Through the Arcades of the Basilica of Constantine.*

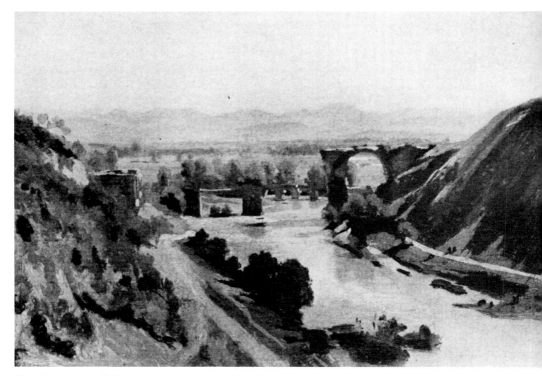

Fig. 87. COROT: *The Bridge at Narni* (study).

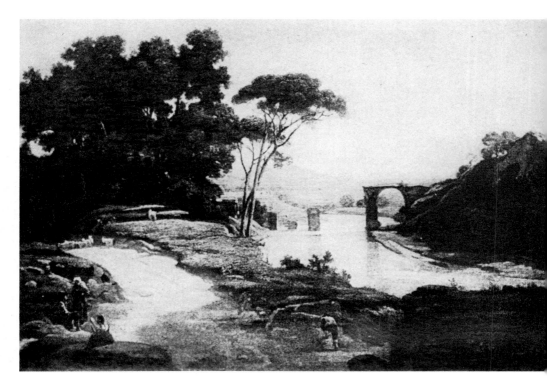

Fig. 88. COROT: *The Bridge at Narni* (finished picture).

g. 89. COROT: *The Promenade of Poussin.*

g. 90. COROT: *View of Volterra.*

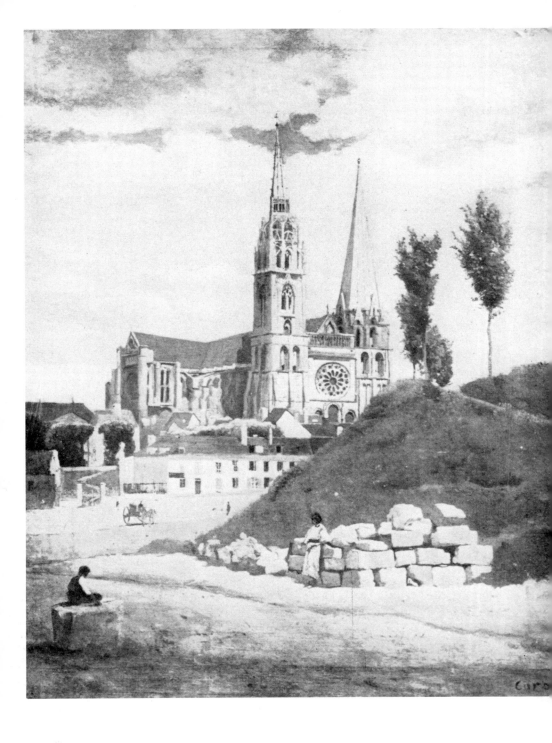

Fig. 91. COROT: *Chartres Cathedral.*

Fig. 92. COROT: *Recollection of Mortefontaine.*

Fig. 93. ROUSSEAU, THÉODORE: *A Clearing in the Woods at Fontainebleau.*

Fig. 94. DAUBIGNY, CHARLES: *Villerville-sur-Mer*.

Fig. 95. COROT: *Homer and the Shepherds*.

Fig. 96. COROT: *Macbeth and the Witches.*

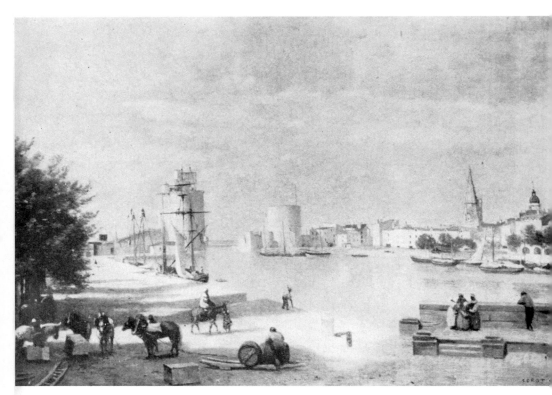

Fig. 97. COROT: *The Port of La Rochelle.*

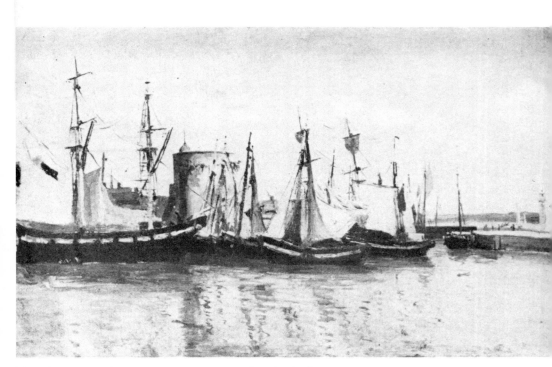

Fig. 98. COROT: *Entrance to the Port of La Rochelle.*

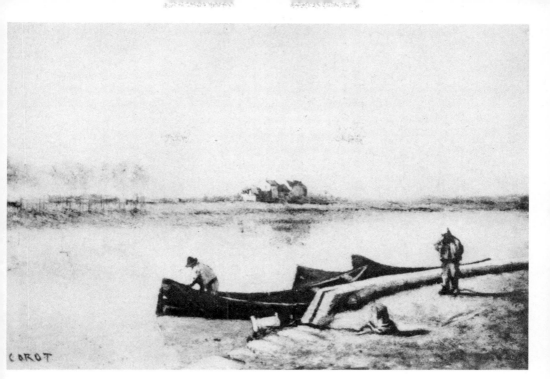

Fig. 99. COROT: *A River*.

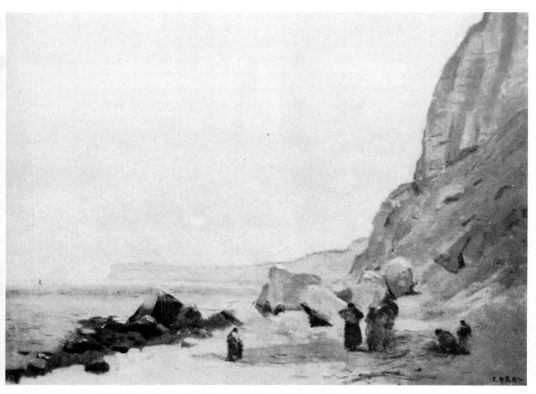

Fig. 100. COROT: *The Beach at the Foot of the Cliffs at Yport*.

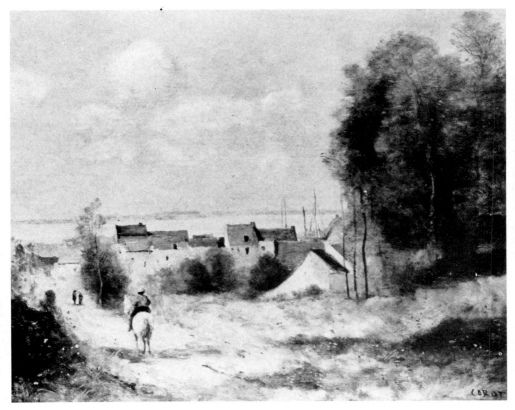

Fig. 101. COROT: *The Village on the Shores of the Sea.*

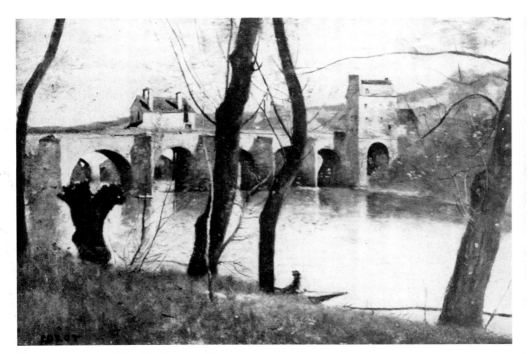

Fig. 102. COROT: *The Bridge at Mantes.*

Fig. 103. COROT: *The Tanneries of Mantes.*

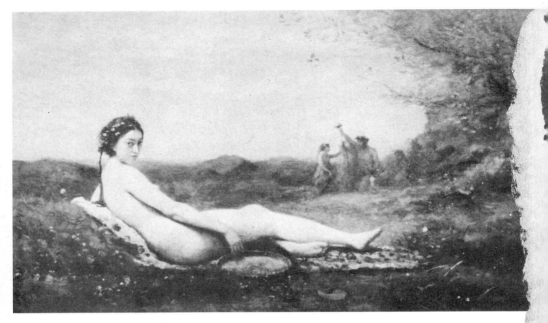

Fig. 104. COROT: *The Bacchante.*

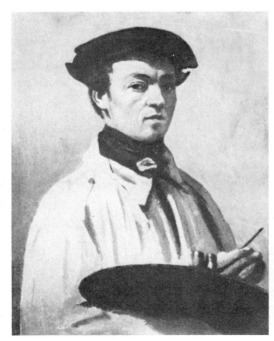

Fig. 105. COROT: *Self-Portrait.*

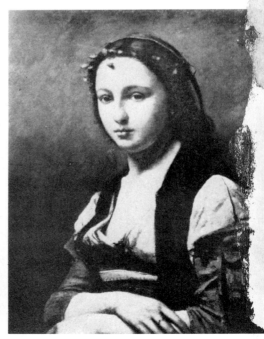

Fig. 106. COROT: *Woman with a Pearl.*

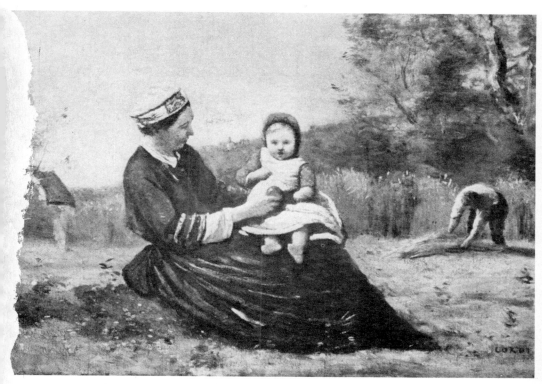

107. COROT: *The Reaper's Family.*

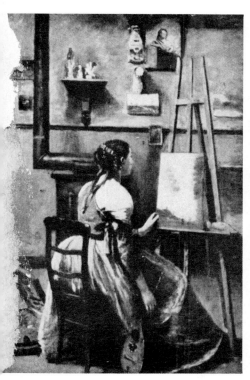

ig. 108. COROT: *The Atelier.*

Fig. 109. COROT: *Melancholy.*

Fig. 110. COROT: *The Interrupted Reading.*

Fig. 111. COROT: *The Greek Girl.*

Daumier

Fig. 112. DAUMIER: *Portrait of Charles de Lameth*.

Fig. 113. DAUMIER: *"Lafayette Gone! Tough Luck, Old Fellow!"*

Fig. 114. DAUMIER: *Rue Transnonain, April 15, 1834.*

Fig. 115. DAUMIER: *The Cancans.*

Fig. 116. DAUMIER: *Regrets.*

Fig. 117. DAUMIER: *The Miller, His Son and Their Donkey.*

Fig. 118. DECAMPS, ALEXANDER:
The Bell-Ringers.

Fig. 119. MILLET: *The Sower.*

Fig. 120. DAUMIER: *Drama*
(lithograph).

Fig. 121. DAUMIER: *Drama*
(painting).

Fig. 122. DAUMIER: *The Riders.*

Fig. 123. DAUMIER: *The Thieves and the Ass* (study).

Fig. 124. DAUMIER: *Don Quixote and Sancho Panza* (sketch).

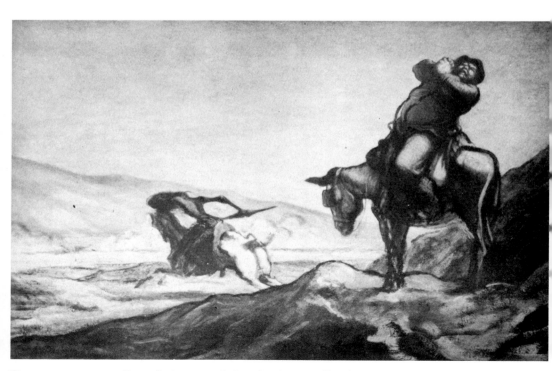

Fig. 125. DAUMIER: *Don Quixote and Sancho Panza* (finished picture).

Fig. 126. DAUMIER: *Don Quixote and Sancho Panza* (another version).

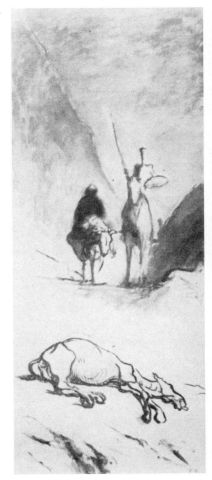

Fig. 127. DAUMIER: *Don Quixote and the Dead Mule*.

Fig. 128. DAUMIER: *The Emigrants*.

Fig. 129. DAUMIER: *The Pardon*.

Fig. 130. DAUMIER: *Third-Class Carriage.*

Fig. 131. DAUMIER: *Orchestra Stalls*.

Fig. 132. DAUMIER: *Old Comedy Types*
(detail).

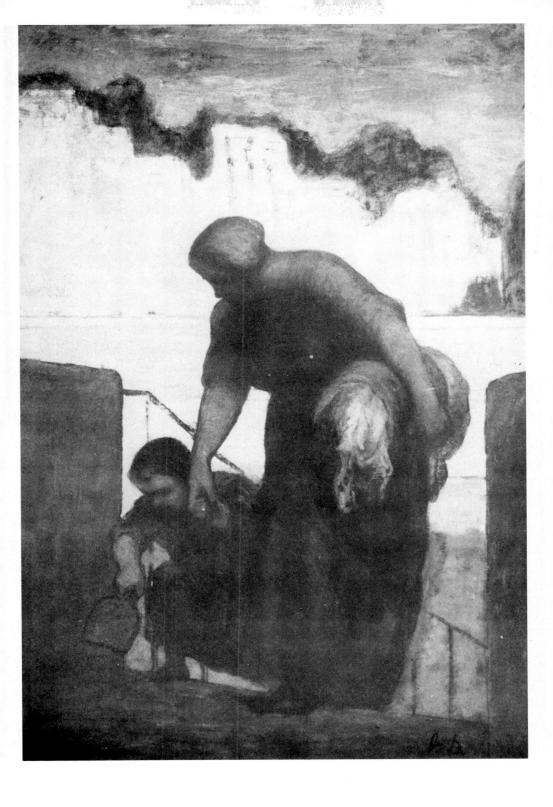

Fig. 133. DAUMIER: *Washerwoman with Child*.

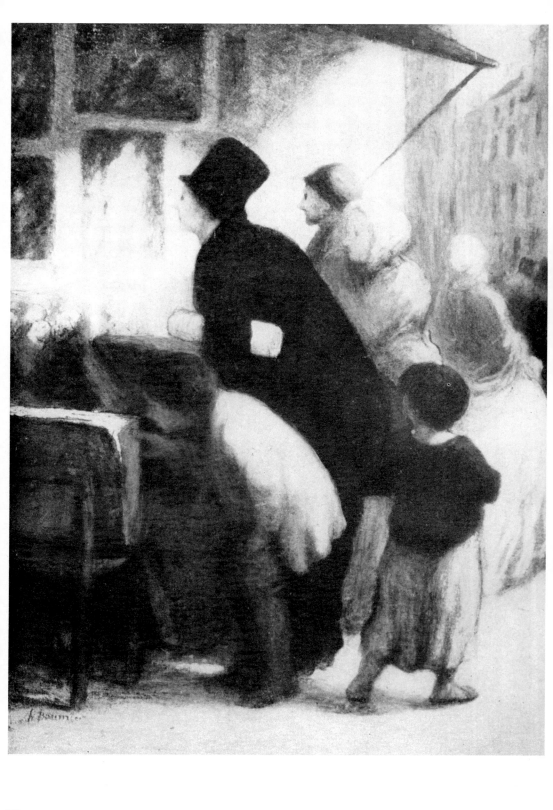

Fig. 134. DAUMIER: *Shoppers at the Stalls.*

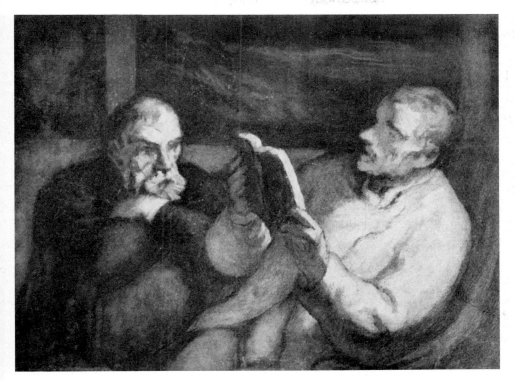

Fig. 135. DAUMIER: *The Reader*.

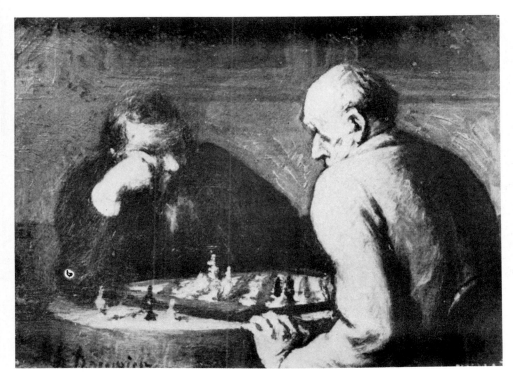

Fig. 136. DAUMIER: *Chess-players*.

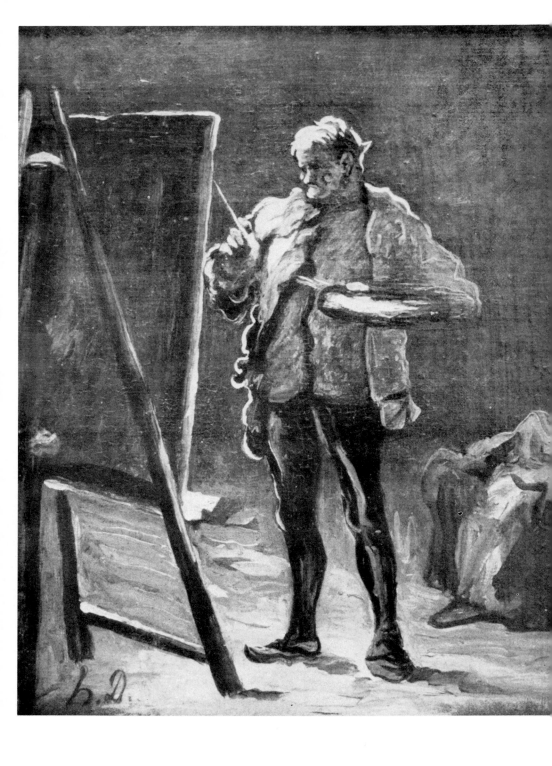

Fig. 137. DAUMIER: *The Painter Before His Picture.*

Courbet

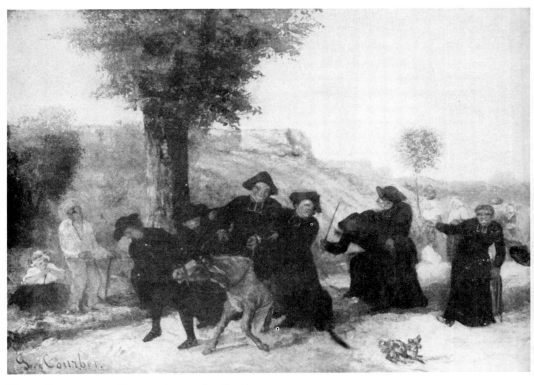

Fig. 138. COURBET: *Return from the Conference.*

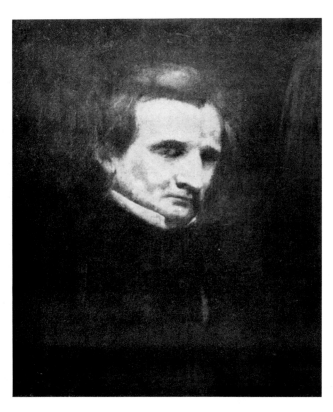

Fig. 139. COURBET: *Portrait of Hector Berlioz.*

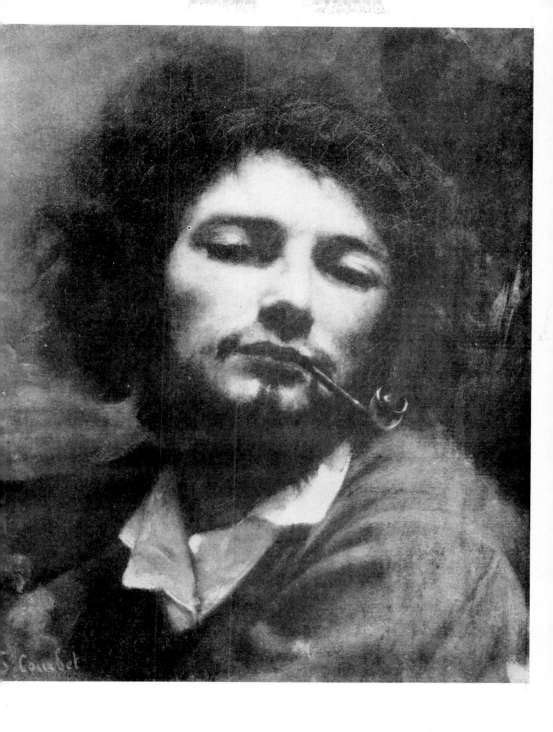

g. 140. COURBET: *The Man with the Pipe.*

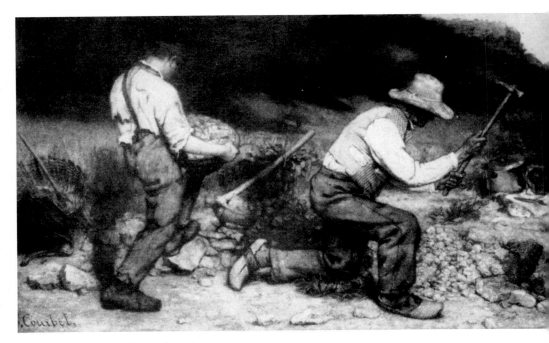

Fig. 141. COURBET: *Stone-Breakers*.

Fig. 142. COURBET: *The Burial at Ornans* (detail).

Fig. 144. COURBET: *The Studio* (detail).

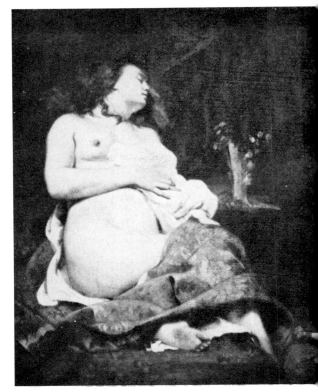

Fig. 145. COURBET: *The Sleeping Blonde*.

Fig. 146. COURBET: *A Young Girl's Dream*.

Fig. 147. COURBET: *The Lady of Francfort*.

Fig. 148. COURBET: *Mother Grégo*

Fig. 149. COURBET: *The Wom with the Parrot.*

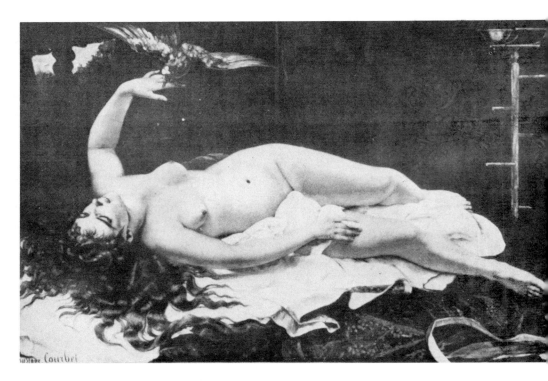

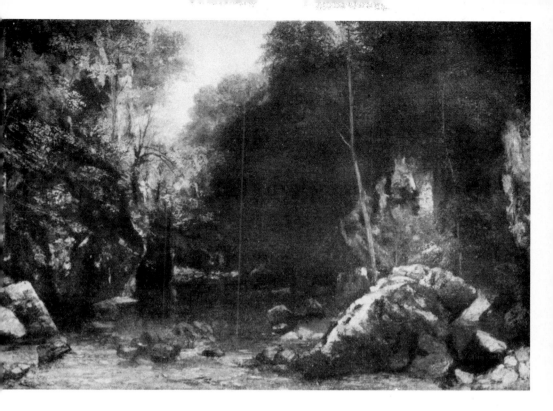

g. 150. COURBET: *The Shaded Stream.*

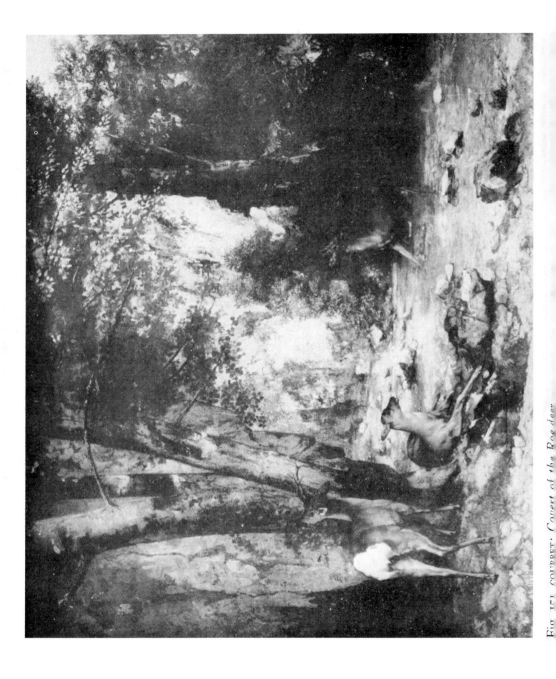

FIG. 151. COURBET: Covert of the Roe-deer

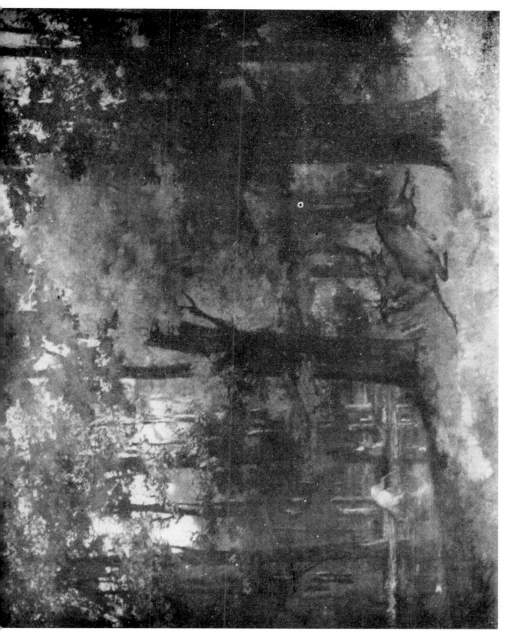

Fig. 152. COURBET: *In the Forest.*

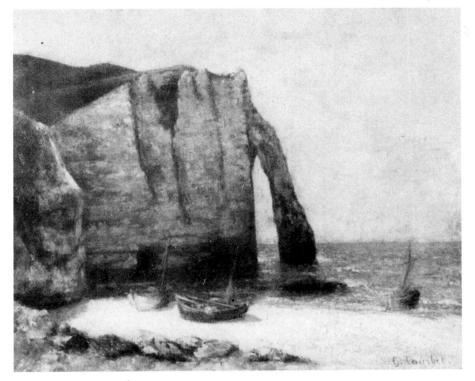

Fig. 153. COURBET: *Étretat*.

Fig. 154. COURBET: *Marine*.

g. 155. COURBET: *Calm Sea.*

Fig. 156. COURBET: *Fruit*.

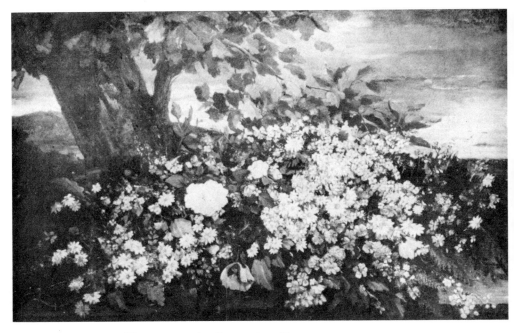

Fig. 157. COURBET: *Flowers at the Foot of a Tree*.